Passage to Wonderland

P·a·s·s·a·g·e TO Wonderland

REPHOTOGRAPHING JOSEPH STIMSON'S VIEWS OF THE CODY ROAD TO YELLOWSTONE NATIONAL PARK

1903 & 2008

Michael A. Amundson

UNIVERSITY PRESS OF COLORADO

Boulder

Published by University Press of Colorado
5589 Arapahoe Avenue, Suite 206C
Boulder, Colorado 80303

The University Press of Colorado is a proud member of
the Association of American University Presses.

The University Press of Colorado is a cooperative publishing enterprise supported, in part, by Adams State University, Colorado State University, Fort Lewis College, Metropolitan State University of Denver, Regis University, University of Colorado, University of Northern Colorado, Utah State University, and Western State Colorado University.

⊗ This paper meets the requirements of the ANSI/NISO Z39.48-1992 (Permanence of Paper).

Library of Congress Cataloging-in-Publication Data

Amundson, Michael A., 1965–
 Passage to wonderland : rephotographing J.E. Stimson's views of the Cody road to Yellowstone National Park, 1903 and 2008 / Michael A. Amundson.
 p. cm.
 Includes bibliographical references and index.
 ISBN 978-1-60732-192-7 (cloth : alk. paper) — ISBN 978-1-60732-204-7 (ebook)
1. Cody Region (Wyo.)—Pictorial works. 2. Scenic byways—Wyoming—Cody Region—Pictorial works. 3. Cody Region (Wyo.)—History—Pictorial works. 4. Scenic byways—Wyoming—Cody Region—History—Pictorial works. 5. Yellowstone National Park Region—History, Local—Pictorial works. 6. Repeat photography—Wyoming—Cody Region. 7. Repeat photography—Yellowstone National Park Region. 8. Stimson, Joseph Elam, 1870–1952—Travel—Wyoming—Cody Region. 9. Cody Region (Wyo.)—Description and travel. 10. Photographers—West (U.S.)—Biography. I. Title.
 F769.C6A48 2012
 978.7'42—dc23
 2012020273
Design by Daniel Pratt

22 21 20 19 18 17 16 15 14 13 10 9 8 7 6 5 4 3 2 1

This University Press of Colorado gratefully acknowledges the generous support of the Charles Redd Center for Western Studies at Brigham Young University and The Office of the Vice President for Research, Northern Arizona University, toward the publication of this book.

To my dog Nellie,
who passed away during the final stages of writing this book.

For ten and a half of her fifteen and a half years,
she was my constant companion. She listened to my ideas but,
more important, always reminded me
that nothing was better than a walk in the forest.

Contents

Acknowledgments

Any long-term project such as this requires the assistance of numerous persons and institutions to see it through to completion. At Northern Arizona University (NAU), I would like to thank the Department of History for its continued support. The academic world is ever-changing, but my home department has been solid in its support of faculty research. I very much appreciate that support. I am especially indebted to my friend and colleague George Lubick, who supported me from my hire there fifteen years ago and, even after retirement, read and commented on this manuscript. Thanks also to my friend and squirrel biologist Syl Allred for his support. Syl is an excellent photographer, and his willingness to look over my pictures and talk ecology with me was greatly appreciated. Thanks also to Vice President for Research Laura Huenneke for her assistance in securing rights to Stimson's photographs and for the subvention to print my rephotographs in color. It's an amazing privilege to have such encouragement from your colleagues to help you do the research you want to do.

Flagstaff is a beautiful place to live, with cool, rainy summers and snowy, snowy winters. NAU is an equally wonderful place to work, with dedicated faculty and inquisitive students. Thanks to all of the undergraduate and graduate students I have worked with over the years,

especially the latter who have continually pushed me to be a better scholar and writer. Beyond my department, thanks to friends Steve and Laura Gray Rosendale. Cline Library Special Collections has always been a home department away from home, and I very much appreciate everyone's support. It's nice to have another place on campus to talk history. Thanks especially to Jess Vogelsang and also to Todd Welch, who made the map for this book. It was fun to see that Todd was not only the best left-handed shortstop in coed Division H summer softball but a skilled map maker as well.

At NAU, I am also indebted to the Faculty Grants Program for providing a research grant to work on this project in the summer of 2008. Thanks also to Tim Darby for all of the computer help.

In Wyoming, the Buffalo Bill Historical Center (BBHC) in Cody provided a Cody Institute for Western Studies summer research grant in 2007 to start my Wyoming rephotography project. Thanks especially to former curator Juti Winchester for her support and encouragement. Lynne Houze, the local Cody historian, also helped with suggestions and encouragement. Thanks also to former BBHC deputy director Bob Pickering for his efforts.

At the Wyoming State Archives in Cheyenne, I cannot adequately thank photography curator Suzi Taylor for her support and encouragement. She not only helped me get reacquainted with the Stimson collection but also provided all the scans of Stimson's images. Former Wyoming state historian and Stimson biographer Mark Junge, a friend and colleague for twenty-five years, also provided encouragement and historical discussion about Stimson and his photography. Mark introduced me, via e-mail, to Erin Kinney, the digital initiatives librarian at the Wyoming State Library. When this project was first getting under way, Erin provided access to the ongoing Wyoming Newspaper Project that is digitizing all newspapers printed in the state between 1849 and 1922. I cannot thank her enough for this courtesy. Access to this website, now public, allows researchers anywhere in the world to do keyword searching of Wyoming papers. Many a night I stayed up late at home in Flagstaff searching through this site.

In Laramie, Tami Hert, head of Special Collections, University of Wyoming Libraries, provided encouragement and, more important, a large package of scanned pamphlets on the Cody Road. Thanks also to American Heritage Center associate director Rick Ewig and Eric Sandeen, director of the American Studies Program, for their encouragement.

At the University Press of Colorado (UPC), thanks to Darrin Pratt for his continued support of my research. I have very much enjoyed our work together. Thanks as well to Daniel Pratt for his layout work and to Jessica d'Arbonne for getting this project through the publication maze. I very much appreciate the work of copyeditor Cheryl Carnahan, who I've worked with on three books for UPC. It may not always show it, Cheryl, but I have learned much from you. Thanks also to an anonymous reviewer for support and suggestions. Thanks also to Douglas Byrd at the Western History Collection, Denver Public Library, for his help in finding Charles A. Heath's *Trial of a Trail*.

Yellowstone National Park historian Lee Whittlesey reviewed my manuscript and made critical corrections and suggestions. I appreciated him taking the time to talk with me on the phone about place names, especially Lichen Pass. Thanks also to Yellowstone National Park supervisory fisheries biologist Todd Koel, who took my out-of-the-blue phone call about Yellowstone Cutthroat Trout and taught me a valuable lesson.

In the field, many thanks to my aunt and uncle, Rozanne and Doug Reachard of Cody. For several weeks over the course of two summers, Doug and Rozanne housed and fed Lauren and me, listened to me talk about rephotography, and looked at my pictures every night. Having lived, hiked, run, hunted, and explored the Cody area for most of his life, Doug was invaluable in helping me find the most difficult camera stations. When I first started the project, he looked at every picture; noted certain rocks, the river, and other things; and gave me an excellent starting point for finding each location. When the project was nearing publication, he drove back and double-checked some locations.

Special thanks to my parents, Arlen and Joan Amundson of Loveland, Colorado, and my sister, Kathy Amundson of Denver, for their love and encouragement. They have always supported me in whatever I wanted to do. Thanks, Mom and Dad, for watching Nellie while we were in Cody. Thanks as well to my in-laws, Britt and Mary DeMuth, and my brother-in-law Eric DeMuth, all of Flagstaff, for their support and encouragement. Finally, here are the pictures from that summer in Wyoming.

My wife, Lauren, has been supportive of me and this project in so many ways. Not only did she take two summers off to work with me in the field taking photographs, but she endured my methodical camera work with good spirits. Further, as an archivist and librarian at Lowell Observatory in Flagstaff, she was a great sounding board for ideas and research possibilities. Mostly, though, her wonderful attitude, sense of humor, and love of rabbits and

squirrels make every day a fun adventure. Every historian should be lucky enough to be married to such a librarian.

My dog Nellie passed away at age fifteen and a half just as I was finishing this project. I had adopted her when she was almost five, and we spent ten wonderful years together. She was my best friend and constant companion. We went on hikes together, and she stayed up late with me when I was writing. It's amazing what great companionship a sweet dog can provide in one's life, and Nellie is missed every day. I dedicate this book to her and to historians' dogs everywhere.

Although Nellie listened to most of my ideas and occasionally contributed ones of her own to this project, any errors are my own responsibility.

Passage to Wonderland

#	Archives Number	Caption Title
1	613	Bird's-eye view of Cody
2	615	Irma Hotel, Cody
3	576	Cedar Mountain
4	569	Irma Post Office, Cody Gateway to Yellowstone National Park (YNP)
5	581	Scene on Cody Gateway
6	611	Index Mountain at twilight
7	604	Scene on Cody Gateway
8	603	Crimson Tower

#	Archives Number	Caption Title
9	609	Dugway and North Fork, Shoshone River
10	608	Rustic Bridge, Cody Gateway
11	606	Roadway and North Fork, Shoshone River
12	610	Diablo Castle and North Fork, Shoshone River
13	571	Landing a big one, North Fork, Shoshone River

#	Archives Number	Caption Title
14	570	Fishing on North Fork, Shoshone River
15	577	Scene on Cody Gateway
16	575	Cody Gateway
17	605	Pastoral scene
18	580	Scene on Cody Gateway
19	578	Canyon scene
20	587	On the way to Yellowstone Park
21	582	Cody Gateway to YNP

All Stimson photographs 1903 except where noted

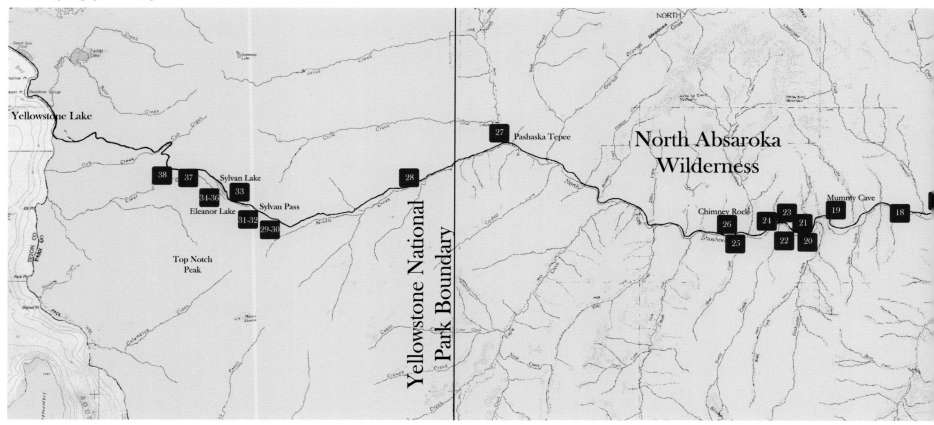

#	Archives Number	Caption Title
22	595	Sentinel Rock
23	598	Sentinel Rock and Shoshone River
24	596	Canyon and North Fork, Shoshone River
25	597	Cody Gateway
26	573	The "Needle," Cody Gateway
27	574	Baten's Cabin, North Fork, Shoshone River
28	600	Lichen Pass on Cody Road to YNP

#	Archives Number	Caption Title
29	589	Middle Creek Canyon from Sylvan Pass
30	599	Summit, Sylvan Pass
31	584	Sylvan Pass
32	591	Fern Lake (actually Eleanor Lake)
33	590	Hoyt's Peak (actually Top Notch)
34	586	Upper end, Sylvan Lake
35	585	Fern Lake, Hoyt's Peak in distance (actually Sylvan Lake, Top Notch Peak in distance)

#	Archives Number	Caption Title
36	579	Sylvan Lake panorama
37	592	Scene near Sylvan Pass
38	583	Yellowstone Lake from Cody Road
39	3164	Shoshone River near Cody, 1910
40	3165	Shoshone Canyon and tunnel, 1910
41	3159	Alpine scene at Shoshone Dam, 1910
42	3163	Cedar Mountain and Shoshone Dam, 1910

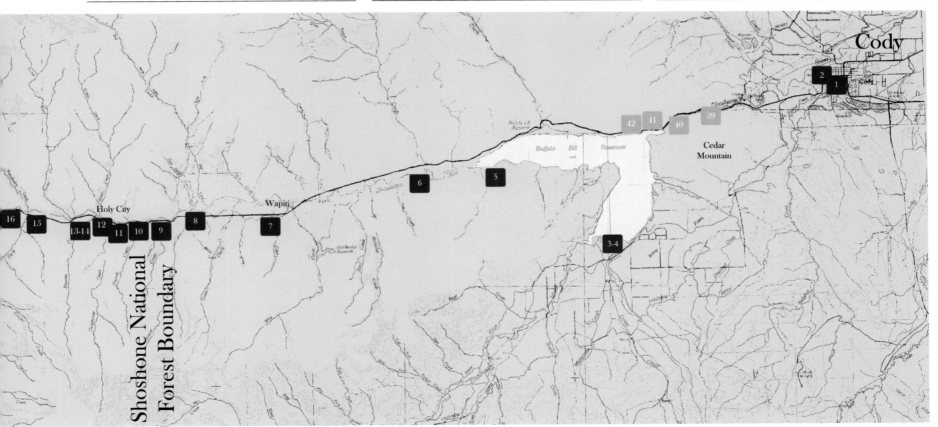

Passage to Wonderland

The road from Cody, Wyoming, to Yellowstone National Park has been called the "most scenic fifty miles in the world." Officially designated the "Buffalo Bill Scenic Byway," the road follows the North Fork of the Shoshone River to the high mountains of the Absaroka Range and the park's East Entrance. Along this course it has no major exits or entrances—it is an expressway to Yellowstone. It first leaves Cody between Cedar and Rattlesnake Mountains, then winds its way past Buffalo Bill Dam where the Shoshone's North and South Forks converge to form Buffalo Bill Reservoir. The road hugs its northern shoreline and then follows the North Fork westward, climbing through the broad Wapiti valley and past its many historic ranches. In the nearby forests live pronghorn, bighorn sheep, grizzly and black bears, elk, and moose. Continuing westward, the road enters Shoshone National Forest—the nation's first—where the North Fork cuts through a volcanic landscape of fantastic rock formations, steep cliffs, and increasingly thick stands of lodgepole pine, Douglas fir, and aspen. Just past Pahaska Tepee, Buffalo Bill's former hunting lodge and tourist stopover, the road leaves the North Fork and enters Yellowstone National Park, where it soon picks up the Middle Fork of the Shoshone and then climbs toward Sylvan Pass. After cutting through the pass, the road

skirts two beautiful alpine lakes—Eleanor and Sylvan—before descending through meadows and forest along mountainsides toward Yellowstone Lake and the park's Grand Loop.

The road opened to the public in July 1903. During that first month Cheyenne, Wyoming, photographer Joseph Elam Stimson traveled the route photographing it and its many wonders. Stimson had been working for the Union Pacific Railroad as a publicity photographer and had recently been hired by the state of Wyoming to photograph a dozen images from each Wyoming county for display at the 1904 Louisiana Purchase Exposition to be held in St. Louis, Missouri. During a week-long jaunt arranged by the Cody Commercial Club and guided by a local man named Fred Chase, Stimson photographed forty-five scenes along the road and reported that the scenery was "grander by far over this road than is the park proper or along any other road." His images, made on 8×10-inch glass plates and produced first as black-and-white prints and then often colored by hand, represent historic primary sources of what this "scenic byway" looked like during its first week of existence.

In the summers of 2007 and 2008, as part of a project to rephotograph Stimson's work across Wyoming, I traveled back and forth along the Cody Road exploring its landscapes and locating the vantage points Stimson had used to make his images more than a century earlier. Ably assisted by my then fiancée, Lauren, and my uncle, Doug Reachard—who has spent more than thirty years hiking, exploring, and hunting along the North Fork—I found thirty-nine original vantage points, marked each location using a Global Positioning System (GPS) unit, and then rephotographed the scene in color using a high-quality digital SLR camera.

Viewed side by side, the before-and-after images illustrate the essence of history—change over time. Like two frames of a motion picture, the then-and-now scenes not only illuminate what's in front of the lens—the effects of nature and human action over a century—but also hint as to why Stimson composed his original views and how those places fit into today's landscape. Further, these views suggest broader cultural ideas about the American West in the first few years of the twentieth and twenty-first centuries. Looking closely at the images and the processes that created them, a viewer today can see hints of the Old West and the New West as they play out through such concepts as liminality, tourism, ecology, and photography. In so many ways, the Cody Road to Yellowstone is indeed a passageway to wonderland.

For example, examine the first photograph attempted in this project, a view Stimson labeled "Irma Post Office, Cody Gateway to Y.N.P., Wyo." Like many of his pastoral images,

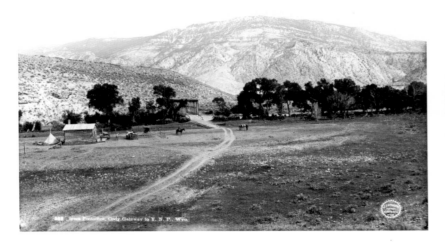

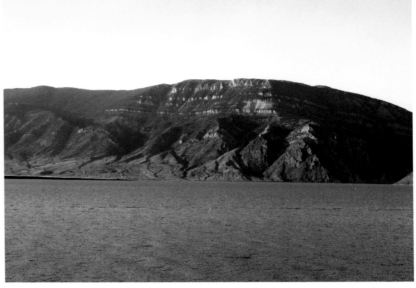

this view focuses on a small log structure in the middle-left foreground. A horse-drawn wagon waits in front, as do several bystanders, a horseman, and another grazing horse. A two-track path leads viewers from the lower-left corner to the log building and then to a glimpse of a truss bridge set amid a row of trees alongside a river. A sagebrush-covered hill stands beyond the river on the left, and a much larger mountain, fainter but grander, looms across the width of the background. Historical research reveals that the Irma Post Office was named for Buffalo Bill Cody's daughter, Irma Louise Cody, and was located on the South Fork of the Shoshone River just west of Cody. Rattlesnake Mountain dominates the background, and the South Fork of the Shoshone moves across the scene. The wagon tracks are the county portion of the Cody to Yellowstone road. In the spring of 1903, just a few months before Stimson's visit, Irma absorbed the nearby Marquette Post Office and took the latter name that spring.

When we began researching the site of the Irma Post Office, folks in Cody directed us to an area now called Irma Flats near the former site of Marquette, on the southeast side of Buffalo Bill Reservoir. By examining the site and comparing its views to those in Stimson's image, we quickly figured out that Irma Flats was not the same location. We also realized that the reservoir, completed in 1910, had probably inundated Stimson's pastoral scene. We soon found a dirt road called Stagecoach Lane skirting the western edge of the lake and began to see

Figure 0.1 The changes in this image are obvious because only the contours of distant Rattlesnake Mountain hint at the location of the Irma Post Office, now far below the surface of Buffalo Bill Reservoir.

similarities between the upper portions of Rattlesnake Mountain to the north and the faint image of the background mountain in Stimson's view. After later learning that Stagecoach Lane was indeed the remnant of the old Cody Road to Yellowstone, we knew we were on the right track but also that Stimson's vantage point now lay many feet below the water's surface. After more searching, we discovered that a recent addition to the Buffalo Bill Dam had led to the creation of a causeway road that extended from the edge of Irma Flats out into the lake. Loading our camera gear, tripod, and original photos into backpacks, we walked out onto the causeway, lined up our image the best we could, and snapped the rephotograph.

A comparison of the two images serves as a good introduction to this book. The most obvious place to begin is with the utter ecological transformation of Buffalo Bill Reservoir on the scene. We believe the very top of the sagebrush-covered hill might be peeking out from the waters on the middle left of the new image, but the valley, trees, and riparian areas are all gone. A close look at Rattlesnake Mountain reveals that the forest seems to have thickened and expanded as well. Although one might want to quickly dismiss the transformation as one from the cowboy-dominated Old West of Stimson's image to the New West of federal reclamation engineers, recall that the dam was begun just a year after Stimson made his image and water inundated the valley less than a decade later. So for most of the century between the two images, the valley appeared as it does in the 2008 photograph. Another consideration when comparing the two images is tourism. Stimson's view depicts the very beginnings of Cody tourism, when the two tracks in the foreground represented a new route to Yellowstone during its first month of existence. At the time, travelers marveled at the excellent highway during their three-day trip to the park. Today, the Cody Road has been moved to the base of Rattlesnake Mountain, where cars now speed to the park in little over an hour and recreational water-based tourism takes place on the reservoir, hundreds of feet above the old road.

Three vantage points later we find another pair of images that further introduce this book's concepts. Labeled by Stimson simply as "Scene on Cody Gateway to Y.N.P., Wyo," this view was taken a few miles west of the previous image on the current Highway 14/16/20, just past the small community of Wapiti. Like the Irma Post Office and much of this road to Yellowstone, Wapiti had a direct tie to Buffalo Bill. As recent biographers illustrate, although Cody was not always an astute businessman, he was an active one. Early on he became a promoter of the road from his namesake Wyoming town to the park. Soon after the road opened, Cody built tourist lodges about halfway to Yellowstone at Wapiti and just outside the East

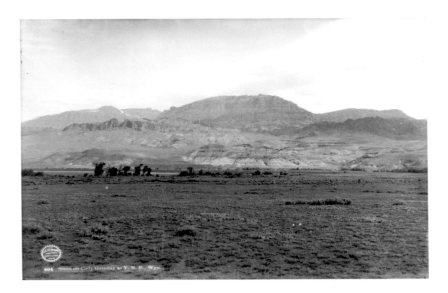 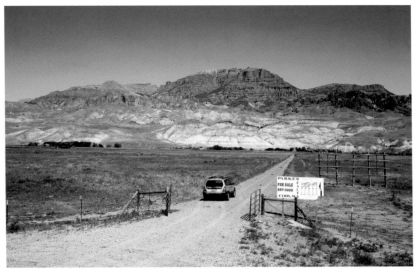

Entrance at Pahaska Tepee. Although Cody is not present in any of Stimson's photographs along the road to Yellowstone, the Old Scout's presence seems always to be lurking in the views.[1]

 Unlike the image of the Irma Post Office, the basic landscape of this scene seems practically unchanged. Looking north toward Jim Mountain, Stimson's view shows wild rangelands, a few cottonwoods, the North Fork of the Shoshone, and then the badlands rising to a few snowfields on the mountain. In the modern photo, irrigated ranchlands spread northward to a line of cottonwoods along the Shoshone's North Fork. Beyond the river are the same badlands, with similar vegetation patterns leading up to the same silhouette of Jim Mountain against a blue summer sky. Most of the background, including the mountain, is within the North Absaroka Wilderness Area, an area of strict environmental protection where no machines are allowed. But the visible differences in this pair of photos are in the foreground. The barbed wire fence running left to right demarks the modern closed range, while the straight dirt road and my Subaru Forester offer hints of automobile tourism and the global marketplace. Most telling is the large white sign to the right (just in front of an old billboard framework), advertising a local realty company that is subdividing the ranch into smaller New West ranchettes. A Google search shows parcels of "raw land" selling here for $850,000 and houses for more than $2 million.

Figure 0.2 Unlike the previous pair of images, these two views of Jim Mountain appear seemingly unchanged. Further research, however, hints at the many cultural differences in the two photographs.

Like so many beautiful places in the American West, the Cody Road to Yellowstone now serves not only as a tourist route but also as an everyday road for "amenity migrants" seeking to own a beautiful piece of property. Globalization has transformed many parts of the West from local working lands into real estate developments selling commodified viewscapes to newcomers importing their wealth into traditional economies.

A comparison of these two sets of photographs reveals that one depicts a completely transformed ecology that hints at more subtle cultural changes, while the other looks practically the same but is rife with cultural transformations. Like two frames in a motion picture, these are but glimpses into bigger, broader stories. To better understand them, it is important to know more about the photographer who made the originals and my own rephotography project, as well as the history of the Cody Road to Yellowstone. The next two chapters discuss those topics.

Note

1. Louis S. Warren, *Buffalo Bill's America: William Cody and the Wild West Show* (New York: Knopf, 2005); Robert Bonner, *William F. Cody's Wyoming Empire: The Buffalo Bill Nobody Knows* (Norman: University of Oklahoma Press, 2007).

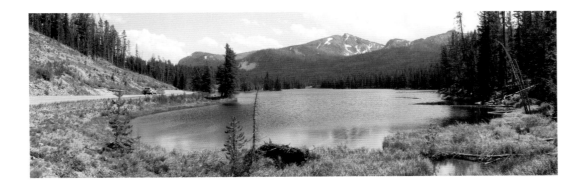

J. E. Stimson, Photography, Rephotography, and Me

Between 1889 and 1948, Joseph Elam Stimson photographed Wyoming and the American West, producing more than 7,500 images of landscapes, mining, railroads, community life, ranching and farming, and tourism. Most of these shots were made on 8×10-inch glass plates and are artistically composed and incredibly sharp. They are not a cross-section of the Progressive Era West but instead promotional photographs, specifically composed and created for Stimson's various employers—including the Union Pacific Railroad, the Wyoming state government, and the Federal Bureau of Reclamation. On many of the images Stimson placed a small stamp, circumscribed by the boundaries of a sun, that proclaimed "J. E. Stimson, Artist, Cheyenne, Wyo." He was indeed an artist, as he carefully composed and then often hand-colored his prints in an era long before the advent of color film.

J. E. Stimson was born in Virginia in 1870 and spent most of his childhood in the southern Appalachian Mountains of South Carolina. At age thirteen he moved with his family to Pawnee City, Nebraska, southeast of Lincoln, near the Missouri and Kansas borders. Three years later he left for Appleton, Wisconsin, to work as an apprentice for his cousin, photographer James Stimson. While in Appleton, he learned the requisite skills of portrait

photography and the details of both the wet-plate and newer dry-plate negative processes. In 1889 Stimson moved to Cheyenne, Wyoming, probably at the suggestion of two brothers who worked for the Union Pacific Railroad. At the time, he was only nineteen years old. Wyoming became a state in July 1890, and by that October Stimson had made a deal to purchase the studio and equipment of Cheyenne photographer Carl Eitner. He renovated the studio and within two weeks began running advertisements in the Cheyenne *Daily Leader* that read "Go to Stimson the Photo Artist for Pictures." Four years later he married Anna Peterson, and in 1895 they had the first of three daughters.[1]

Throughout the 1890s Stimson worked primarily as a studio portrait photographer. According to biographer Mark Junge, his clients included the area's earliest citizens as well as folks from outlying farms and ranches. An early account ledger indicates that Stimson often scheduled up to six sittings in a single day and sometimes traveled to patrons' homes to photograph them. Although most of these glass plates were accidentally broken in the 1930s, the small surviving sample shows the usual small-town portrait assortment including individuals, families, groups such as cowboys on roundups, politicians, fraternal organizations, athletic teams, and social clubs.[2]

Although George Eastman had introduced his flexible film, handheld Kodak to the masses in 1888, professional photographers such as Stimson relied on a large-format, 8×10-inch view camera that captured images on dry emulsion glass plates. For Stimson, this meant a wooden camera mounted on a heavy tripod. To take a picture, he would set up the camera, select the lens, open the diaphragm to a wide aperture to let in the most light, and then step under a black cloth behind the camera to compose and focus the image on the 8×10-inch ground glass. Once the composition was secure, he would slide a holder containing two covered sheets of unexposed glass into the camera's back, stop down the diaphragm and set the shutter speed for the correct exposure, remove one of the glass plate covers, and trip the shutter. He would then return the plate's cover to protect his image, remove the plate holder, and start the whole process over for the next image. The process was slow and deliberate. All photographs were more or less staged. That said, properly exposed images created in this manner produced outstanding negatives with a lot of visual information stored in the large-format light-sensitive plates. Although extremely fragile, images of this size could be contact printed at a 1:1 ratio on 8×10-inch paper or greatly enlarged without losing resolution. Stimson routinely enlarged his images to 30×44 inches.[3]

The Wyoming on which Stimson focused his large-format camera was a state barely a year old. Its previous life as a territory had, since 1868, been one of booms and busts, including railroad construction, cattle, and gold mining. To balance its economy, the territory had distributed its government institutions—and their assured payrolls—all along the railroad, with Cheyenne getting the capital, Laramie the university, Rawlins the penitentiary, and Evanston the asylum. To the north, the end of the Plains Indian wars in 1877 opened lands for settlement, although the native Shoshone and Arapahos were placed on a central reservation along the east side of the Wind River Range. The federal government carved out Yellowstone National Park from the northwest corner of the territory in 1872 and created an adjacent forest reserve to its east in 1891.[4]

When Stimson set up shop in the new state, Wyoming was on the upswing. Its population was only 60,000; its largest city, Cheyenne, had just over 11,000 residents. Laramie and Sheridan were the only other towns with more than 8,000 citizens. The state's economy was focused on the railroad, government, ranching, and coal mining in the south and cattle ranching, farming, and tourism in the north. According to longtime state historian T. A. Larson, the period between the end of the Spanish-American War and the start of World War I was one of "optimism, belief in progress . . . and [an] eagerness for economic development [that] possessed Wyoming citizens as never before nor since." Wyomingites had reason for optimism. During this time, the sheep industry tripled in size and soon matched the state's booming cattle production. Dry-land farming and irrigated agriculture expanded, with the number of farm units doubling. The miles of railroad track increased as the Union Pacific double-tracked its main line and other railroads, such as the Burlington, entered the state. Coal mining grew, and a small copper boom developed in the southeastern part of the state. Oil production was just beginning around Casper. Overall, the state's population grew by more than 50,000, from 92,000 in 1900 to 146,000 ten years later. Of this increase, most people settled in the northern half of the state. The federal government's influence also expanded in the first decade of the twentieth century, with Devil's Tower becoming the nation's first national monument and Shoshone Dam the first federal reclamation project. The young state thus offered a photographer such as Stimson an exciting array of progress and development to document beyond his studio.[5]

Several events during this period moved Stimson's career path from studio portraiture to landscape photography. In 1894 Wyoming engineer Elwood Mead, later commissioner of

the Bureau of Reclamation and for whom Lake Mead was named, asked Stimson if some glass plates he had made on a recent irrigation study in the Big Horn Mountains could be developed. Stimson obliged, and he was impressed with the scenery and surprised to learn that such beautiful landscapes existed in his adopted state. The following summer Mead brought Stimson along on another excursion to the Big Horns. Although the twenty-five-year-old photographer loved the scenery, his first pictures were overexposed. Four years later Albert Nelson, Wyoming's first game warden, took Stimson to visit the Jackson Hole area and the picturesque Teton Range, a place that came to be Stimson's favorite.

These images were better and more marketable than his earlier effort. In 1898 the Sheridan *Post* ran a small ad for Stimson's "beautiful pictures of Mountain Scenery" in sizes ranging from 8×10 to 30×40 inches. The photographer then traveled to nearby Wheatland and to the Shoshone Indian Reservation in central Wyoming to make portraits. He also photographed the beginnings of Cheyenne's famous rodeo, Frontier Days. By the turn of the century, Stimson had begun presenting magic lantern slide shows of his images and selling small portfolios and albums based on this growing collection of negatives. Newspaper announcements advertising "Stimson's Indians" appeared in Cheyenne papers around Christmas 1900 and described the work as a "fine collection." They also reported that the photographer was receiving orders from "all over the country for his celebrated photographs of the Grand Teton mountains and other scenics in the vicinity."[6]

Around this time, a Union Pacific Railroad agent obtained one of these albums and hired Stimson as a publicity photographer for the railroad. Reorganized in 1897 by Edward H. Harriman, the Union Pacific (UP) was in the midst of rebuilding and modernizing the nation's first transcontinental railroad by operating bigger trains, straightening the rail line's many curves, and double-tracking the entire route.[7] The UP needed an energetic photographer to document its efforts and contracted Stimson to photograph the line, not just in Wyoming but throughout the West. Under the open-ended terms, the railroad paid Stimson four dollars for the first 8×10-inch print, one dollar each for the next ninety-nine, and seventy-five cents apiece for every print thereafter. No restrictions were placed on the subjects he photographed or the number of images he made as long as they promoted the railway. Further, any negatives made for the UP could also be printed and sold for Stimson's own gain. In addition, the railroad provided free transportation for him either by train or, more often, through the use of a small gas-powered one-seat railcar.[8]

Over the next decade Stimson photographed such railroad landscapes as depots, train wrecks, bridges, tunnels, and new lines from Omaha to California. More important, he photographed adjacent UP cities and towns, as well as nearby farms, ranches, timber outfits, dams, and mines. Stimson also captured Wyoming's beautiful scenery, including Yellowstone National Park, for the developing tourism industry.[9] As an artist, Stimson often enlarged his prints and then hand-colored them, using paints, to produce beautiful, one-of-a-kind color prints. The Union Pacific agreement not only gave the young photographer the means to travel the West and a ready buyer for his photographs, but it also exposed his work to others who wanted similar images. Stimson's work for the Union Pacific catapulted him and his portfolio to even greater heights, as evidenced by his inclusion in the June 1903 issue of *Leslie's Weekly* magazine, which featured six of his images. The magazine stated that Stimson had a "keen eye for the picturesque and an artistic sense of position and proportion" and called him "one of the best scenic photographers in the United States."[10]

As important as his Union Pacific arrangement, in June 1903 the Wyoming Commission of the Louisiana Purchase Exposition hired Stimson to make photographs of the state for display at the 1904 St. Louis Fair. The commission paid Stimson $875 to produce 182 hand-colored prints of scenes across Wyoming. More specifically, he was to make a dozen 8×10-inch images from each of the state's twelve counties, plus another twelve scenes from Yellowstone National Park. In addition, Stimson would provide one 30×40-inch print of the state and another of the park. Although the contract called for Stimson to cover his own expenses for travel, printing, coloring, framing, labeling, and boxing the images, the photographer felt the pay was reasonable because, as with the UP agreement, he would retain ownership of all negatives so he could print and sell them for himself while working on the state contract (figure 1.1).[11]

The 1904 Louisiana Purchase Exposition in St. Louis commemorated the 100th anniversary of the acquisition of much of the American West, including most of Wyoming. The official guidebook for what has been called the 1904 World's Fair proudly stated that "this Exposition has already rendered an inestimable public service by awakening a universal popular interest in the story of the Louisiana Purchase and its glorious results." Like previous such fairs, the 1904 expo featured elaborate grounds and promotional displays from nearly every state and many foreign countries. The fair also hosted the 1904 Olympics.[12]

Although the Wyoming Commission of the Louisiana Purchase Exposition hired Stimson to promote the state through his photographs, it did not construct its own state

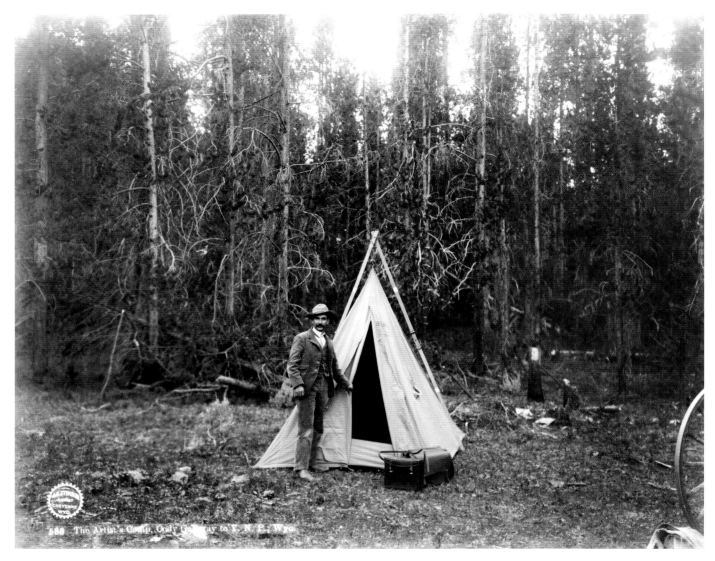

Figure 1.1 This view of Stimson is titled simply "The Artist's Camp" and was made in July 1903 while the photographer was in the field taking images of the Cody Road to Yellowstone. The thirty-three-year-old photographer had been hired by the Wyoming Commission for the St. Louis Fair to take promotional pictures of each of the state's twelve counties plus Yellowstone National Park. Stimson referred to himself as an artist both because of his excellent eye for composition and because he often enlarged and then hand-colored his images. Several of these images hang in the Cheyenne Masonic Lodge and in the Wyoming State Capitol.

building at the fair. Instead, its $25,000 appropriation was devoted entirely to exhibits in the Palaces of Mines and Agriculture.[13] Stimson's photographs, like his work for the Union Pacific, would promote the state through photography. To do this, Stimson was to "travel all over Wyoming, consult with boards of county commissioners and local industrial committees, and make views best calculated to show our varied resources and magnificent scenery."[14]

The summer and fall of 1903 were a whirlwind of photographic fieldwork for Stimson. In late June, just three weeks after he was awarded the contract, Stimson began photographing the state by traveling to the irrigated farming community of Wheatland and the nearby iron mining town of Sunrise. He then spent five days at Newcastle in the northeast corner of the state. Two weeks later, in a story titled "A Busy Day for Mr. Stimson," the Buffalo *Voice* reported that the photographer had captured images around that northern Wyoming community. He then photographed ranches in nearby Big Horn and Beckton. A week later the Sheridan *Post* recorded that Stimson had photographed that city and the coal mining town of Dietz to the north. At about the same time, the Crook County *Monitor* in Sundance reported that the photographer was at work in that community, as well as at nearby Devil's Tower. He then traveled to Cody and Yellowstone National Park before turning east to capture Meeteetsee and the Pitchfork Ranch the first week in August. Stimson traveled next to the Shoshone Indian Reservation, Lander, and the Popo Agie River valley and by the end of August had photographed Evanston and Kemmerer. He returned to Cheyenne in the middle of August, when Cheyenne's *Wyoming Tribune* reported in an article titled "Some Fine Views" that the photographer had spent six weeks in the field and was "very busy these days developing" the hundreds of exposures he had made. Stimson was back on the road to Douglas and Converse County the first week in September, Laramie by mid-month, and then west to the Sierra Madre, where the Grand Encampment *Herald* reported that the nearby Dillon *Doublejack* noted that he photographed the famous Ferris Haggerty Copper Mine in late September. The first week of October found him in Casper, and a month later he was finally home in Cheyenne.[15]

Stimson made his trip to Cody and Yellowstone during his initial six-week foray around the state. He had arranged with the local booster organization, the Cody Commercial Club, for a guide, Fred Chase, and a conveyance—a buggy pulled by two white horses. Chase is listed in the 1900 census as a taxidermist in the nearby community of Ishawooa, on the South Fork of the Shoshone River. Of the forty-five images taken during this outing, Stimson

included Chase and the conveyance in twelve of them, with Chase appearing fishing alone in two others. There are also two images of Stimson, one alongside his tent and another of him fishing in the Shoshone. A careful examination of newspaper accounts against a period calendar shows that the two men left Cody on Wednesday July 22 and returned to the small community of Irma, at the junction of the North and South Forks of the Shoshone, on Sunday the 26th. According to the papers, the two men found each others' company very agreeable. They spent four nights camping along the road, where they found "great quantities of wild fruit" and streams "alive with the finest of fish." Stimson added that he was "especially enthusiastic over the beauty of the Cody route" and pronounced it "by far the greatest scenic road to the Wonderland." After Stimson and Chase returned to Irma, H. W. Darrah, a Cody lumberman, met Stimson and escorted the photographer to his sawmill, nearby ranches, and then southeast to Meeteetsee.[16]

Stimson worked for eight months on his portfolio of Wyoming views for the St. Louis Fair and included all of the photographs taken on the Cody Road in his catalog of 500-plus images. At St. Louis, his specially selected 182 hand-colored images—12 from each county plus another dozen from Yellowstone—were displayed in two buildings, the Palace of Mines and the Palace of Agriculture. Some of the views were grouped together as an individual exhibit, while others simply illustrated Wyoming's economy. All of them were used to promote the new state. Expo judges awarded Stimson a silver medal for his photographs of mines and machinery, and two other exhibits containing his images also received silver medals. The following year the Wyoming exhibits were displayed at the Lewis and Clark Exposition in Portland, Oregon. There, Stimson won two bronze medals for his photos of Wyoming scenery and for images of mines and machinery. Stimson biographer Mark Junge suggests that his work from these two fairs gained the artist "national and international recognition" and placed him at the peak of his career.[17]

Stimson continued to photograph the Union Pacific Railroad until World War I and the state of Wyoming throughout the rest of his life. He made images for the Wyoming Department of Immigration, sold scenic photographs and postcards from his downtown Cheyenne studio, returned to portrait work, and did occasional commissions for a Cheyenne business or a nearby ranch. In 1929 his old friend Elwood Mead, now commissioner of the Bureau of Reclamation, hired the fifty-nine-year-old photographer to document bureau dams and irrigation projects throughout the West. He photographed Civilian Conservation Corps

camps in the 1930s and in 1948 was hired by the Wyoming Department of Commerce and Industry to photograph the Grand Tetons and Yellowstone. He was seventy-eight at the time. Stimson became a widower in 1938 and died of a heart attack in 1952 at age eighty-two. The state of Wyoming purchased his collection of more than 7,500 negatives for $2,000 in 1953, and it remains at the Wyoming State Archives, Museum, and Historical Department in Cheyenne.[18]

Stimson's images can be described as the work of a skilled photographic craftsman. As his biographer Junge notes, Stimson "avoided abstractions or photojournalistic statements . . . and understood how to form light and shadow into patterns." His compositions were strong, often with clear vanishing points that gave his images perspective and interest. Although many of his images were made in the "golden hours" of early-morning and late-afternoon light, his travel requirements, clients' needs, and the sensitivity of his glass plates meant that he worked throughout the day. He often used above-the-eye vantage points from rooftops, water towers, and high rocks and made panoramic views that included multiple plates. He understood exposure and edge-to-edge focusing. In addition, he often enlarged his 8×10-inch negatives into much larger prints and hand-colored many of them to better represent nature.[19]

Stimson's work can be analyzed as industrial portraiture. Trained to present people in their best light, Stimson took the skills of the portrait photographer to the outdoors to record for his employers the progress and development the Union Pacific Railroad and the state of Wyoming wanted to show. In that sense, his images of Wyoming ranches, farms, mines, roads, railroads, and communities are products of a concerted effort to always present the best Wyoming had to offer.[20]

But things are not always what they are presented to be. In a fascinating study of Buffalo Bill and his Wild West Show's European tours, historians Robert W. Rydell and Rob Kroes explain the difference between cultural production and consumption. In their example, Buffalo Bill Cody formed his famous Wild West Show by collecting icons of the American frontier such as cowboys, Native Americans, and trick shooters into a circus and exhibiting them across the Atlantic to show Europeans what the American West was like. But when the show came to Prussia, army officers took note not of the frontier icons but instead of the organization and efficiency with which Cody fed, housed, and transported his cast. Simply put, while Buffalo Bill was *producing* images of the frontier West, the Prussian army was *consuming* an image of Chicago and the industrial East.[21]

For Stimson, this analogy means that although his images were *produced* to represent progress and development, they can also be *consumed* as documentary photographs representing a slice of Wyoming life. Ultra-sharp images on 8×10-inch glass negatives contain huge amounts of visual data. When scanned and viewed on a computer monitor, the photographs can be enlarged again and again without losing resolution and thus reveal minute details not noticed at first glance. For example, it was only through this process of digitization that I noticed that, in Stimson's image of the Irma Post Office, one can clearly see his horseless buggy at the back left of the image and what is probably Fred Chase leading the two white horses on the right. Further details can reveal signs, people, plants, and other minutiae brought to the light of day. For this reason, Stimson's images must be reconsidered not only as promotional images but as documentary photographs as well.

As such, Stimson's work fits into the broader spectrum of western photographers who followed a few decades after the exploration surveys of William Henry Jackson and Timothy O'Sullivan. For this "second generation," photographers such as Stimson and Denver's Louis C. McClure shifted their focus from images of discovered canyons, mountains, and ruins to pictures that promoted the region's railroads, mines, ranches, farms, and burgeoning tourist industry.[22]

One of the best ways to get to know Stimson's images is to rephotograph them. Rephotography—also known as repeat photography or before-and-after photography—is the process of finding and duplicating photographs from the same vantage points used by earlier photographers, and it has been popular for more than a hundred years.[23] My first exposure to the process in Wyoming was the small book *Rediscovering the Big Horns*, a Bicentennial Project of the Wyoming State Historical Society that retraced the images made by an eastern scientist through turn-of-the-century northern Wyoming. The best-known effort, and the one that became the standard, was photographer Mark Klett's *Second View: The Rephotographic Survey Project* (RSP), which used precise arithmetic formulas, large-format cameras, and instant Polaroid film to make subtle camera shifts that expertly zeroed in on the classic photographs made by nineteenth-century exploration photographers all around the West, including O'Sullivan and Jackson. As part of this project, Klett rephotographed several sites around Wyoming, including Yellowstone Park and the Green River area.[24]

My discovery of Klett's work and Junge's biography of Stimson led me to undertake my rephotographic project on Stimson in 1987 and 1988. Over those two years I used a

large-format 4×5 camera and sheet film, and I developed and printed all of the images while a student at the University of Wyoming in Laramie. The first year focused on Stimson's work for the Union Pacific, capturing images in Cheyenne, Laramie, Rawlins, Rock Springs, Green River, and Evanston as well as Kemmerer, Diamondville, Cokeville, Hartville, Sunrise, and Ft. Laramie. The following year I concentrated on the northern half of the state, rephotographing Douglas, Newcastle, Sundance, Sheridan, Buffalo, Worland, Thermopolis, Cody, Yellowstone, and Grand Teton National Park.

The project was amazing for a twenty-two-year-old, as I not only found a good number of vantage points but also because the entire process served as a sort of photographic apprenticeship. I traveled throughout the state, planned my own fieldwork, made pictures in far-off places, and then developed and printed final images. As the project was concluding, I joined the Wyoming Humanities Council's Speaker's Bureau and was able to present my work to audiences across the state. In 1991 I published a coffee table–style book, *Wyoming Time and Again: Rephotographing the Scenes of J. E. Stimson,* that featured 100 black-and-white pairs of images grouped into chapters on scenic landscapes, the built environment, and ghost towns. The book was well received, and its 3,000-issue printing run sold out within a few years.[25]

Following the rephotographic project on Stimson, my focus turned to completing my master's degree in American studies in Laramie, earning a doctorate in history of the American West at the University of Nebraska–Lincoln, and then working as a history professor at Idaho State University, Mesa State College, and Northern Arizona University (NAU). Throughout these years I continued to be interested in Wyoming, organizing a catalog raisonné of an artist who was Stimson's contemporary, writing an MA thesis on the polo-playing town of Big Horn, Wyoming, and finally writing a dissertation and a book on uranium mining communities in the American West—including Jeffrey City, Wyoming.[26]

But I also remained interested in photography and rephotography. I continued to play with the 4×5 camera, learned to shoot with a 1950s stereo camera, and then, around 1998, I discovered a Sony Mavica digital camera owned by NAU that employed a fixed lens, shot one-third megapixels, and stored its images on an internal 3.5-inch floppy disc. I soon purchased my own digital cameras, first a 3-megapixel Kodak point and shoot and then a 6-megapixel Canon digital SLR. I also followed the rephotography projects of other photographers, including ones on the Colorado River, the Grand Canyon, Arizona, the Sonoran Desert, Route 66, Colorado, the Dust Bowl, Lake Tahoe, Estes Park, and Yellowstone.[27] Although

most of these projects were focused on the broader idea of landscape photography, others followed people over time or changes in grasslands. These books rekindled my interest in rephotography, and I tried at first stereo rephotography and eventually digital rephotographs of northern Arizona. But I kept thinking about Wyoming and J. E. Stimson.

Some suggest that a good way to think about a photograph is as a contract among what's in front of the camera, the technology of the camera, and what's behind the camera.[28] If this is true, then wouldn't everything about my Wyoming rephotographic project have changed? After all, Wyoming had to be somewhat different in the early twenty-first century than it was in the late 1980s. I knew as well that digital had completely revolutionized photography.[29] Finally, I knew that as a tenured professor of history, I was now much better prepared to think about what I was seeing than I had been as a undergraduate history-journalism major.

As I contemplated another rephotography project on Wyoming, the first place I turned to was the continuing rephotographic work of Mark Klett. After completing the RSP, Klett had published several more works that not only included stunning photography but also asked poignant questions about time, photography, and rephotography. His published work included an amazing set of panoramas of San Francisco; a follow-up to the RSP called *Third Views, Second Sites* in which he traveled back to many of the original RSP sites to rephotograph them more than twenty years later, as well as new sites added along the way; another on the 1906 San Francisco earthquake and fire that included color photos and foldout before-and-after panoramas; and yet another that focused on Yosemite. All of Klett's work glowed with the precision of a master craftsman who still used Polaroid sheets in his 4×5 camera to zero in on his vantage point. His books used multiple original photographers and often employed essays by western writers and historians to help provide cultural context. Added to this mix was the book *View Finder: Mark Klett, Photography, and the Reinvention of Landscape* by William L. Fox, which provided background biographical information about Klett and then followed him and his team as they prepared images for the *Third Views* book. Examining these works fueled my fire to return to Wyoming and J. E. Stimson.[30]

The Wyoming Time and Again Revisited Project began in the summer of 2007 when I secured a research grant from the Buffalo Bill Historical Center in Cody. A major aspect of the work was to explore what was in front of the camera by examining Wyoming twenty years after I had first rephotographed it to see how the intervening two decades had affected the state. One clear focus was Yellowstone, which I had first rephotographed during the early

summer of 1988, the year of the Yellowstone fires. In fact, three of the fires had started the week I was in the park that year. Another interest was to see how the developing energy resource industry had affected the state.

The technology I employed to capture the changing state was also different. Rather than use a large-format view camera and cut sheet film, this time I employed a 35-mm digital SLR camera. Although one would think digital technology would make photography much faster and easier, the reality was more complicated. Obvious benefits included not having to carry film, needing to load and unload it in total darkness, or having to develop it later. Lining up new shots was also easier because I had the ability to instantly examine the image on the camera's view screen or upload it to a laptop while in the field. I could then open the images in Photoshop at night and develop them further if need be while still in the vicinity of the original. Finally, the ability to print these images on my own printer removed the hundreds of hours of darkroom work required for the first project. The digital darkroom could thus be far handier and save time.

On the other hand, a digital SLR camera did not have similar optics or the swing and shift movements of either my 4×5 or Stimson's 8×10 view camera, so some image compromise was inevitable. My Canon Digital Rebel Xsi was 12.2 megapixels, and nearly all shots were made with a tripod. For lenses, I decided to use a professional 24–105-mm zoom lens. When used with my camera's APS-C sensor, the lens' focal length was multiplied by a factor of 1.6. This combination allowed some flexibility in the field and meant I would not have to place boxes or frames over my images to mark Stimson's original frames. Although there was no film, I did have to carry and maintain adequate space on several memory cards, which meant also carrying a portable hard drive—in this case an Epson P-2000 that combined a rechargeable battery-operated hard drive, disc reader, and viewing screen. It also meant that I needed to take along a laptop computer and a special tent-like protector for viewing the screen in the bright Wyoming sun. All of these electronics had to be protected from the constant Wyoming wind and dust, so each came in its own bag. Finally, the camera, portable hard drive, and laptop had rechargeable batteries that had to be removed and recharged every day. In the end, although digital was advantageous, it was less clear-cut a win than one might expect.

My growth as a historian meant that I would have new things to say about this process. With almost two decades of postgraduate education as a student and professor, I was

clearly better prepared for this rephotography project than I had been as an undergraduate. With several books and a number of scholarly articles to my name, I had studied, researched, pondered, taught, and written about the West for two decades. My resources were better, too. Since the digital revolution, I not only had a digital camera, but I also had e-mail, the Internet, cell phones, topographical maps on CD, Global Positioning Systems (GPS), and Google Earth to enhance my communications, research, and locating abilities. Further, the Wyoming Newspaper Project, a massive effort headed by the Wyoming state librarian, is in the process of digitizing all Wyoming newspapers since territorial days.[31] This meant that I could do systematic indexed searching from my home in Arizona. Last but not least, my fiancée, Lauren—a skilled archivist—accompanied me to nearly every site, listened to my ideas, gave suggestions, recorded GPS readings, and generally worked as my rephotography assistant.

In the summer of 2007, Lauren and I traveled throughout Wyoming, rephotographing many of the sites I had first visited twenty years earlier. We also planned to rephotograph new locales, especially the handful of panoramas Stimson had made. We started with a trip to the Wyoming State Archives in Cheyenne, where we spent several days going through the entire 7,500-item Stimson collection, culling potential sites to revisit. During this research I first realized that Stimson had shot 45 images on the Cody Road the first month it opened. I had photocopies made of each of these images and tucked them away for later, when we would be in Cody. That summer I rephotographed most of Wyoming, including Cody, Thermopolis, Worland, Sheridan, Buffalo, Yellowstone, Kemmerer, Diamondville, Saratoga, Encampment, Evanston, Green River, Rock Springs, Laramie, Rawlins, and Jackson Hole. At the end of that first summer, Lauren and I felt a bit like Stimson must have felt at the end of 1903 when he spent six intense weeks making images for the St. Louis Exposition. I concluded the first part of this project with a presentation at the Buffalo Bill Historical Center and pocketed my plans for the Cody Road.

The following summer I secured a small research grant from NAU to go back to Wyoming and finish rephotographing the parts of the state I had missed, including most of the eastern part—especially Newcastle, Sundance, and the Black Hills. I also filled in a few other spots, including Ft. Laramie, Douglas, the South Pass area, Lander, and Wheatland. In addition, I planned to spend a few more days in Cheyenne revisiting the Stimson collection, talking with the archivists there, and rephotographing a few more sites in and around Wyoming's capital city.

I also concentrated on the Cody Road. To better prepare for this unique part of the project, I examined two rephotography books that focused specifically on roads and roadside culture: Russell A. Olsen's *Route 66 Lost and Found* and William Wyckoff's *On the Road Again: Montana's Changing Landscape*. Route 66 ran through my home in Flagstaff, so I was more familiar with the scenes in Olsen's work. Wyckoff's book took a more scholarly approach and had much more to say about the effects of the passage of time on the landscape. A cultural geographer at Montana State University in Bozeman, Wyckoff is a scholar of the American West who has also written a fascinating book on the cultural landscape of my home state of Colorado. *On the Road Again* proved an ideal model for how I wanted to proceed.[32]

Lauren and I left for Cody on Independence Day 2008. We had the good fortune to have relatives, my Aunt Rozanne and Uncle Doug Reachard, who live above Buffalo Bill Reservoir and allowed us to bunk with them and helped us find Stimson's original vantage points. This offer proved extraordinarily valuable, as Uncle Doug had been hiking and hunting along the North Fork of the Shoshone for more than thirty years and instantly knew where to start looking for Stimson's original vantage points. He was an intrepid guide. We would give him a Stimson photo, and he would look at the surrounding mountains or the size of the river or the trees and suggest a location that inevitably proved to be very close to Stimson's original vantage point.

In the end, we spent about ten days on the Cody Road, returning to my relatives' home every night after having spent the day photographing four or five original sites. Lauren and I laughed about having lunch at Pahaska Tepee every other day for a week. At each site I brought a photocopy of the Stimson print and examined it against the landscape in front of me. I then set up my tripod, attached the camera, and set it to "live view," which allowed me to see through the lens on the large screen on the back of the camera. Once the possible position was determined, I adjusted my camera and snapped a picture. The image was then brought up on the screen and compared with the Stimson photocopy. Additional adjustments were made until the desired effect was reached. I then made multiple exposures to bracket my shot, uploaded the images to backup memory cards, and went on to the next scene. At night, I lightly processed the best images in Photoshop and backed them up onto a portable hard drive.

The results were stunning. With my uncle's assistance or simply by driving back and forth along the road, scanning the landscape, and then getting out and scouting potential

views, we located and rephotographed thirty-nine of Stimson's original vantage points from his 1903 excursion. In addition, we added four images he took in 1910 when he came back to Cody to travel the route on the new road through Shoshone Canyon and around the reservoir. Some spots, such as Sylvan Lake and Index Mountain, could be viewed from exactly the same location, making the modern views very close to the originals. In other places, tree growth meant that I had to move back or to one side to show that the site was indeed the same one. In these instances, I always noted the change in location and felt that the result justified the move. Of course, the vantage points for the two photographs of Cedar Mountain and the Irma Post Office are now far below the water level of Buffalo Bill Reservoir. In these cases we walked along a causeway in the lake and made as close a view as possible, highlighting the background hills as clues to the exact location.

We also had a great deal of fun. The area between Cody and Yellowstone National Park is prime grizzly bear country, and my relatives had a grand time telling us about the time they had seen a big bear exactly on the spot we were seeking. Every time I had to push through brush, I did so with trepidation. At Sylvan Pass we faced the potential of unexploded howitzer shells among the rocks where I was standing, remnants of the spring snow removal program. After plotting several GPS points on Google Earth, we learned that a few of our vantage points coincided with known Bigfoot sightings. In the end, the best Wyoming wildlife we encountered were three very playful river otters splashing and swimming like porpoises as they made their way up a side canal near Signal Mountain.

Capturing the rephotographs was just the first part of the project. As we left Cody for the last time, we reviewed our images, placing Stimson's images in an order based on what one would experience traveling the road to the park in one direction rather than replicating his original photographic order, which included shots made both going to and returning from Yellowstone. When we returned to Arizona, I downloaded all of the images to my computer, burned backup DVDs, and made minimal adjustments to each image using Adobe Photoshop CS3. I then compared my view to a scanned image of Stimson's original.

I next turned to researching this book, using the online Wyoming Digital Newspaper Project. I sought out every book on the Cody route that I could find and every guidebook to Yellowstone that I could obtain, and I had the University of Wyoming Library copy and send me its entire collection of brochures on the Cody Road. I downloaded every GPS point and

entered it into Google Earth to check to be sure it was accurate. I read books on the history of tourism, Yellowstone, Cody, Buffalo Bill, and an assortment of other related topics.

At the time of this writing (July 2011), Google Earth provided an application called "Street View," with a small person-shaped icon called "Pegman." When Pegman is dragged to a road that has been photographed by Google Earth, one can see not only the topography from that vantage point but actual 360-degree panoramic photographs that can be moved until the correct direction is achieved. Upon exiting Street View, the viewer is returned to a satellite image.[33]

For rephotography, this application is simply amazing. As I was writing this book, I could enter GPS coordinates into Google Earth, double-check their accuracy against the topography, and then drag the Street View icon to that location and see actual photographic images of spots very close to where both J. E. Stimson and I had stood. For many images taken off the main road, this service will be limited. But for such well-traveled routes as the Cody Road to Yellowstone, Street View provides constantly accessible, constantly changing windows into our landscapes. It also suggests that, for the rephotographer, the GPS locations found are just as important, if not more so, as the actual photographs. One has to wonder if future rephotographers will be able to simply sit at home at their computers and make images based on Google Earth.[34]

Until that day, what you see before you is the culmination of my vision of rephotographing J. E. Stimson's trek up the Cody Road in 1903. Each set of photographs contains Stimson's original black-and-white image followed by my digital color rephotograph. Every pair also includes Stimson's original archive number, which is its finding call number at the Wyoming State Archives. I have also included a caption based on Stimson's original photograph title. Finally, each image contains the GPS reading made for each site and a caption explaining any history or other interesting facts about the site or the rephotographic process.

I invite you to sit back and enjoy comparing and contrasting the two images as an armchair tourist. Better yet, take the book to your computer, enter the GPS locations, and access Pegman to take a virtual trip down the Cody Road on Google Earth. Or still better, pack the car, head for Cody, and follow Lauren and me as we traced J. E. Stimson's route up the Cody Road to Yellowstone Park in July 1903. I'm sure that you will also have a royal time as you travel "the greatest scenic road to the Wonderland."

Notes

1. Mark Junge, *J.E. Stimson: Photographer of the West* (Lincoln: University of Nebraska Press, 1985); Cheyenne *Daily Leader*, October 5 and 21, 1890.

2. Junge, *Stimson*.

3. Ansel Adams, *The Camera* (Boston: Little, Brown, 1980).

4. T. A. Larson, *History of Wyoming* (Lincoln: University of Nebraska Press, 1978), remains the cornerstone of Wyoming history.

5. Ibid. See also Larson's introduction to Stimson in Junge, *Stimson*.

6. Junge, *Stimson*; Sheridan *Post*, October 27, 1898; Wheatland *World*, January 14 and 21, 1898; Cheyenne *Wyoming Tribune*, December 12, 1900; Cheyenne *Daily Leader,* December 17, 21, and 25, 1900.

7. Maury Klein, *Union Pacific*, vol. 2: *1894–1969* (Minneapolis: University of Minnesota Press, 2006).

8. Junge, *Stimson*.

9. I recently purchased a rare album of Stimson Yellowstone photos from a bookstore in Germany. The album contains twenty-five black-and-white scenes and was published by Stimson with the Albertype Company of Brooklyn, New York. The Cheyenne *Daily Leader* ran a small ad for this album on August 21, 1903, which described it as a "beautiful collection of views of the most striking features of the National Park in Wyoming" and listed the price as $1.50. The images were made using a new photomechanical process that allowed inexpensive photographic reproductions as postcards and portfolios. See J. E. Stimson, *Yellowstone Park* (Brooklyn, NY: Albertype, 1903). For information on the Albertype Company, see the Historical Society of Pennsylvania's website: http://www.hsp.org/sites/default/files/migrated/findingaidv18albertype.pdf [accessed July 19, 2011].

10. Junge, *Stimson*. The March 12, 1901, issue of the Laramie *Daily Boomerang* is one of the first accounts identifying Stimson as "the Union Pacific photographer," although it incorrectly names him as "W. E." rather than "J. E." See also "Curious Bits of Western Scenery," *Leslie's Weekly* XCVL, no. 2493 (June 18, 1903): 611, 623.

11. Junge, *Stimson*; "For the St. Louis Fair," Cheyenne *Wyoming Tribune*, June 3, 1903.

12. *Official Guide to the Louisiana Purchase Exposition* (St. Louis: Louisiana Purchase Exposition Company, 1904), 7. This and other documents about the exposition can be found at the website hosted by the 1904 World's Fair Society Home Page at http://www.1904worldsfairsociety.org/index.htm [accessed July 20, 2011].

13. *Official Guide to the Louisiana Purchase Exposition*, 115.

14. "For the St. Louis Fair"; "Magnificent Collection," Cheyenne *Wyoming Tribune*, February 17, 1904.

15. Thanks to the ongoing Wyoming Newspaper Project, which is in the process of digitizing all of the state's papers, it is much easier to follow Stimson's travels around the state in 1903. See http://www.wyonewspapers.org/ [accessed July 20, 2011]. By doing a search for Stimson or in some cases "Stimpson," one can follow his photographic exploits week by week all over the state. This brief overview is culled from these newspapers: Wheatland *World*, June 26, 1903; "A Busy Day for Mr. Stimson," Buffalo *Voice*, July 18, 1903; "Making Fine Views," Cheyenne *Wyoming Tribune*, July 19, 1903; Sheridan *Post*, July 23, 1903; "Mr. Chase Home Again," Cody *Wyoming Stockgrower and Farmer*, July 28, 1903; "For the St. Louis Fair"; "Stimson at Lander," Cheyenne *Wyoming Tribune*, August 10, 1903; "Some Fine Views," Cheyenne *Wyoming Tribune*, August 18, 1903; Cheyenne *Wyoming Tribune*, September 8 and 18,1903; Grand Encampment *Herald*, September 28, 1903; Douglas *Bill Barlow's Budget,* September 30, 1903; Cheyenne *Wyoming Tribune*, October 8, 1903; Laramie *Boomerang,* October 10, 1903; "Photographer Stimson's Work," Cheyenne *Wyoming Tribune,* November 6, 1903; "Wyoming Will Make Hit," Cheyenne *Wyoming Tribune,* December 18, 1903.

16. Accounts of the trip are derived from five newspaper articles from the Cody *Wyoming Stockgrower and Farmer*: "Fred Chase Started Wednesday," July 28, 1903; "Mr. Chase Home Again," July 28, 1903; "Mr. Darrah's Trip," August 4, 1903; "The Finest Route," August 11, 1903; and "Beautiful Views," August 25, 1903. Biographical information on Darrah and Chase can be found in US Census Bureau, "1900 Federal Population Census," www.archives.gov/publications/microfilm-catalogs/census/1900/ [accessed August 24, 2010].

17. Junge, *Stimson.*

18. Ibid.

19. Ibid. An understanding of the time of day and the vantage point from which Stimson shot his photographs can be best ascertained through a rephotography project such as this one.

20. Mark Junge, telephone interview with author, August 24, 2010.

21. Robert W. Rydell and Rob Kroes, *Buffalo Bill in Bologna: The Americanization of the World* (Chicago: University of Chicago Press, 2005), 114–115.

22. Louis C. McClure is probably the best comparison to Stimson because he worked for railroads and photographed similar subjects between 1890 and 1935 in neighboring Colorado. His collection is located at the Denver Public Library and is highlighted in William C. Jones, Elizabeth B. Jones, and Louis C. McClure, *Photo by McClure: The Railroad, Cityscape, and Landscape Photographs of L. C. McClure* (Boulder: Pruett, 1991). William Henry Jackson's work during the early twentieth century for the Detroit Publishing Company compares as well. See Peter B. Hales, *William Henry Jackson and the Transformation of the American Landscape* (Philadelphia: Temple University Press, 1988).

23. Robert H. Webb, Diane E. Boyer, and Raymond M. Turner, eds., *Repeat Photography: Methods and Applications in the Natural Sciences* (Washington, DC: Island, 2010); Garry F. Rogers,

Harold E. Malde, and Raymond M. Turner, *Bibliography of Repeat Photography for Evaluating Landscape Change* (Salt Lake City: University of Utah Press, 1984), xii.

24. Wyoming State Historical Society, *Rediscovering the Big Horns* (Cheyenne: Bighorn National Forest Volunteer Committee, 1976); Mark Klett et al., *Second View: The Rephotographic Survey Project* (Albuquerque: University of New Mexico Press, 1984).

25. Michael A. Amundson, *Wyoming Time and Again: Rephotographing the Scenes of J. E. Stimson* (Boulder: Pruett, 1991).

26. My published work on Wyoming history includes "Through the Lens of Stimson: Past and Present," *Annals of Wyoming* (Spring 1988): 32–45; "The Rise and Fall of Big Horn City, Wyoming," *Wyoming Annals* (Spring-Summer 1994): 10–25; "No Longer a Home on the Range: The Booms and Busts of a Wyoming Uranium Mining Town, 1958–1985," *Western Historical Quarterly* 26 (Winter 1995): 483–505; "Pen Sketches of Promise: The Western Drawings of Merritt Dana Houghton," *Montana: The Magazine of Western History* (Fall 1994): 54–65; *Yellowcake Towns: Uranium Mining Communities in the American West* (Boulder: University Press of Colorado, 2002); "The British at Big Horn: The Founding of an Elite Wyoming Community," *Journal of the West* 40, no. 1 (Winter 2001): 49–55; and "These Men Play Real Polo: The History of an Elite Sport in the 'Cowboy' State, 1890-1930," *Montana: The Magazine of Western History* (Spring 2009): 3–22.

27. Hal G. Stephens, Eugene M. Shoemaker, and John Wesley Powell, *In the Footsteps of John Wesley Powell: An Album of Comparative Photographs of the Green and Colorado Rivers, 1871–72 and 1968* (Boulder: Johnson Books and the Powell Society, 1987); Robert H. Webb, *Grand Canyon, a Century of Change: Rephotography of the 1889–1890 Stanton Expedition* (Tucson: University of Arizona Press, 1996); Allen A. Dutton, *Arizona: Then and Now* (Englewood, CO: Westcliffe, 2002); Raymond M. Turner et al., *The Changing Mile Revisited: An Ecological Study of Vegetation Change with Time in the Lower Mile of an Arid and Semiarid Region* (Tucson: University of Arizona Press, 2003); Russell A. Olsen, *Route 66 Lost and Found: Ruins and Relics Revisited* (St. Paul, MN: MBI, 2004); John Fielder: *Colorado 1870–2000* (Englewood, CO: Westcliffe, 1999); John Fielder: *Colorado 1870–2000 II* (Englewood, CO: Westcliffe, 2005); Bill Ganzel, *Dust Bowl Descent* (Lincoln: University of Nebraska Press, 1984); Peter Goin, C. Elizabeth Raymond, and Robert E. Blesse, *Stopping Time: A Rephotographic Survey of Lake Tahoe* (Albuquerque: University of New Mexico Press, 1992); James H. Pickering, Carey Stevanus, and Mic Clinger, *Estes Park and Rocky Mountain National Park: Then and Now* (Englewood, CO: Westcliffe, 2006); Mary Meagher and Douglas B. Houston, *Yellowstone and the Biology of Time: Photographs across a Century* (Norman: University of Oklahoma Press, 1999).

28. John E. Carter, "Architecture, Photography, and a Quest for Meaning," *Exposure* (Fall 1987): 16.

29. Stephen Johnson, *On Digital Photography* (Sebastopol, CA: O'Reilly Media, 2006).

30. Mark Klett and Eadweard Muybridge, *One City/Two Visions: San Francisco Panoramas, 1878 and 1990* (San Francisco: Bedford Arts, 1990); Mark Klett et al., *Third View, Second Sights: A Rephotographic Survey of the American West* (Santa Fe, NM: Museum of New Mexico Press, 2004); Mark Klett, Rebecca Solnit, and Byron Wolfe, *Yosemite in Time: Ice Ages, Tree Clocks, Ghost Rivers* (San Antonio: Trinity University Press, 2008); Mark Klett et al., *After the Ruins, 1906 and 2006: Rephotographing the San Francisco Earthquake and Fire* (Berkeley: University of California Press, 2006); William L. Fox, *View Finder: Mark Klett, Photography, and the Reinvention of Landscape* (Albuquerque: University of New Mexico Press, 2001).

31. See http://www.wyonewspapers.org/ [accessed July 20, 2011].

32. Olsen, *Route 66*; William Wyckoff, *On the Road Again: Montana's Changing Landscape* (Seattle: University of Washington Press, 2006).

33. The starting point for learning about Street View is http://maps.google.com/help/maps/streetview/learn/using-street-view.html [accessed July 26, 2011].

34. For information on how images are constructed on Street View, see http://maps.google.com/help/maps/streetview/technology/photos-into-street-view.html [accessed July 26, 2011].

History of the Cody Road to Yellowstone

When J. E. Stimson traveled the Cody Road in July 1903, he was probably one of the first fifty people to take the new route to Yellowstone's East Entrance. His images record a brand-new highway cut through the wilderness. Except for his conveyance, a survey of his photographs shows no other tourist or wagon. Indeed, a close look reveals only a few wagon tracks embedded in the soft dirt. When I followed in his footsteps more than a century later, hundreds of cars whizzed by every time I set up the camera. But as I looked through the viewfinder, I found that most of the scenes Stimson had captured remained. Comparing his images with my own, I began to think about what it must have been like to be one of the first travelers on this new road. As I heard those cars and trucks rushing by, I thought about what had happened over the last century and why this route had become so popular. At the same time, I questioned how a place seemingly so different remained so much the same through my viewfinder. An overview of the history of the Cody Road, with special emphasis on what it was like in July 1903 and then in July 2008, is a good place to begin.

Since Yellowstone National Park's creation in 1872, railroads have been key figures in developing its resources for tourism. The Utah and Northern, a subsidiary of the Union

Pacific, first brought tourists toward the park's West Entrance in 1881 when it built its line to Monida, Idaho. From there, travelers had to endure a long stagecoach ride of more than sixty miles to reach the park. Two years later the Northern Pacific built its first line toward the North Entrance, depositing tourists in Cinnabar, Montana—still outside the park but only three miles from the entrance. That year the Army Corps of Engineers sent an officer to take charge of road building within the park, and soon the familiar Grand Loop, or "Belt Line" as it was called at the time, was organized. This route entailed a great circle through the park, connecting the five main attractions: Mammoth Geyser Basin, Norris Geyser Basin, Firehole Basin, Yellowstone Lake, and the Grand Canyon of the Yellowstone. In addition, a crossroad from Norris to the Grand Canyon cut the circle in half. Along the route, the railroads built hotels and lunch stations at spots both conveniently located and interesting to see.[1]

At the time, no one discussed an eastern connection to the loop. Possible routes had been explored by Captain William A. Jones in 1873, who described the fantastic scenery along the Shoshone River—then called the Stinking Water River—from Wyoming's Big Horn Basin through the Absaroka Range to the park. Eight years later Yellowstone superintendent Philetus Norris escorted a group, including Wyoming territorial governor John Hoyt, along the Stinking Water and into the park. But such a path would be difficult to justify. The adjacent Wyoming population was very small, and no railroads connected to larger cities further east. In addition, a road to the park would have to bisect the Yellowstone Forest Reserve—established in 1891 just to the east of the park—and then cross the Absarokas at either Jones Pass, elevation 9,500 feet, or Sylvan Pass, 1,000 feet lower. This combination of distance, population, lack of railroads, and terrain deterred the construction of an eastern road throughout the nineteenth century.[2]

The first governmental mention of a change in attitude about an eastern entrance to Yellowstone appeared in the 1899 annual report of Chief Engineer Hiram Martin Chittenden. Chittenden had come to Yellowstone in 1891 to serve as an assistant to William Jones. Although he stayed in the park for only two years, Chittenden remained interested, authoring the first book-length history, *The Yellowstone National Park*, in 1895. He then served in the Spanish-American War before returning to Yellowstone in 1899 as chief engineer. That year Chittenden recorded in his annual report that while there might eventually be the need for an eastern approach, there were still too few Wyoming tourists to warrant it. He wrote:

It is probable that before many years it may be necessary to make an approach from [the] Big Horn Basin via Jones's Pass to the outlet of the Yellowstone Lake. The necessity for such a road, however, will be contingent upon the advent of a railroad in the Basin, and it is, therefore, not included in the present estimate.[3]

Within two years, the necessity for an eastern route had come to pass. The reasons were simple: Buffalo Bill Cody and the Burlington Railroad.

William F. Cody was present everywhere in the area's early history. After seeing the Big Horn Basin for the first time in 1894, the next year Cody explored the North Fork of the Shoshone to Yellowstone and began advocating for an access road to the park.[4] That same year he became a partner in the Shoshone Land and Irrigation Company, which dug the Cody Canal to bring water from the South Fork to the bench lands to the east. In 1896, partner George T. Beck laid out the town and named it Cody to capitalize on the famous showman's name. Buffalo Bill soon founded the town's newspaper, the *Cody Enterprise*. Within five years the town had incorporated, and Buffalo Bill convinced the president of the Burlington Railroad to construct a line into Cody. Until his death in 1917, Cody invested a great deal of money in "his" town, including the canal and the famous Irma Hotel on the main street.[5]

At about the same time Cody became interested in the region, the Army Corps of Engineers surveyed a road linking the new railroad to the park. In June 1900 and again the following March, the US Congress appropriated $90,000 for the park, including $20,000 earmarked for the construction of a road connecting Cody and the Grand Loop at Yellowstone Lake.[6] In his 1901 annual report, Chief Engineer Chittenden noted that the two possible routes into the park from the east—Jones Pass and Sylvan Pass—were both considered "excessively difficult" because of their steep grades and "immense obstacles."[7] After careful consideration, Chittenden chose the Sylvan Pass route because it was 1,000 feet lower and "its scenic attractions [were] unsurpassed in any part of the mountains."[8] Near the summit the route would pass Sylvan Lake, a "small but exceedingly beautiful sheet of water," and then cut through the loose rock that made Sylvan Pass "unique among mountain passes." Heading east, the new road would descend sharply to the Middle Fork of the Shoshone River, then follow its North Fork just beyond the park's eastern boundary. From there, the route would follow the North Fork through the adjacent Yellowstone Forest Reserve, then continue along almost to its confluence with the South Fork. At that point, the road would avoid the treacherous canyon west of Cody by skirting to the south of Cedar Mountain, following the Cody Canal

into town. According to Chittenden, the scenery along the river was "on the highest scale of grandeur and sublimity."[9]

Construction of the road to Cody took three summers. Work began in 1901 at Yellowstone Lake and moved eastward. Crews completed about twelve miles of roadway as well as six major bridges, including one over 300 feet long across the Yellowstone River (the future Fishing Bridge). The following summer the engineers completed another fifteen miles of road up to Sylvan Pass. At the same time, Wyoming's Big Horn County constructed a twenty-four-mile road from Cody to the eastern boundary of the forest reserve. Then, in February 1903, Wyoming state legislator Byron Sessions won a contract from Chittenden to construct a thirty-mile connecting road from the army's work on Sylvan Pass to the county's effort at the eastern edge of the forest reserve. Reports stated that Sessions would be paid "based on the amount of rock and dirt removed" but estimated that the amount would be about $40,000. Sessions boasted that his portion "will be the finest scenic roadway in the world and will enter the park by the most picturesque route."[10] Careful not to exclude the railroad, reports called the road "the continuation of the Burlington's branch line to Cody" before noting that more tourists would now enter the park through Wyoming than Montana.[11] Sessions soon completed his task, and the road opened to the public on July 10, 1903.[12]

At this same time, J. E. Stimson had begun his work for the Wyoming Commission of the Louisiana Purchase Exposition. After photographing Wheatland and Sunrise, he moved north to the Black Hills and shot Sundance and Devil's Tower. He then traveled to Buffalo and Sheridan before crossing over the Big Horns to photograph Cody. As instructed by the committee, Stimson made arrangements with the Cody Commercial Club to select the best sites with which to portray the community, including a guided, five-day trip up and back the newly opened road to Yellowstone.[13]

To understand what Stimson saw and experienced on the road takes some historical exploration. There were no hotels along the route, no established guide services, and no automobiles. Most travelers brought their own wagons and teams and camped along the way. Because Stimson was sort of a promotional VIP, the Cody Commercial Club provided him with a local guide—Fred Chase—a wagon, and two horses. But neither man left a journal or a diary of what he saw or experienced. Indeed, the only written record consists of five brief newspaper accounts. The visual record is more complete, with its forty-five images, but one must "read" the photographs to obtain their possible meaning. For this task, the rephotog-

raphy process provides insight because by researching and finding Stimson's vantage points, one gets a good idea of what he was observing and perhaps what he might have been thinking about or feeling. To supplement these records, we must piece together other firsthand accounts.

The newspaper reports of Stimson's trip were recorded in the *Wyoming Stockgrower and Farmer* and reflected the tone of most early accounts of the new road. In its July 28 edition, the editor wrote that a "Mr. Stimpson" had left for the park on Wednesday and noted that Fred Chase had served as guide, while the Cody Commercial Club furnished the pair of horses and buggy. The paper also reported that the two men had returned on Sunday after having had a "royal time." According to the editor, "Artist Stimpson" declared that the "scenery was grander by far over this road than in the park proper or along any other route" and that he had taken a large number of pictures. After he returned, Stimson was met at Irma and taken east to Meteetsee for more photographs.[14]

A month later, Cheyenne's *Wyoming Tribune* reported that Stimson had found Cody a "very lively little town with up to date stores and a fine hotel." The paper noted that the photographer had made the trip to the park over the new road, which is "now considered the best route to the Yellowstone" and has "fine camping places . . . great quantities of wild fruit abound along the road and the streams are alive with the finest of fish." It concluded that Stimson went to Yellowstone Lake and then returned, securing forty-five views of the new road.[15]

All of these images were included in Stimson's *Catalogue of Wyoming Views*, which listed the full set of photographs made for the World's Fair Commission as well as others made for the Union Pacific and Burlington Railroads. Organized into two sections labeled "St. Louis Fair Series" and "Yellowstone Park Series," the catalog included more than 500 images covering each Wyoming county and the national park. Under the banner of Big Horn County (Park County was not created until 1909), Stimson listed both "General Views" and "Views along Cody Gateway to National Park." He further noted that the standard-sized print that could be ordered was 8×10 inches, "tinted in natural colors and matted for framing." Larger, framed images, up to 30×40 inches, could be purchased as well.[16]

The *Wyoming Stockgrower and Farmer* article also mentioned the poor condition of the county road between Cody and the forest reserve, a theme echoed by many early travelers. According to the article, Fred Chase stated that it was "absolutely necessary that a lot of work

be done on [that portion] without delay or this route will receive a black eye that will be very disastrous to our town. There are many washouts and dangerous sideling places. The road certainly should receive attention promptly."[17]

In other published accounts from the *Wyoming Stockgrower and Farmer,* tourists traveling the new Cody Road also complained about the county's portion of the road. One warned that "if the people of Cody don't want this route condemned by the traveling public they will have to get a hustle on and fix that part which connects this town with the new government road. There's no use denying the fact that it's a hard proposition at this time." The following month a traveler noted wryly that the "county road between Cody and the [forest] reserve line *would be fine if the boulders were thrown out of the track*" (emphasis added). The September 1 edition stated simply that the "county road should be put in better repairs to make the first days' drive a pleasant one."[18]

By contrast, tourists returning to Cody that first summer commented on the magnificence of the government road through the forest reserve and the park. In an oft-quoted passage, Pastor J. D. Cain described the federal road as "par excellent to travel over." He went further, suggesting that "one feels like returning thanks to Uncle Sam, for building such a splendid highway."[19] In its 1905 promotional pamphlet "The Cody Road to Yellowstone Park," the Burlington Railroad also noted the difference between the two roads, describing the county's portion as "like a good country road" with "some sand in places" before turning "rough and rocky but quite safe." The federal road, on the other hand, was a "good trotting road" and "fine as a city boulevard."[20]

J. E. Stimson's images confirm these differences. Of the six images he made on the county road that first week, only one includes the actual road in the photograph. That view of the Irma Post Office, as discussed in the introduction, shows what amounts to wagon tracks crossing an open field to a bridge over the South Fork of the Shoshone River. All the other views were taken from the road, showing various mountains that could be seen along the route. By contrast, the very first view taken on Chittenden's road within the forest reserve shows the road with Stimson's conveyance headed to the park. The caption for that image, in fact, is the first to mention the road itself, describing the scene as "Dugway and North Fork of the Shoshone River" rather than the more generic "Cody Gateway" that appeared on the first half dozen images. Further, of the next twenty-nine photographs taken between the eastern edge of the forest reserve and the descent to Yellowstone Lake, twenty-one place the govern-

ment road in the scene. So for a photographer such as Stimson seeking to promote the state, it is telling that when the road was poor, he focused on the adjacent landscapes. But when the road was good, he included it in his scenes of progress.[21]

Beyond the road conditions, most travelers commented on the scenic grandeur of the new route to Yellowstone. Stimson remarked that the scenery on the Cody Road was better than that in the park itself.[22] His contemporaries agreed. The *Wyoming Stockgrower and Farmer* reported that the road passed through "some of the finest scenery to be found on the continent" and that the "Cody route to the park is by all odds the finest now open to the tourist." Reverend Cain added that while on this "beautiful scenic route," his party went up "Sylvan Pass crossing the divide where the snow capped peaks stand out so prominent, [where] we halted and cooled our heated blood by a few snow balls." Another party of tourists stated that they were "highly pleased with the wonders of the national play ground and the grand scenery of the Cody route," while yet another group was "greatly pleased with the scenic beauty of the Cody route."[23]

Perhaps the best early account of the route by an unbiased outsider was produced by Charles A. Heath in his privately published 1905 book *Trial of a Trail: From Cody to the Yellowstone*. Part travelogue and part guidebook, *Trial of a Trail* recounts the seventeen-day trip Heath and sixteen others made in July 1905 as part of that season's first wagon party and the largest such group to have gone over Sylvan Pass to that date. After leaving town on July 5, Heath spent four nights on the Cody Road, arriving at the Lake Hotel on July 9. After a nine-day counterclockwise tour of the park following the belt line, his party returned to Cody via Sylvan Pass. Although Heath traveled two years later than Stimson and in a much larger group, his published account still makes for a good comparison because he, too, used a local guide and traveled by wagon to the park and back, camping along the way. Further, the fact that he and his party "took more than 600 pictures" during their seventeen-day trip suggests that Heath might have had at least a similar interest in visually recording his trek.[24]

Trial of a Trail resonates with the accounts of other early travelers who praised the road. Although it did not mention the problems associated with the county road, it did note that after crossing the forest reserve boundary "we strike a fine road made by the government, and quite equal to a boulevard." As he climbed toward Sylvan Pass, Heath remarked that the road had been "so carefully constructed and built by the government that it is a veritable boulevard of the forest any automobile could easily pass along on it." Near the top of the pass,

Heath noted that "the road is cut in the side of the mountain, and in many places out of solid rock; it was in no way inferior to that already traveled." At the summit, Heath wrote that an avalanche had left snow so deep it reached the top of his saddle, but 150 men had shoveled the road clear.[25]

Trial of a Trail also described repeatedly the sublime grandeur of the Cody Road that was captured on Stimson's glass plates. On the county road west of the confluence of the Shoshone's North and South Forks, Heath wrote that the "sky line of the mountains to the west . . . was most striking and stood clear against the sunset hues and twilight . . . the many sharp angles in the mountain outline catch and hold the eye of the observer." He described the North Fork's current as "very rapid . . . and pure snow water." Upon entering the forest reserve, he wrote that he felt "entranced" by the scenery. Then, climbing a hill near Wapiti Creek, Heath noted "the grandest view yet seen on this trip: range upon range of timbered mountains, while higher up and to the south we see the lofty snow-capped Rockies." Across Sylvan Pass the party stopped at Sylvan Lake, "a veritable mirror of the mountain—clear as crystal—abounding in trout, which are easily caught by casting from the shore." Yellowstone Lake soon came into view, and Heath again remarked on its grandeur: "Nothing here is incongruous; everything is in full perfection and harmony. Our eyes are carried along the green valleys to the lake and farther on to the Spruce clad mountains beyond, and still higher up to the gray rock and snow-clad summits of the distant Rockies and Tetons, until we feel we have witnessed the setting of the grandest harmony of nature's greatest symphony."[26]

Heath found the descent to Yellowstone Lake very different, however. At Turbid Springs he camped for one night amid the "vapors of sulphur and odors." He recorded that the ground was hot underfoot and that many in the party felt "hell is nearer than we expected to see it" as he described the "grewsomeness [*sic*] about this place." He concluded the passage by comparing this last camp with Sylvan Pass: "We find ourselves filled with thoughts directly opposite those we enjoined on the height above."[27]

After spending more than a week touring the park and seeing the Old Faithful area, Mammoth Hot Springs, Mount Washburn, and the falls of the Grand Canyon of the Yellowstone, Heath and his party returned to Cody via Sylvan Pass. Despite having seen the park's many wonders, Heath suggested that he was seeing the Cody route as if for the first time and thought its flowers were better than those in Yellowstone. He concluded, "All

the party voted and were unanimous that the Sylvan Pass surpassed the scenery of the Park excepting that of the Grand Canyon, which is unique in its beauty."[28]

In comments he made to the local Cody newspaper, the *Wyoming Stockgrower and Farmer*, Heath was even more blunt, stating that the "scenery up the North Fork and at Sylvan Pass is a thousand fold finer than in the park itself." As he continued, his hyperbole increased: "When you see one geyser you have seen them all, but the scenery over the Cody trail and at the summit of Sylvan Pass presents a constantly changing panorama of beautiful and grand views of kaleidoscopic variety and beauty."[29] After such an interview, it should come as no surprise that when Heath returned the following year for another Yellowstone tour, the newspaper reported his arrival and noted that he had given away nearly the entire 1,000-copy run of his "beautifully illustrated" book, *Trial of a Trail*.[30]

Heath's account contains such a sense of freedom that one has to wonder if Stimson felt it as well. In an age when most tourist experiences were nearly totally controlled by railroads and their subsidiaries—for example, the Santa Fe Railway and the Fred Harvey Company in the Southwest—which decided where their passengers would stop, how tourists would move through a lunchroom or a hotel, and what kind of things they would see, the Cody route offered a completely opposite experience. Indeed, this sense of tourist freedom was uncommon at the time; although Yellowstone had many independent travelers, the American public did not widely know such freedom until the advent of automobile tourism in the 1920s.[31] Heath best described this feeling first when he explained why his group chose to form a wagon train led by a guide rather than take a prearranged tour. He wrote that this travel method ensured "the entire freedom of action accorded the camper—he has no 'must' in his schedule—he can travel two miles or forty as suits his pleasure." He added that a camper not only had "freedom of action as regards time, but also of place; he chooses his own route, varying it as his pleasure directs, making this side trip or that."[32] Perhaps this was the same exuberant feeling Stimson and Chase described to the newspaperman in Cody.[33]

By the time Heath published *Trial of a Trail* in 1905, important developments to the Cody Road were already in the works that changed the route from the one Stimson had known in 1903. First, Heath's party had hired guide Aron Holm to escort them through the park. Holm had purchased tourist coaches and in early 1905 started the Yellowstone Park Camping and Transportation Company to take travelers to the park.[34] Second, Heath described the construction of Buffalo Bill Cody's two lodges along the route, the Wapiti Inn

on the eastern edge of the forest reserve and Pahaska Tepee just east of the park.[35] Third, the federal government had commenced work on each end of the road to make it easier for travel. On the west side, the Army Corps of Engineers sought to lessen the grade up Sylvan Pass by constructing the famous Corkscrew Bridge, routing the road up and over itself as it climbed to the pass. On the route's eastern side, engineers from the Bureau of Reclamation completed a new road from Cody to the construction site of the new Shoshone Dam. This alpine short-cut eliminated the road around the south side of Cedar Mountain, and the new route's harrowing twists, turns, climbs, and drop-offs added to its drama.[36]

In addition to these changes, the first guidebook for travelers on the Cody Road was also printed in 1905. Although earlier Yellowstone books had included short blurbs about the new road, "The Cody Road into Yellowstone Park," published by the Burlington Railroad, contained illustrated descriptions of the scenery, accommodations, hunting possibilities within the forest reserve, a map of the route with distances and road descriptions, available stage rates and guide services, and connecting rates on the Burlington route from across the West. The pamphlet's language reflected *Trial of a Trail*'s sense of sublime scenery, adventure, and freedom and the advancements already under way. It stated that the Cody Road had "advantages that must commend it particularly to those who prefer to be leaders of the general tide of travel, rather than followers after it." It then picked up on *Trial of a Trail*'s conclusion that the "scenery along this new road through Yellowstone Forest Reserve is equaled only by that in the Grand Canyon of the Park proper." Elaborating on this theme, it suggested that the term *forest reserve* fit only a small part of the Cody Road and that the rest offered "miles of grandeur so diversified as to include every imaginable variety of natural sublimity and beauty." It went on to mention the Shoshone River and its "amazing formations," which "may become as famous as the longer-known features of the Park."[37]

The pamphlet presented a complicated message of individualism and freedom to travelers at the same time it offered comfort and safety. On one page it called the Cody route a "pioneer's trail blazed through a region primeval," with "no store, no shops, no furnace smoke, no 'social etiquette'—nothing but the great rugged West, crude, heroic, and cordial." It further suggested that "sportsmen" would find the route ideal because Wyoming's hunting regulations were no more stringent than "absolutely necessary to prevent wanton slaughter." Then, on the very next page it described the accommodations available at the Irma Hotel, Wapiti Inn, Pahaska Tepee, and in the park, noting that Yellowstone's lunch stations provided

plenty of good food "at prices, which, though higher than in cities and towns, are far from exorbitant."[38]

The following spring, the Burlington ran a story in the May 2, 1906, issue of the *Wyoming Stockgrower and Farmer* that detailed a fifteen-day camping trip from Cody through the park and back again. Illustrated with photographs of Sylvan Pass, scenes in Shoshone Canyon, Chimney Rock, a camp, and Old Faithful, the piece highlighted Holm's Yellowstone Park Camping and Transportation Company and provided a day-by-day account of a typical trip through the park, including the first four days on the Cody Road. Day 1 included passing through the "proposed reservoir" site, "a beautiful agricultural valley," and the rock formation of the Holy City before camping at Wapiti. The second day included Chimney Rock, "beautiful forests of pine untouched by the despoiling hand of man," and another camp just outside the park. The third day marked the ascent up Sylvan Pass, including the new "loop the loop" Corkscrew Bridge, where "one member of the party may stand far above and directly over another," before crossing the pass to another camp at Sylvan Lake. The last day on the road included descending past Turbid Lake and camping on the shores of Yellowstone Lake. Mirroring similar sentiments about the Cody Road, this piece noted that the government had constructed an "excellent road" with "vastly superior scenic beauty" and that many travelers "declare that the scenery shown exclusively on the Cody Road is superior to that later shown on the Park circuit."[39]

At about this same time, the Federal Reclamation Service (later the Bureau of Reclamation) was building the Shoshone (now Buffalo Bill) Dam. Started as one of the nation's first projects under the 1903 Newlands Act, the project began in 1904 by locating construction camps on each side of the canyon and then blasting a road from solid granite to connect them. In the fall of 1905, the government's contractor began constructing the arch concrete dam that would trap the waters of the Shoshone, inundating the small community of Marquette as well as the portion of the county road to Yellowstone on the west side of Cedar Mountain. As work on the dam progressed, the federal government also constructed a new road to the park from the dam site along the north side of the new reservoir's location. When the dam was completed in 1910, the Cody Road then began with a fantastic alpine route through tunnels amid the depths of a deep canyon and made a steep climb to the top of the world's highest dam. It then wound through more tunnels around the country's largest reservoir before reconnecting with the old county road for about ten miles before joining the federally constructed road at the national forest boundary.[40]

Descriptions of the new route through the canyon suggest that it added to the rugged and sublime features of the Cody Road. *Campbell's 1909 New Revised Complete Guide and Descriptive Book of the Yellowstone Park* contained many images and descriptions along the Shoshone from the park to Cody. When the guide neared the town, it wrote:

> Before long the road is winding along the edge of what in a short time will be the Government Shoshone Reservoir, an extensive lake to be formed by impounding the waters of the river for irrigation purposes. From here the last stage of the ride along the Government Road through Shoshone Canon is thrillingly interesting, and shortly after passing the Shoshone Government dam, which seems like a long, narrow wedge driven down between the walls of the Canon (it is the highest masonry dam in the world) Cody, the terminus of the Burlington Road, is reached, and our trip, through scenery unsurpassed on the continent for loveliness, is over.[41]

The Burlington Railroad's 1912 brochure played up the adventure of a trip over the new canyon road. It first described the sublime grandeur of the canyon, with its "almost perpendicular sides" that were "rocky, jagged, and almost barren of vegetation." It then boasted of the government's triumphal conquest as it "blasted from the solid rock a broad, solid highway" that followed the river: "now level with it, now overlooking it from sheer, giddy heights, now and then through rock-hewn tunnels, always gradually rising." The pamphlet noted that the new dam was thirty-seven feet higher than New York's Flatiron Building and provided travelers with a "broad magnificent vista to the westward."[42]

At about this same time, Cody area guides Ned Frost and Fred Richard published their own brochure on the Cody Road titled "Cody Road thru Yellowstone Park." With images of Shoshone Dam, its spillway, tunnels on the canyon road, Chimney Rock, the Holy City, and the Corkscrew Bridge, this guide served as a private alternative to the railroad's promotional materials. But with the exception of the description of their own ranch, "situated in the most beautiful part of this wonderful valley" and decorated with such luxuries as a "great fireplace, a fine piano, plenty of music and hundreds of books," it read like any other promotional piece. Its accolades included the "brilliant green acres of alfalfa," the "strange outlines" of the nearby mountains, the "madly rushing mountain streams," and the climb over Sylvan Pass where travelers encountered Eleanor Lake, "green as an emerald, fed by perpetual snows . . . scintillating in the sunshine."[43]

Given such characteristics, it is not surprising that J. E. Stimson visited the new road in the summer of 1910 and photographed the canyon route. His images from that summer include fourteen views of the canyon, dam, and the town of Cody plus photographs taken on the Shoshone Irrigation Project at nearby Garland and Powell. Of the images he took on the new Cody Road, I rephotographed four of them—featuring the river and road at the eastern end of the canyon, one of the tunnels located in the depths of the canyon en route to the dam, another of a primitive guardrail and structures along the road with Cedar Mountain in the distance, and finally a view taken from the new road on the northern edge of the reservoir looking back across the water toward Cedar Mountain.[44]

At about the same time Stimson was photographing the new road, two other developments brought even more changes to the Cody route. The first, the introduction of tourist lodges and guest ranches, had begun during the previous decade and was indicated in Frost and Richard's brochure. Beginning with the construction of Buffalo Bill's Wapiti Inn and Pahaska Tepee, private entrepreneurs had been constructing lodges to capitalize on the growing number of tourists traveling along the Shoshone. In addition to Cody and Frost and Richard, leading guides Aron Holm and John Goff built the Crossed Sabres Ranch and Goff Creek Lodge, respectively. Others soon followed until there were more than a dozen such facilities between Cody and the park. This development, which offered guided trips along the road, into Yellowstone, and into the adjacent back country, slowly changed the Cody Road from purely a route to the park into its own destination spot. As Frost and Richard's brochure indicates, visitors to the Shoshone could now enjoy a relaxing and comfortable stay without ever setting foot in Yellowstone.[45]

The second development, the introduction of automobiles on the Cody Road, would have an even larger and more important impact. Automobile ownership nationwide was booming during the first decade of the twentieth century, especially after Ford introduced the affordable Model T in 1908; it exploded again over the next twenty years. Although cars were banned in Yellowstone until 1915, a few had tried to navigate the Cody Road starting in the early 1900s. Recall that *Trial of a Trail* had remarked that the Sylvan Pass route was a veritable boulevard smooth enough for any automobile. With the completion of the new road around the dam in 1910, the stage was set. In June of that year, Buffalo Bill introduced a White 60-horsepower Steamer for Pahaska. This vehicle picked up passengers at the Irma Hotel in town and drove them to Pahaska, stopping for lunch at the Wapiti Inn. The following year,

Tex Holm ordered his own twelve-passenger Stanley Steamer to bring guests to his lodge. Cody responded with two more Whites.[46]

The automobiles had immediate impacts. They seemed to shorten the Cody Road, as what had been a two- or three-day camping trip to reach the park's East Entrance now became a half-day pleasure drive. Traffic increased as more than 1,500 tourists, twice as many as in 1910, traveled the route. Improvements soon followed. At first, employees from area lodges and city boosters removed rock and boulders, knowing that a smooth road helped everyone. But problems persisted. Because the road was too narrow for two-way traffic, cars had to wait on turnouts or back up to wide spots when encountering others. Nevertheless, in 1912 the Cody Road became part of the Black and Yellow Trail, a promotional tourist highway from Chicago to the Black Hills and on to Yellowstone. To prepare for more cars, the government began widening the road in 1913. There were other impacts as well. That same year, Buffalo Bill tore down the Wapiti Inn and reused the lumber at Pahaska Tepee because auto tourists no longer needed the overnight spot. Then in 1915 Yellowstone was opened to individual autos, causing Holm's Transportation Company to fold. William F. Cody died in 1917, and by the end of World War I the Cody Road's first generation of tourist operations had ended.[47]

The earliest accounts of this first era of automobile travel reflect much of the same sense of freedom and adventure as the earlier guided tours. The 1916 edition of the Burlington guide featured a painting of a fully loaded automobile in Shoshone Canyon with Buffalo Bill in a cloud high above. At the bottom, the pamphlet clearly stated that the Cody Road was "the Only Auto Route into the Park."[48] David M. Steele, rector of Philadelphia's Church of St. Luke and the Epiphany, traveled throughout the West during World War I. After visiting such spectacular places as the Grand Canyon, Lake Tahoe, Yosemite National Park, Glacier National Park, Jasper National Park, and Yellowstone, Steele felt compelled to see the "new Cody road." Although he bemoaned the town of Cody and the Irma Hotel, he was enraptured by the road to the park. He wrote that neither he nor anyone in his party had ever so greatly enjoyed a single day's ride and that the "sustained beauty and grandeur of this scenery is greater than within the Park itself." He explained:

> This Cody Road has almost all the features of all the famous sight-seeing places
> combined in this country. It has features severally grander than their greatest ones
> in series. The Shoshone Canyon, through the bottom of which we rode, is as deep
> as the Yellowstone Canyon, from the brink of which we later looked down. The

snowcapped mountains all about us, although at a distance, were [as] impressive as the Selkirk Range on the Canadian Pacific. The Falls of the Yellowstone are as fine as Niagara. Frost's Caves, under Cedar Mountain, are as extensive as those in Kentucky. The approach to Absaroka Range is between rock walls as narrow, looking up to peaks quite as precipitous as in and through the Royal Gorge on the Denver and Rio Grande. The Corkscrew is like that at Georgetown, Colorado; while those miles of brownstone pinnacles beat Manitou and all the Garden of the Gods at their own game. And, as for Wild West country, it is that about the town of Cody, surely a whole county being Buffalo Bill's winter quarters for himself and his mixed company.

Finally, Steele put his finger on the comparison between the Cody Road and the park by noting that the former was the work of man and the other the "lone work of nature." He continued, "Here is nature, there, man's ingenuity in overcoming nature." This juxtaposition, he concluded, is the "feeling of pride in achievement of our kind" versus being "awed into humility at [the] sight of something so sublime" of God's handiwork.[49]

By the time Steele published these words, the Cody Road had changed considerably from the new route photographed by J. E. Stimson just a decade and a half earlier. With the exception of the road through Shoshone Canyon, it followed basically the route engineered by Chittenden in 1901. But since that time, it had been widened and smoothed out. Automobiles had replaced horse-drawn wagons, and guest lodges had sprung up all along it. During the entire summer of 1903, when Stimson made his images, only 303 tourists traveled the road to the park. By 1920, more than 16,000 were doing so. Six years later that number had grown to over 45,000, and by the end of the decade it had reached more than 60,000 annually.

To keep up with the demand, the National Park Service (created in 1916) and the Bureau of Roads worked to make the road safer and easier to navigate. In 1917 the government replaced the popular timbered corkscrew viaduct with one of concrete and stone and fourteen years later removed it altogether by realigning the road high up the adjacent hillside. Government workers during the Depression graded and oiled the road. In 1959, after a landslide closed the Shoshone Canyon route, engineers blasted new tunnels and replaced the steep grades to the dam with a new route alongside it. These and other improvements brought more people to the Cody Road.

East of the park, local entrepreneurs constructed a ski resort, while the federal government designated wilderness areas and placed historical markers alongside the road. Inside

the park, workers rerouted the road away from Turbid Lake, and the National Park Service realigned and lessened the grade through Sylvan Pass. Bridges were replaced and the road straightened. Perhaps most telling by the time I visited the road in July 2008 were the facts that the mileage from Cody to the Lake Hotel had declined by almost twenty miles simply as a result of curves having been straightened, and the number of people who whizzed by every two minutes equaled the entire number who entered the park on the Cody Road that first summer.[50]

Over the course of about ten days in the summer of 2008, I relocated and rephotographed thirty-nine of Stimson's forty-five original images. This remarkable percentage reflects at least two important points, including the fact that my guide, Doug Reachard, had explored and hunted along this route for more than thirty years. Equally important, though, the road's basic route had remained more or less the same for over a century. While these two ideas might help to explain my rephotography success, other considerations explain the significance of the Cody Road's popularity. To get at this, we must dig deeper into tourism history and theory.

The basic truths of geography attest to a few plausible explanations. One reason for the Cody Road's popularity is the simple fact that more Americans live east of the park than north, south, or west of it. Thus, for most Americans the Cody Road represents the shortest route to Yellowstone National Park. Another is its compactness. While many writers suggested that the route's scenery was better than that in Yellowstone itself, few explained that the road from Cody to the park is less than half the distance of the loop around the park, with no side trips. In other words, the compactness of the Cody Road's scenery might account for part of its allure.

The sense of adventure and freedom early tourists on the route expressed must also be considered a source of its popularity. Although tourism historians suggest that this type of individual exploration and sightseeing did not become the rage until the popularity of the automobile and "intra-regional" tourism in the 1920s, tourists on the Cody Road manifested such feelings beginning that first summer, in 1903. Picking up on this, in its brochures the Burlington Railroad sold this freedom. This is unusual, as most railroads at that time practiced a type of "hegemonic tourism" whereby the company or its affiliates controlled where its tourists stopped and what they saw and experienced. The most famous example is the "invention" of the American Southwest by the Atchison, Topeka, and Santa Fe Railroad and

its subsidiary, the Fred Harvey Company. But no railroad ever ventured up the Shoshone River from Cody to the park, so there was never an ability to control the passengers' experience. Instead, the Burlington capitalized on the freedom and adventure the independent road offered and sold those qualities to passengers who came as far as Cody. Thus, travelers on the Cody Road were forerunners of the tourist experience most Americans came to understand only later in the 1920s and especially after World War II.[51]

This idea of freedom and independence is a complex one on the Cody Road because of the very strong presence of the federal government along its entire route. Indeed, the Cody Road serves as a sort of "highway of federal firsts" as it passes from the town to Buffalo Bill Dam and Reservoir (the first project of the Bureau of Reclamation), across Shoshone National Forest (the nation's first forest reserve), and into Yellowstone (the world's first national park). Add to this the wilderness areas and the Wyoming state government, and one finds that the road that has always been the very model of freedom and independence is also one of the most government-controlled corridors in the West. This is not to suggest that the government cannot promote freedom through its projects—the federal interstates do just that—but rather to remind us that the situation is more complex than is obvious at first.

Along with the ideas of freedom and independence are the artistic ideas of grandeur and the sublime. Strictly speaking, grandeur is defined as magnificence. Clearly, places such as Sylvan Lake and the Holy City qualify under this term. The second word, sublime, is more complicated and suggests not only grandeur but exaltation and awe as well. Regarding scenic landscapes, the sublime usually connotes a sense of smallness in the landscape and the overpowering presence of God. In practical terms, writers who expressed these sentiments about the Cody Road were implying that its scenery approached the power of Yellowstone.[52]

This leads to the concept of liminality. Usually perceived as a place of transition, a place of re-creation, a threshold or gateway, liminal space is of particular importance in understanding the popularity of the Cody Road. In the liminal state, the normal rules of society and its ideas of how the world works simply do not apply. In this sort of "twilight zone," tourists can escape social restrictions and refashion themselves as more free, democratic, or natural. For more than a century, tourists traveling the Cody Road have commented on what a "royal time" they had and how the road provided freedom from their everyday lives. Moreover, as they descended into the depths of Shoshone Canyon and then climbed to the top of the great dam, saw the country's largest manmade reservoir, viewed volcanic rock formations at

the Holy City, crossed through July snowfields on Sylvan Pass, and felt the heat of geysers at Turbid Lake, they experienced a liminal landscape far outside the bounds of their normal lives.[53]

Put in a more classic literary sense, if Yellowstone was indeed the "Wonderland" its press agents proclaimed, then the Cody Road served as the gateway, or rabbit hole, to this magical place. The connections are clear. In Lewis Carroll's 1865 classic, *Alice in Wonderland*, Alice was bored, sitting on a riverbank with her sister until she followed a large white rabbit and fell down the rabbit hole into a fantasy world called Wonderland. As in the story, the Cody Road has always been a long passageway to an extraordinary place, where the world doesn't look or act normal. This passage is a liminal space, where tourists feel more free, independent, and natural, and it helps us understand the road's popularity.[54]

The flip side of these emotional responses involves the very real effects these popular roads can have on native ecosystems, the ones national forests and parks are trying to protect. Sport fishing on the Shoshone led to the introduction of non-native, hatchery-bred rainbow trout that have nearly replaced the native Yellowstone Cutthroat.[55] Further, biologists suggest that highways can lead directly to increased road kills, wasted energy as animals avoid traffic, and habitat fragmentation as roads split species into smaller populations. They also create a variety of types of pollution, including increased noise levels that can cause stress and affect animals' territory establishment. Heavy metals, including lead, can also be found alongside roads after decades of travel by vehicles using leaded gas. Plants can suffer habitat loss and the invasion of exotics in the forms of weeds, pests, and parasites. Increased "edge habitat," with changes in vegetation structure and composition, can also occur, along with hydrological impacts of increased runoff, erosion, and sedimentation. Finally, ecologists suggest that by simply allowing access to more and more humans, indirect effects such as over-hunting and increased fires often result.[56]

The bottom line is chilling. The same roads that can provide a sense of freedom and independence can reduce native populations, stress survivors, and introduce the same set of cosmopolitan weeds across the country—leading to increased homogenization across bioregions and, in the end, "impoverishing global diversity."[57]

When J. E. Stimson took a side trip up the Cody Road in July 1903, he was documenting the new road for the state of Wyoming's exhibit at the 1904 St. Louis World's Fair. His images of the route show, in fact, two roads—the county two-track, barely more than a path,

and the engineered federal road complete with dug ways and bridges. A close look at his images reveals few remnants of earlier travelers and even fewer people. The sparse reports of Stimson's trip add to our understanding, while additional firsthand tourist accounts help to round out the picture. Learning the basic history of the road adds layers to our understanding, while broader cultural ideas flesh out the significance of the road to American culture but also the impact of that culture and the road on the wilds of northwestern Wyoming. A closer "reading" of Stimson's images paired with my rephotographs of the same locations in the next chapter will further aid in our understanding of this passage to Wonderland.[58]

Notes

1. Alfred Runte, *Trains of Discovery: Western Railroads and the National Parks* (Boulder, CO: Roberts Rinehart, 1990); Thornton Waite, *Yellowstone by Train: A History of Rail Travel to America's First National Park* (Missoula, MT: Pictorial Histories Publishing Co., 2006); Hiram Martin Chittenden, *The Yellowstone National Park: Historical and Descriptive* (Cincinnati: Robert Clarke, 1903), 261–268. The Tower Falls area was added to the Grand Loop in 1905.

2. Ester Johansson Murray, *A History of the North Fork of the Shoshone River* (Cody, WY: Lone Eagle Multimedia, 1996).

3. Quoted in Kenneth H. Baldwin, *Enchanted Enclosure: The Army Engineers and Yellowstone National Park: A Documentary History* (Washington, DC: Office of the Chief of Engineers, United States Army, 1976). This source can be found online at http://www.nps.gov/history/history/online_books/baldwin/chap7a.htm [accessed September 2, 2010].

4. W. Hudson Kensel, *Pahaska Tepee: Buffalo Bill's Old Hunting Lodge and Hotel, a History, 1901–1946* (Cody, WY: Buffalo Bill Historical Center, 1987), 11.

5. Ibid., 9; Lynn Johnson Houze, *Images of America: Cody* (Charleston, SC: Arcadia, 2008), 32–33; Waite, *Yellowstone by Train*, 93–96; Robert E. Bonner, *William F. Cody's Wyoming Empire: The Buffalo Bill Nobody Knows* (Norman: University of Oklahoma Press, 2007).

6. Mary Shivers Culpin, *The History of the Construction of the Road System in Yellowstone National Park, 1872–1966: Historic Resource Study*, vol. 1 (Denver: Division of Cultural Resources, Rocky Mountain Region, National Park Service, 1994), 43–68; available at http://www.nps.gov/history/history/online_books/yell_roads/hrs1-15.htm [accessed September 2, 2010].

7. Quoted in ibid., 339–354.

8. Quoted in ibid., 339.

9. Quoted in ibid.

10. "A Big Contract," Cheyenne *Daily Leader*, February 7, 1903.

11. Ibid.; "New Yellowstone Park Road," Rawlins *Republican*, March 7, 1903.

12. "New Highway," Cheyenne *Daily Leader*, July 29, 1903.

13. "For the St. Louis Fair," Cheyenne *Wyoming Tribune*, June 3, 1903; "Magnificent Collection," Cheyenne *Wyoming Tribune*, February 17, 1904.

14. "Home News," Cody *Wyoming Stockgrower and Farmer*, July 28, 1903; "Mr. Chase Home Again," Cody *Wyoming Stockgrower and Farmer*, July 28, 1903.

15. "Some Fine Views," Cheyenne *Wyoming Tribune*, August 18, 1903.

16. J. E. Stimson, *Catalog of Wyoming Views* (Cheyenne: J. E. Stimson, 1904). This item was found at the Wyoming State Archives, Cheyenne.

17. "Mr. Chase Home Again."

18. "Home News," Cody *Wyoming Stockgrower and Farmer*, July 28, August 8, and September 1, 1903. This argument is also made in Kensel, *Pahaska Tepee*, 11–15.

19. J. D. Cain, "A Vacation: Fifteen Days Trip Sight Seeing in the Yellowstone Park," Cody *Wyoming Stockgrower and Farmer*, September 1, 1903.

20. Burlington Route, "The Cody Road into Yellowstone Park" (Chicago: Burlington Route, 1905). These pamphlets were found in the Hebard Collection, University of Wyoming Library, Laramie.

21. These data are calculated from the scenes depicted in this book.

22. "Mr. Chase Home Again."

23. "To the Park," Cody *Wyoming Stockgrower and Farmer*, July 14, 1903; "A Vacation: Fifteen Days Trip Sight Seeing in the Yellowstone Park" and "Home News," Cody *Wyoming Stockgrower and Farmer,* September 1, 1903.

24. Charles A. Heath, *A Trial of a Trail: From Cody to the Yellowstone: Notes from the Journal of Charles A. Heath* (Chicago: Franklin, 1905).

25. Ibid., 34–43.

26. Ibid., 44.

27. Ibid.

28. Ibid., 71–77.

29. "To the National Park," Cody *Wyoming Stockgrower and Farmer*, July 26, 1905.

30. "To the Park," Cody *Wyoming Stockgrower and Farmer*, July 12, 1906.

31. Hal K. Rothman, *Devil's Bargains: Tourism in the Twentieth Century American West* (Lawrence: University Press of Kansas, 2000), 143–167.

32. Heath, *Trial of a Trail*, 11–12.

33. "Mr. Chase Home Again."

34. "Park Transportation," Cody *Wyoming Stockgrower and Farmer*, January 18, 1905; "Are You Going to the Park?" Cody *Wyoming Stockgrower and Farmer*, June 14, 1905; "Over the Road to Cody," Cody *Wyoming Stockgrower and Farmer*, July 26, 1905; Robert V. Goss, "Holm on the Range: Camping the Yellowstone with Aron 'Tex' Holm," *Annals of Wyoming: The Wyoming History Journal* (Winter 2010): 2–21.

35. Heath, *Trial of a Trail*, 36; "Buffalo Bill's Hotels in the Rockies," Cody *Wyoming Stockgrower and Farmer*, July 12, 1906. With Cody's Irma Hotel having opened in the fall of 1902, the Old Scout was positioned to capitalize on tourist travel from the Burlington Railroad all the way to the park. By the following summer he was advertising the Irma, the Wapiti Inn, and Pahaska Tepee under the single banner, "Buffalo Bill's Hotels in the Rockies."

36. Kensel, *Pahaska Tepee*, 14; Beryl Gail Churchill, *Challenging the Canyon: A Family Man Builds a Dam* (Cody, WY: WordsWorth, 2001); F. H. Newell, Department of the Interior, United States Geological Survey, "Fourth Annual Report of the Reclamation Service" (Washington, DC: Government Printing Office, 1906), 350.

37. Burlington Route, "Cody Road."

38. Ibid.

39. "Through Yellowstone National Park," Cody *Wyoming Stockgrower and Farmer*, May 2, 1906.

40. Chamberlain, *Challenging the Canyon*, 63.

41. Reau Campbell, *Campbell's New Revised Complete Guide and Descriptive Book of the Yellowstone Park* (Chicago: Rogers and Smith, 1909), 135.

42. Burlington Route, "In Camp and Ranch in the Yellowstone Country/The Cody Road into Yellowstone" (Chicago: Burlington Route, 1912).

43. Ned W. Frost and Fred J. Richard, "Cody Road thru Yellowstone Park" (Cody, WY: Frost and Richard, 1912).

44. This list is from the Wyoming State Archives master list of all Stimson images housed there. Wyoming State Museum, *Along the U.P. Line: A Listing of the J. E. Stimson Photographs in the Collection of the Wyoming State Museum* (Cheyenne: Wyoming State Museum, 1977). Several of Stimson's images are used in the Burlington promotional brochures.

45. A good history of the "North Fork Lodges" can be found in a chapter by that name in Murray, *History of the North Fork of the Shoshone River*, 95–108. An excellent discussion of the bigger picture of the effect of such developments can be found in Rothman, *Devil's Bargains*, 113–142.

46. "Automobiles for Pahaska," Cody *Wyoming Stockgrower and Farmer*, June 4, 1910; "Tex Holm's Passenger Auto Expected June 15," Cody *Wyoming Stockgrower and Farmer*, April 29, 1911. Kensel, *Pahaska Tepee*, 24–64, has an excellent discussion of automobiles on the Cody Road.

47. Available at http://www.aaroads.com/west/us-016_wy.html [accessed August 14, 2010]; Kensel, *Pahaska Tepee*, 55–64; Rothman, *Devil's Bargains,* 143–167.

48. Burlington Route, "In Camp and Ranch Buffalo Bill Country/The Cody Road into Yellowstone" (Chicago: Burlington Route, 1915); Burlington Route, "The Cody Road to Yellowstone Park" (Chicago: Burlington Route, 1916).

49. David M. Steele, *Going Abroad Overland: Studies of Places and People in the Far West* (New York: G. P. Putnam's Sons, 1917), 112–124.

50. East Entrance numbers are from Kensel, *Pahaska Tepee*, 14, 20; and Murray, *North Fork,* 138. Realignments are in Culpin, *History of Park Roads*, at http://www.nps.gov/history/history/online_books/yell_roads/hrs1-15.htm [accessed September 2, 2010].

51. Rothman, *Devil's Bargains*, 50–80.

52. The concepts of the sublime and picturesque are discussed in Albert Furtwangler, *Acts of Discovery: Visions of America in the Lewis and Clark Journals* (Urbana: University of Illinois Press, 1993), 23–51.

53. See Margerite Shaffer, "Seeing America First: The Search for Identity in the Tourist Landscape," in David M. Wrobel and Patrick T. Long, eds., *Seeing and Being Seen: Tourism in the American West* (Lawrence: University of Kansas Press, 2001), 165–201. Liminality is also discussed on the website "What Is Liminality?" at http://www.liminality.org/about/whatisliminality/ [accessed September 2, 2010].

54. Lewis Carroll, *Alice's Adventures in Wonderland* can be accessed online at http://www.cs.cmu.edu/~rgs/alice-table.html [accessed September 2, 2010]. Yellowstone National Park historian Lee Whittlesey discusses the connection between the park and "Wonderland" in *Yellowstone Place Names* (Helena: Montana Historical Society Press, 1988), 166.

55. Interview with Todd Koel, supervisory fisheries biologist, National Park Service, Yellowstone, WY, February 3, 2011; Carole Cloudwalker, "YNP Cutthroat Trout in Trouble," *Cody Enterprise,* April 7, 2010.

56. Recall the early railroad guides that described Wyoming's hunting laws adjacent to the road as no more stringent than "absolutely necessary to prevent wanton slaughter." See the 1905 pamphlet, Burlington Route, "Cody Road."

57. Reed Noss, "The Ecological Effects of Roads," available at http://www.wildlandscpr.org/node/41/print [accessed October 7, 2010].

58. A good place to begin to understand how to "read" a photograph is Alan Trachtenberg, *Reading American Photographs: Images as History, from Matthew Brady to Walker Evans* (New York: Hill and Wang, 1990).

Photographs and Rephotographs

When J. E. Stimson explored the Cody Road over four days in the summer of 1903, he made images both going to Yellowstone and on his return to Cody. I have reconstructed these images into a single linear geographic passage moving westward on the road from Cody to Yellowstone, representing the scenes a traveler would encounter during the trip to the park. From the town, the route flanked Cedar Mountain to the south, crossed over to Irma on the South Fork of the Shoshone, then moved over to the North Fork and followed it all the way to Yellowstone Park's East Entrance. Along the way it passed through fields and canyons, past volcanic rock formations, and through the nation's first national forest. It then climbed over Sylvan Pass, past Eleanor and Sylvan Lakes, then descended to Yellowstone Lake. The four images that follow this organization represent four additional images Stimson made in 1910 on the new road past Shoshone Dam and Reservoir. The numbering system of the rephotographic pairs (1–42) was constructed for this book.

The number that follows each photo number—for example, #613 after number 1— is Stimson's original index number. Those interested in viewing or obtaining copies of any historic photograph can provide this number to the Wyoming State Archives.

The caption titles are based on Stimson's original photograph caption titles often listed on the bottom of the original negative. They have been modified for clarity and to reduce repetition.

The Global Positioning System (GPS) information provided was either calculated in the field using a handheld GPS unit or approximated on US Geological Survey (USGS) maps or Google Earth from known locations. Data are presented in degrees, minutes, and decimal minutes. It is said that civilian GPS units are accurate enough to place one within an area about the size of a tennis court near a location, so entering this information into a mapping system or Google Earth should take viewers very close to each camera station. Viewers will need to be at the sites, however, to find exact vantage points.

As noted earlier, Google Earth provides an application called Street View with a small person-shaped icon called Pegman. To get both a topographical view of the surrounding landscape as well as a 360-degree photographic panorama, enter the GPS coordinates and then drag Pegman to the site, making sure it is within the application boundaries marked in blue. After a computer-generated topographical view appears, the application switches to the photographic image if Google Earth has photographed the site. Drag the image to the proper direction, and it should match the computer image to Stimson's original photograph and my rephotograph. Exiting Street View returns the viewer to a satellite image.

Several captions note that my rephotographs are not made from Stimson's original camera stations. Although each case is unique, natural obstructions such as tree growth facilitated moving from the original point to show the "essence" of the original image. In other cases, earth removal for highway construction or the damming of the river made it impossible to find the exact Stimson location. Each of these occurrences is noted in its respective caption.

Captions are not footnoted. Information from them was gleaned from sources provided in the bibliography.

THE CODY ROAD

1903 & 2008

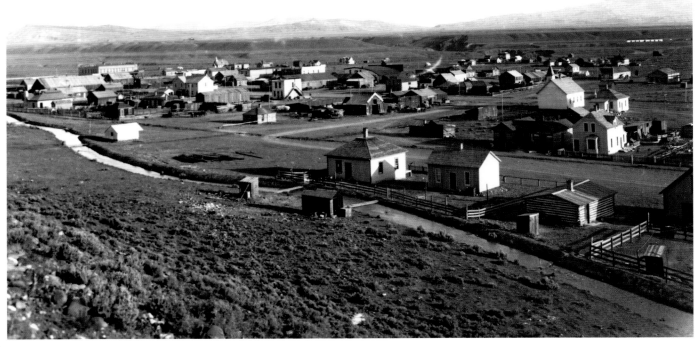

1. #613 **Bird's-eye view of Cody**

GPS coordinates: 44 31.373n, 109 03.523w

The road to Yellowstone begins in Cody, and this view is a classic Stimson shot. As with many of his town photographs, Stimson composed this one from a nearby hill to give the viewer a "bird's-eye" view of the town. The vantage point is the north side of Cody's upper bench below the current community building. The photo looks to the northwest, with Heart Mountain on the right horizon, the Shoshone River in the center, and Rattlesnake Mountain to the left. The absence of the far distant mountains attests to the fact that Stimson's dry-plate emulsions were very sensitive to blue light; thus they are washed out in his image. Stimson's shot was taken in the early morning, as evidenced by the well-lit right walls and the long shadows. The lack of any trees taller than a person allows one to see into every property.

As do many of his views, the composition shows his boosterism ethos, with an irrigation ditch running diagonally from the mid-center of the image to the lower

right corner, separating the sagebrush plain from the community. The town appears neat and orderly, with its commercial district clearly visible in the center of the image, Buffalo Bill's Irma Hotel at left center, and the town grid, telephone poles, and at least two churches in view. Moreover, with the ditch clearly symbolically separating the "civilization" of the town from the "wilderness" of the sagebrush plain, Stimson is suggesting that water was the key to Wyoming's development.

The modern view, taken in the summer of 2007, shows no sign of the irrigation ditch, although water's effect—namely, the many deciduous trees—is its most striking feature. The far horizon, with Heart Mountain and the far benches, identifies the vantage point. The trees on the right mid-horizon show the town's growth along Highway 120 toward Montana. As I wandered around the site, I could pick out individual houses still standing, but this particular point limited their appearance.

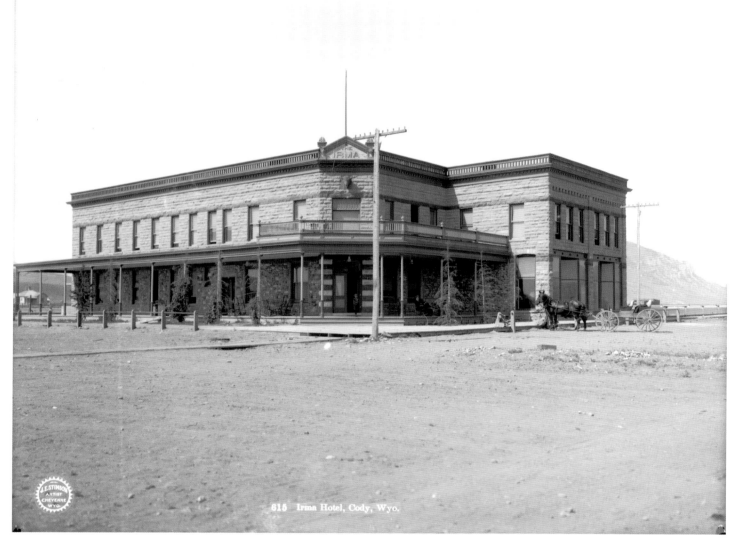

615 Irma Hotel, Cody, Wyo.

2. #615 **Irma Hotel, Cody**

GPS coordinates: 44 31 34.10n, 109 3 49.75w

Buffalo Bill Cody's Irma Hotel was constructed in 1902 and named for his daughter, Irma Louise Cody. The hotel, considered the finest in town, was the favorite starting point for travelers heading to Yellowstone. Within a couple of years, Cody built two more hotels along the route to the park: Wapiti Inn, located thirty-eight miles from Cody, and Pahaska Tepee, just outside the eastern gate.

Stimson's photo was taken in the late morning, as evidenced by the well-lit eastern wall and the shadows. It is a classic building portrait, framed dead center with no other buildings in view. In Stimson's photograph, note Cedar Mountain in the right distance

and the careful composition, which includes a telephone pole as a symbol of progress but just off-center so the hotel's name is clearly seen, as is its buffalo head.

The Irma remains the center of the Cody scene, and its restaurant and bar (the addition at right) are always busy. The hotel still accommodates visitors, and on the left porch, local actors stage daily gunfights for tourists.

A comparison of the two images reveals that many original design elements remain, including the flagpole, name plate, buffalo head, windows, and porch. It's fun to see that automobile parking spaces have replaced the hitching posts. The many signs in

the modern image hint at the increased competition for the tourist dollar in Cody, even at the Irma.

Although Buffalo Bill was certainly selling the passing frontier to western fans in his Wild West Show, with his mock stagecoach attacks, cowboy paraphernalia, and fake Indian battles, the Irma was always presented as a symbol of civilization for those traveling into the Yellowstone wilderness. It's interesting that a century later, that role has changed to one in which the hotel serves not as the last facet of progress but as the first step into Wild West nostalgia.

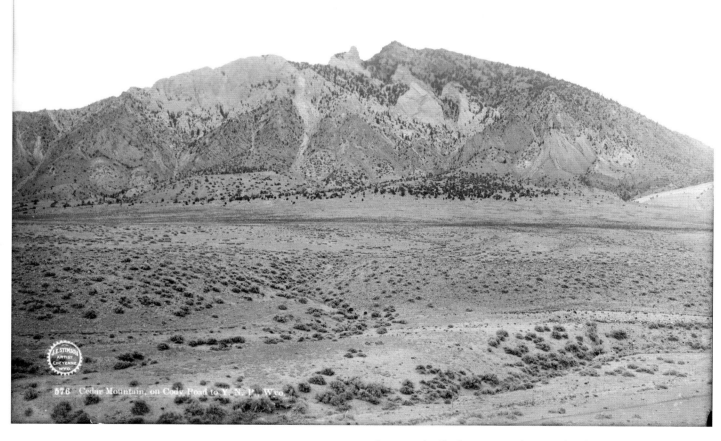

576 Cedar Mountain, on Cody Road to Y. N. P., Wyo.

3. #576 Cedar Mountain

GPS coordinates: 44 26.722n, 109 13.531w

When Joseph Stimson traveled the Cody Route to Yellowstone in 1903, there was no road through Shoshone Canyon. Instead, the route swung south out of Cody around Cedar Mountain, crossing the South Fork of the Shoshone River first and following the present Stagecoach Lane south of the North Fork of the river. The route changed when construction began on the Shoshone Dam; when completed, its reservoir inundated the original route.

Like his view of the Irma, Stimson's view of Cedar Mountain is a straight-ahead portrait, with sagebrush plains in the foreground and the mountain centered in the frame. Since the view looks to the east-northeast, the lighting suggests that exposure was made late in the day.

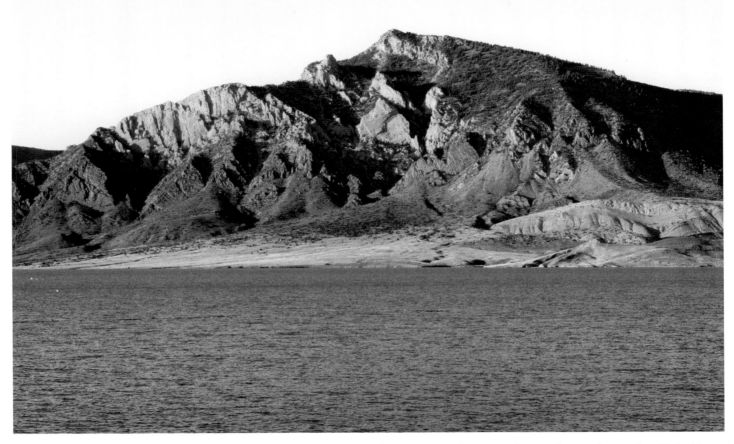

It was a problem to get close to the site of Stimson's original, and we eventually discovered that doing so would clearly require a boat. But before we made that discovery, Lauren and I set out trying to trace Stimson's route around Cedar Mountain, working our way along public roads, weaving in and out of the public lands of Buffalo Bill State Park, and trying not to cross into the many private lands that spread out across the south side of the reservoir. From Irma Flats we worked our way over Stagecoach Lane, eventually figuring out that it took us too far away from Cedar Mountain and too far north. We backtracked to a causeway that had been constructed into the reservoir in 2008 when the dam was heightened. With camera in tow, we walked the entire distance of this causeway out into the reservoir, visiting with locals out walking their dogs or fishing from its banks. The result is obviously not the same vantage point Stimson used but one that is fairly close and clearly highlights the fact that the original site is now under Buffalo Bill Reservoir.

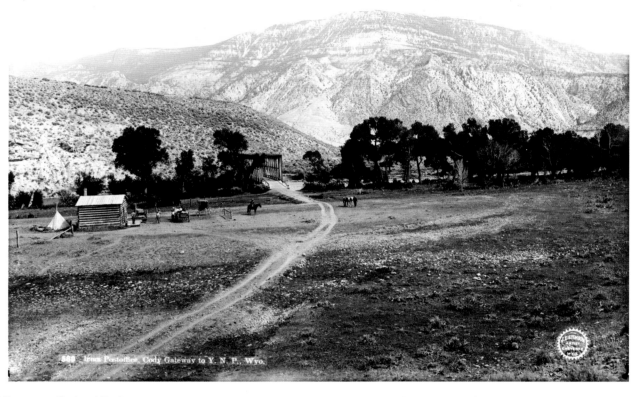

4. #569 **Irma Post Office, Cody Gateway to Yellowstone National Park**

GPS coordinates: 44 26.722n, 109 13.531w

As with so many of his pastoral images, this view focuses on a small log structure in the middle left foreground. A horse-drawn wagon waits in front, as do several bystanders, a horseman, and another grazing horse. Stimson's unhitched wagon can be seen, as can his guide, Fred Chase, walking his two white horses. A two-track path leads viewers from the lower left corner to the log building to a glimpse of a truss bridge set amid a row of trees alongside a river. A sagebrush-covered hill stands beyond the river on the left, and a much larger mountain, fainter but grander, looms across the width of the background.

Historical research reveals that the Irma Post Office was named for Buffalo Bill Cody's daughter, Irma Louise Cody, and was located on the South Fork of the Shoshone River just west of town. Rattlesnake Mountain dominates the background, and the South Fork of the Shoshone moves across the scene. The wagon tracks are the county portion of the Cody to Yellowstone Road. In the spring of 1903, just a few months before Stimson's visit, the Irma Post Office absorbed the nearby one at Marquette and was renamed the Marquette Post Office that year.

When we began researching the site of the Irma Post Office, folks in Cody directed us to an area now called Irma Flats near the former site of Marquette, on the southeast side of Buffalo Bill Reservoir. By looking at the landscape, we quickly figured out that

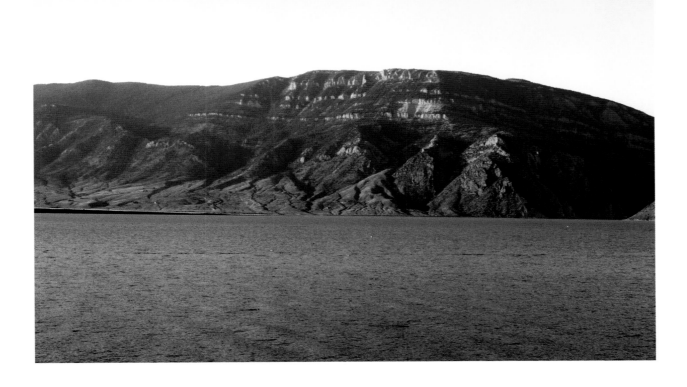

Irma Flats was not the same location. We also realized that the reservoir, completed in 1910, had probably inundated Stimson's pastoral scene. We soon found a dirt road called Stagecoach Lane skirting the western edge of the lake and began to see similarities between the upper portions of Rattlesnake Mountain to the north and the faint image of the background mountain in Stimson's view. After later learning that Stagecoach Lane was the old Cody Road to Yellowstone, we knew we were on the right track but also that Stimson's vantage point was now many feet below the water's surface. After more searching, we discovered that a causeway road extended from the edge of Irma Flats out into the lake. We walked out onto the causeway and lined up our image the best we could.

A comparison of the two photos begins with the utter ecological transformation caused by the reservoir. We believe the very top of the sagebrush-covered hill might be peeking out from the waters on the middle left of our image, but the valley, trees, and riparian areas are gone. Looking closely at Rattlesnake Mountain, it seems that the forest has thickened and expanded. Although a viewer might dismiss the transformation as one from the cowboy-dominated Old West of Stimson's image to that of the federal bureaucrat reclamation engineer of the modern view, remember that the dam was begun just a year after Stimson made his image and inundated the valley less than a decade later. So for most of the century in between images, it has appeared as it does in the 2008 photo.

Stimson's view also depicts the very beginnings of Cody tourism, when the two tracks in the foreground represented a new road to Yellowstone during its first month of existence. At the time, travelers generally scoffed at the county portion of the road during their three-day trip to the park. The route has moved to the base of Rattlesnake Mountain, where cars now speed to the park in a little over an hour.

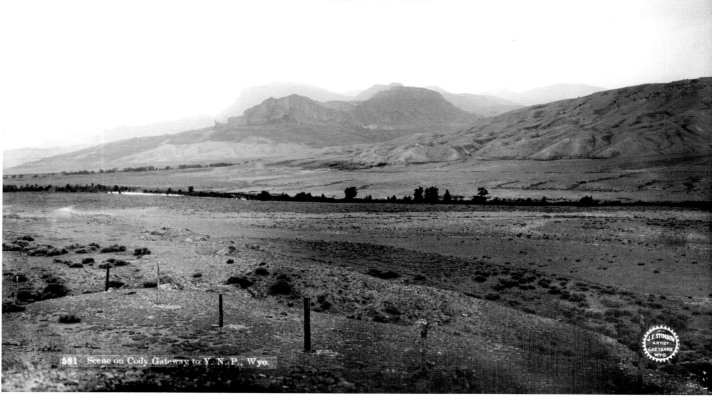

581. Scene on Cody Gateway to Y. N. P., Wyo.

5. #581 **Scene on Cody Gateway**

GPS coordinates: 44 28.85n, 109 19.318w

Unlike the two previous scenes of drastic inundation, this view looking northwest shows the tail end of Buffalo Bill Reservoir, Buffalo Bill State Park, and Jim Mountain looming in the distance. It was also taken from Stagecoach Lane, a county dirt road that runs from the south side of the reservoir to the state park and then to Wapiti, along the south side of the North Fork of the Shoshone River. This view was taken from the road just to the east of the state park.

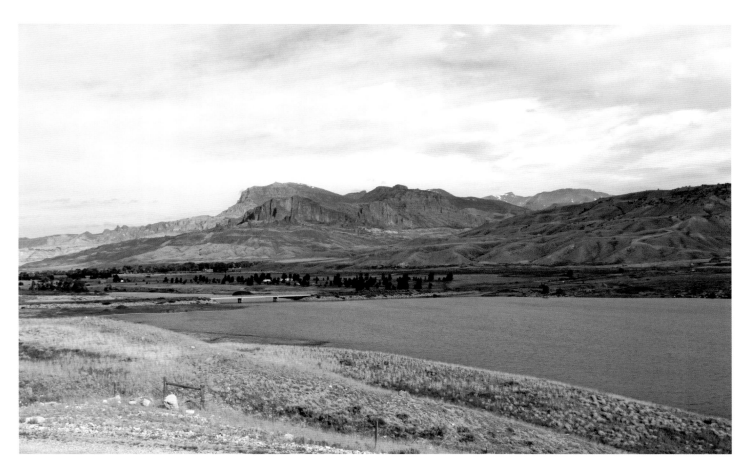

A comparison of the two views reveals that vegetation in the foreground and background is quite similar. Of course, the North Fork here is part of Buffalo Bill Reservoir, and the trees along it have changed drastically. The bridge across the reservoir, the ranches along the river, and the irrigated fields running north from the Shoshone to the bench lands beyond are new. The snowfields in the very high reaches of Jim Mountain, however, appear similar. Jim Mountain and much of everything beyond it now lies in the North Absaroka Wilderness Area, more than 350,000 acres of the Shoshone National Forest in which machines are forbidden and humans must remain visitors. Created in 1975, the wilderness further forbids logging and mining but allows hiking and fishing with permits.

In these contexts, these two images exhibit many of the invisible lines that cross the modern West. Stimson's entire view shows what was at the time a de facto wilderness, while the modern image shows a federally managed reservoir, a state park, a federally managed forest, and, within that, a more tightly managed federal wilderness area.

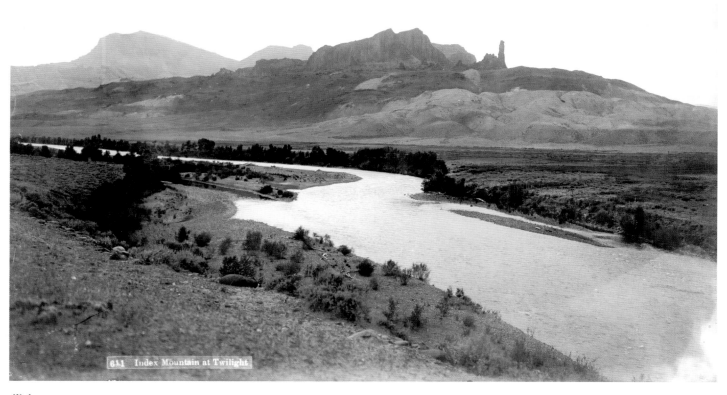

611 Index Mountain at Twilight

6. #611 **Index Mountain at twilight**

GPS coordinates: 44 28.69n, 109 21.16w

This Stimson view is one of the few of the more than 200 images I have rephotographed that provides a clear time as to when the original photo was made. Although foliage and shadows can indicate a season and time, Stimson's title suggestion that this image was made at twilight is unique. For the actual clock time, remember that there was no daylight saving time in 1903, so twilight occurred an hour earlier for him. In July at this latitude, twilight for me would have been around 9 p.m. mountain daylight time.

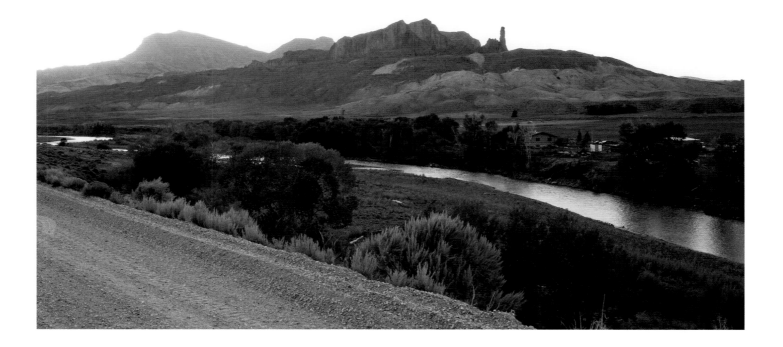

The location of the view is along a dirt road called Stagecoach Lane west of Buffalo Bill State Park. This road follows the original route of the Cody Road on the south side of the North Fork of the Shoshone River. The current Highway 14/16/20 runs along the north side at this point. The two roads reconnect at Wapiti.

The pair of images shows that the course of the North Fork has changed within its floodplain over the last century and that trees along the river have thickened and grown as well. Foliage on the far hills and mountains is very similar. The house along the river is new, but the silhouette of the far range would be very familiar to J. E. Stimson.

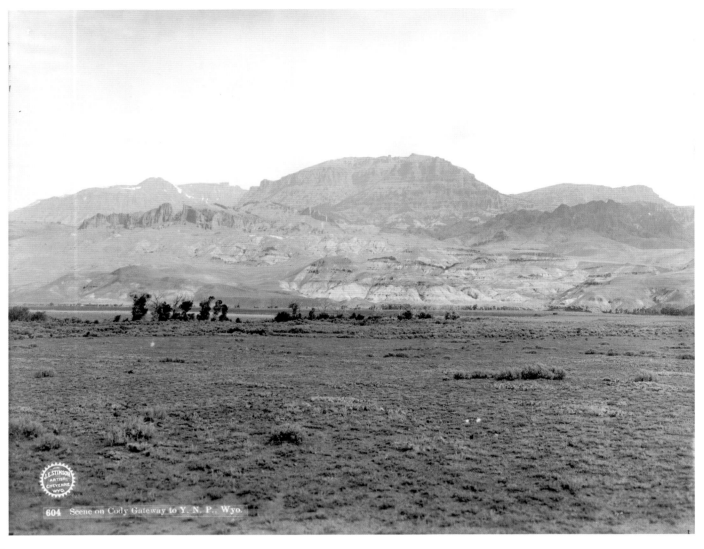

604 Scene on Cody Gateway to Y. N. P., Wyo.

7. #604 **Scene on Cody Gateway**

GPS coordinates: 44 27.759n, 109 27.396w

Labeled by Stimson simply as "Scene on Cody Gateway to Y.N.P., Wyo.," this view was taken just past the small community of Wapiti. Like the Irma Post Office and much of the road to Yellowstone, Wapiti had a direct tie to Buffalo Bill. As recent biographers illustrate, Cody was not always an astute businessman, but he was an active one and very early on became a promoter of the road from his namesake Wyoming town to the park. Just two years after Stimson's visit, Cody built tourist lodges about halfway to Yellowstone at Wapiti and just outside the East Entrance at Pahaska Tepee. Thus, Buffalo Bill Cody's presence seems always to be lurking in Stimson's views.

Unlike the view of the Irma Post Office, however, the basic landscape of this scene seems practically unchanged. Looking north toward Jim Mountain, Stimson's view shows wild rangelands, a few cottonwoods, the North Fork of the Shoshone, and

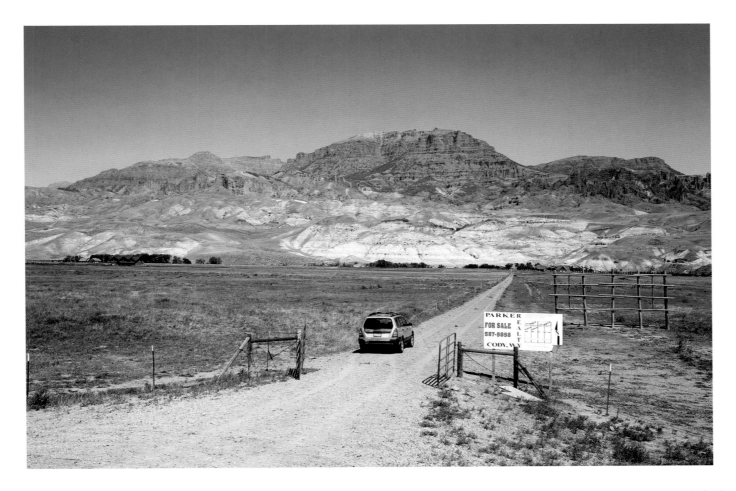

then the badlands rising up to a few snowfields on the mountain. In my view, irrigated ranchlands spread northward to a line of cottonwoods along the North Fork. Beyond the river the same badlands are present, with similar vegetation patterns leading up to the same silhouette of Jim Mountain against a blue summer sky. Most of the background, including the mountain, lies within the North Absaroka Wilderness Area, an area of strict environmental protection where no machines are allowed.

But the visible differences in this pair are in the foreground. The barbed wire fence running left to right hints at the modern closed range, while the straight dirt road and my Subaru Forester offer hints of automobile tourism and the global marketplace. Most

telling, of course, is the large white sign to the right (and just in front of an old billboard framework), advertising a local realty company that is subdividing the ranch into smaller New West ranchettes. A Google search shows individual parcels of "raw land" selling for $850,000 and houses for more than $2 million. As with so many beautiful places in the American West, the Cody Road to Yellowstone now serves not only as a tourist route but also as an everyday road for "amenity migrants" seeking to own a beautiful piece of property. Globalization has transformed many parts of the West from local working lands to real estate developments selling commodified viewscapes to newcomers importing their wealth into traditional economies.

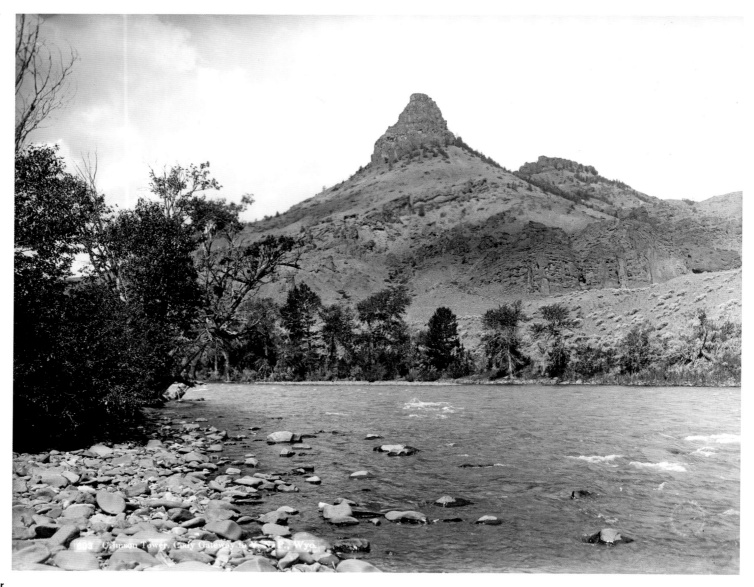

8. #603 **Crimson Tower**

GPS coordinates: 44 27.890n, 109 31.149w

Stimson called this view Crimson Tower, but current maps indicate its name as Signal Peak. It is located north of both the North Fork and the Cody Road just beyond the eastern edge of Shoshone National Forest. My view is back from the river because the trees along its banks shield the view but also because an irrigation canal now runs along the river's south side at this point and was too difficult to cross. This is also prime grizzly bear country, and there are warnings all over about crossing into brush. Although we did not see any bears at this site, when I uploaded the GPS coordinates to Google

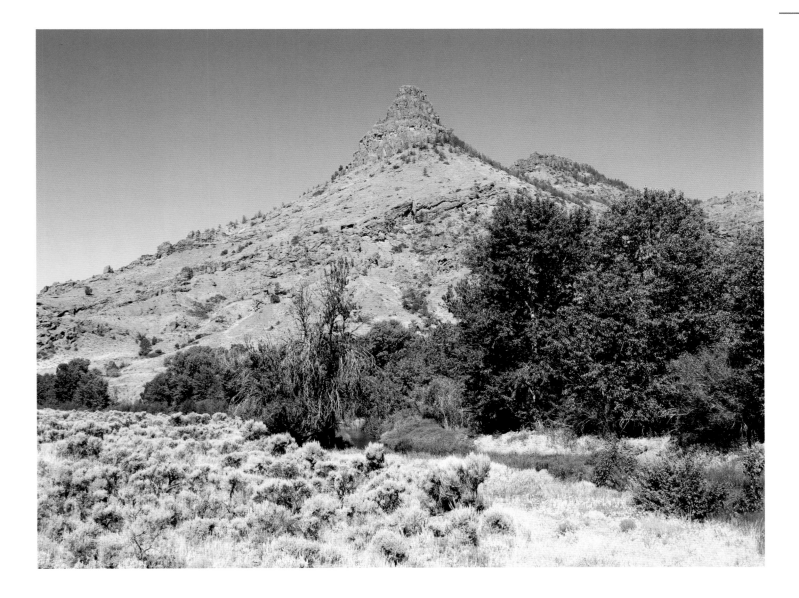

Earth for the first time, I noticed that Bigfoot sightings had been reported near this location. Alas, we saw neither bears nor Bigfoot when we rephotographed, although three playful river otters came swimming up the canal just as I was making my picture.

On the side of Signal Peak, specific rocks and small brush can be located in both views; but, as in most of these images, the lines of Shoshone National Forest and the North Absaroka Wilderness Area remain invisible on the landscape.

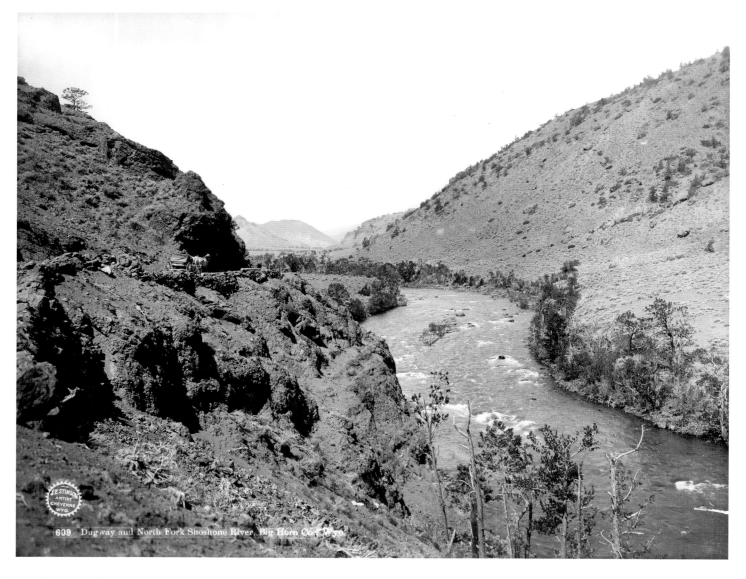

609 Dugway and North Fork Shoshone River, Big Horn Co., Wyo.

9. #609 Dugway and North Fork, Shoshone River

GPS coordinates: 44 27.624n, 109 32.310w

This view marks the entry to the eastern edge of the Shoshone National Forest (called the Yellowstone Forest Reserve when Stimson photographed it) and thus the beginning of the federal road designed by Hiram Martin Chittenden and his Army Corps of Engineers. Tellingly, except for the view of Irma Post Office, it is also the first of many in which Stimson included the road as well as Fred Chase, his two white horses, and their buggy. The "dugway" to which Stimson refers is simply a road cut or dug from a hill. In this case, the engineers dug their road from solid rock on the south side of the Shoshone. Just past this dugway is the formation known as Laughing Pig. A

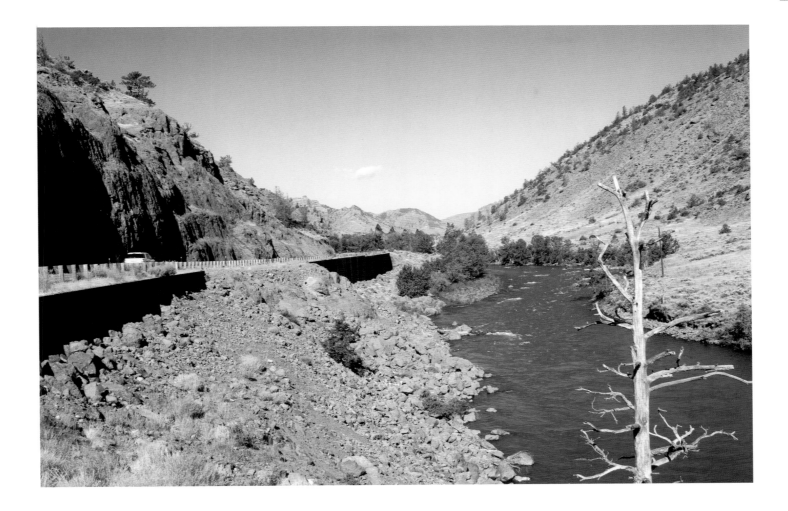

close look at the original reveals timber guardrails alongside the road. Stimson labeled his image as located in Big Horn County because Park County was not created until 1909.

The modern view shows a similar but more extensive dugway, with a guardrail made from vertical log posts. A closer look reveals that, although the wide modern highway has required blasting away a part of the hill that has opened the view further upriver, the evergreen tree atop it remains, albeit somewhat fuller. To the right, the course of the Shoshone, its scant riparian vegetation, and the hillside trees appear very similar. A close look to the right of the river also reveals several telephone poles.

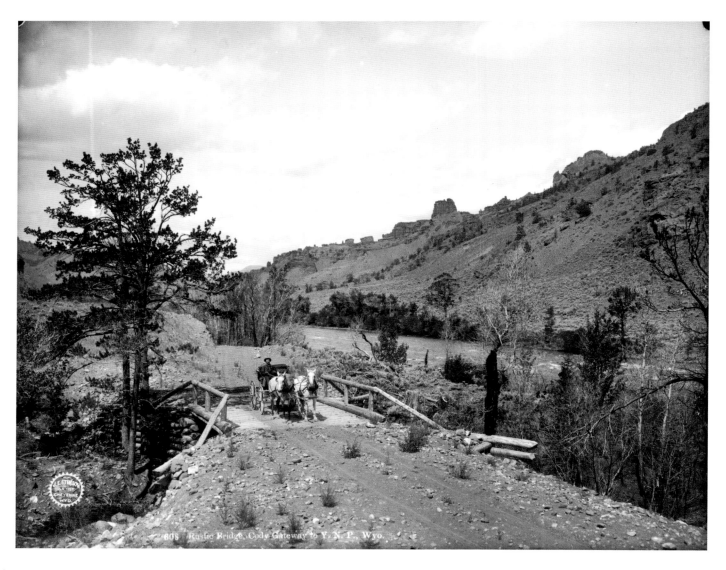

10. #608 **Rustic Bridge, Cody Gateway**

GPS coordinates: 44 27.597n, 109 33.141w

Stimson's description of this bridge built by the Army Corps of Engineers as "rustic" is interesting since it was less than a year old when he photographed it. Fred Chase and the team are pointed downriver toward Cody, as this view looks west across Nameit Creek. Although a few weeds pop up from the road in Stimson's view, the pole crib work and bridge hint at the reason many early travelers likened this portion of the road to a city boulevard. The Shoshone River cuts across the background, while the rock formations of the Holy City stand out on the far hill.

This is a classic Stimson composition, with the hill to the right and the tree to the left framing the bridge, which in turn frames Fred Chase and the team. Even the clouds

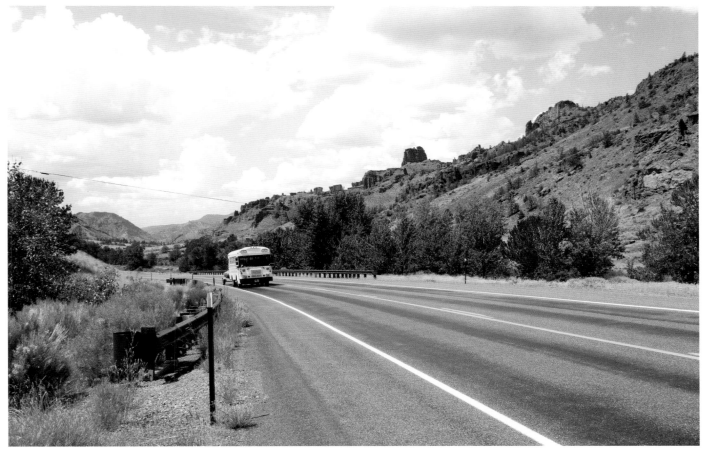

in the sky are visible—a difficult exposure with Stimson's glass plates, which were more sensitive to blue light, making most skies white.

The creek was supposedly given its unusual moniker when forms sent to the government for this little stream were filled in simply as "name it," suggesting that locals did not know what to call it and left it to the government to suggest a name. Government officials took the application literally and made it Nameit Creek.

A comparison of the background hills confirms this location, but the buildup of the modern road has changed the angle. The bridge has been replaced by a culvert. The trees along the Shoshone have thickened and several telephone/power lines cross the highway. The white bus pulls a trailer carrying an inflatable raft, hinting at the

recreational tourism that has now made the Cody Road not just a route to Yellowstone, but its own tourist destination. Just behind the modern vantage point is the driveway for Bill Cody Lodge. This historic ranch was once owned by Buffalo Bill's grandson, William Cody Garlow.

Hiram Martin Chittenden is famous for the Melan Arch Bridge, a type of steel-reinforced concrete arch bridge, which he constructed over the Yellowstone River near the Upper Falls in 1903. It was cutting-edge bridgework for its time and is now simply known as the "Chittenden Bridge." One has to love the fact that at about the same time he was also designing this pole bridge, which Stimson called "rustic," over an unnamed stream now called Nameit Creek.

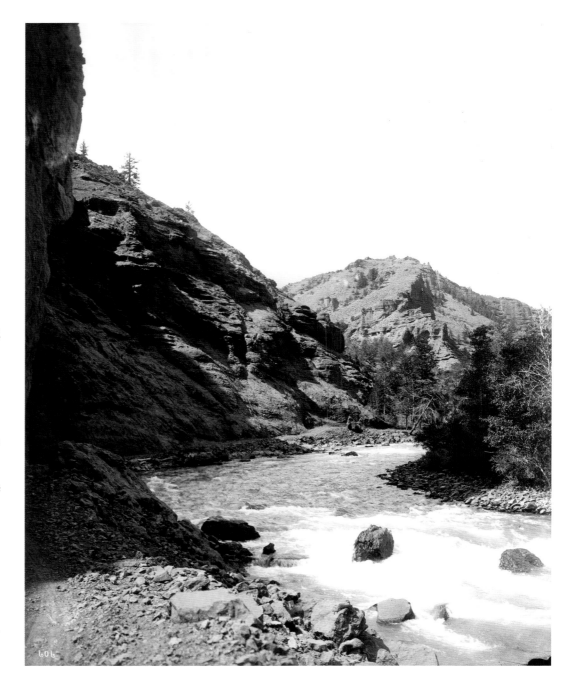

11. #606 **Roadway and North Fork, Shoshone River**

GPS coordinates: 44 27.574n, 109 33.594w

This view shows the Thousand Foot Cliff, or Hanging Cliff, framing the left side of the shot. This sheer wall was described in all the early guidebooks to the Cody Road. In Stimson's view, the army's road loops around the base of the cliff, along the hills, and then disappears into the brush at the center. This is another classic composition in which the cliff, the road, and the river all work together to lead the viewer's eye through the photograph.

To make my rephotograph, my uncle knew this was the spot to start. But the sense of the cliff made us begin the process at its base, on the far side of the modern road. A look at the "live view" display on the camera told me that we needed to move out into the road. We began inching into the east-bound lane, but the far hillsides told me that I had to move farther out to the middle of the road, then to the west-bound lane, then to its far shoulder, and finally across the shoulder and down toward the river.

In comparing the two photographs, one instantly notes that the profile of the cliff against the sky reveals two small rock outcroppings. Moving along, several of the same trees and groves appear on the far hillsides. The modern highway is wider and more built up, but it still follows the route of the original road. Although it appears that the river runs beneath the bridge, it actually flows hard into this bend and the protective riprap below the road.

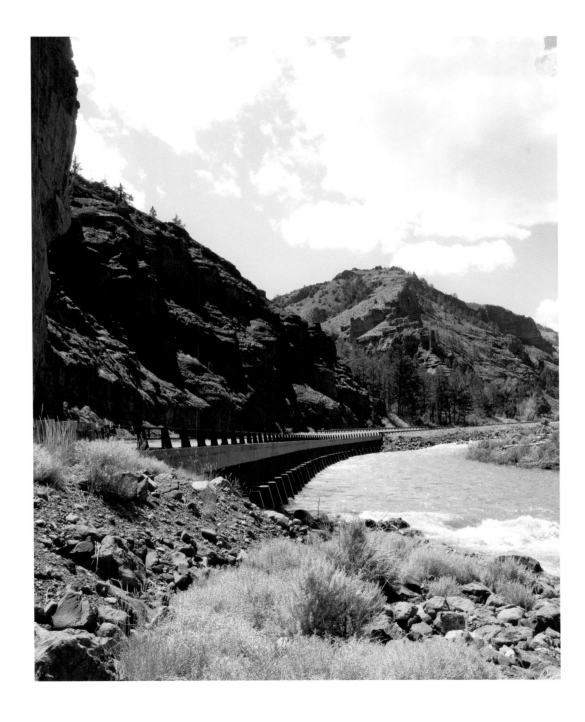

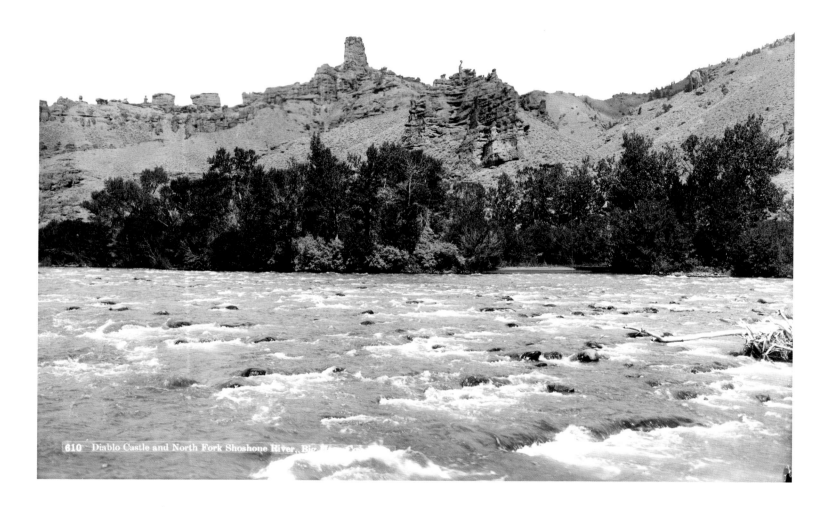

610 Diablo Castle and North Fork Shoshone River, Big

12. #610 Diablo Castle and North Fork, Shoshone River

GPS coordinates: 44 27.617n, 109 34.028w

This is another view where it would have been impossible to photograph exactly from Stimson's vantage point because of the tree growth. After walking down to the riverbank, I determined to move back to where I could see the rock formations now called the Holy City. Each rock along the hill can be picked out in the modern view.

The Cody Road cuts through the Absaroka Volcanic Field. This unique rock formation, named Diablo Castle—one of more than forty with specific names—was created through the erosional forces of wind, water, and freezing/thawing. A parking area and informational marker are just to the left of the vantage point.

I rephotographed this formation in 1988 as part of my book *Wyoming Time and Again*. Since that time, the sagebrush and the trees have thickened considerably.

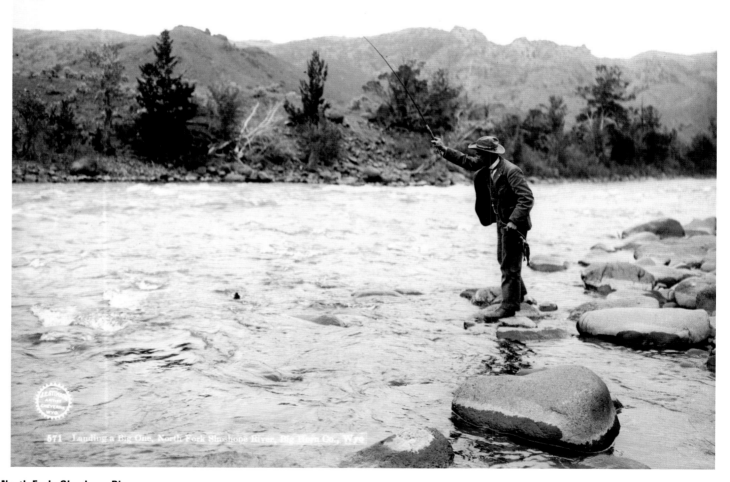

571 Landing a Big One, North Fork Shoshone River, Big Horn Co., Wyo

13. #571 **Landing a big one, North Fork, Shoshone River**

GPS coordinates: 44 27.7163n, 109 35.9036w

J. E. Stimson loved to fish. His photo collection has several images of him angling and a favorite view of his early car loaded to the gills as he prepared for such an outing. The few brief newspaper articles about his trip up the Cody Road mention fishing on Sylvan Lake. This view of the photographer, with necktie, hat, and string of fish, is labeled "Landing a big one" and must have been taken by Fred Chase. In comparing this picture with the following one of Chase "Fishing on North Fork, Shoshone River,"

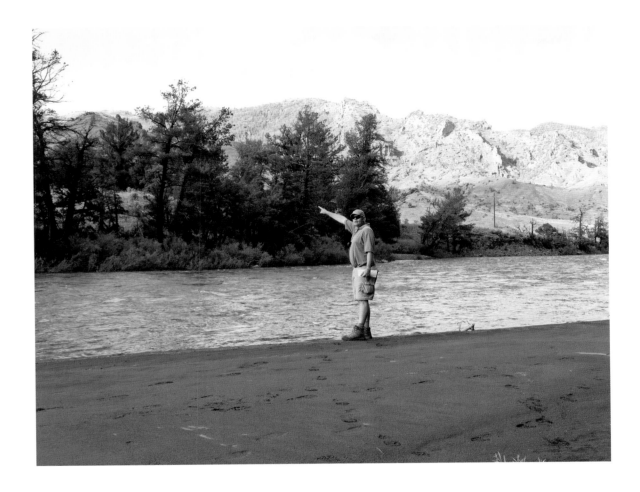

taken by Stimson, one quickly determines that the same pole and fish were probably exchanged between subjects and that the photographer tweaked the settings of his camera on the next image to bring the background into sharper focus.

Reaching the vantage point involved walking through brush down to the riverbank. Such activity is always scary in bear country and was made worse because my aunt and uncle had told us several times that they had seen a large grizzly bear swimming across the river at this very point. Once there, we quickly lined up the far horizon as best we could—the foreground sandbar is obviously very different from the rocks in the original view—and staged our shots. For the one with Stimson as subject, Lauren snapped the picture of me, pointing into the distance to simulate the artist's fishing pole. My outfit of polo shirt, cargo shorts, ball cap, and wraparound Oakley sunglasses on my six-foot nine-inch frame clearly identifies this photo as early twenty-first century, as much as the original with Stimson's hat, coat, vest, and necktie marks the first decade of the twentieth century. The ubiquitous power pole can also be seen across the river to the right.

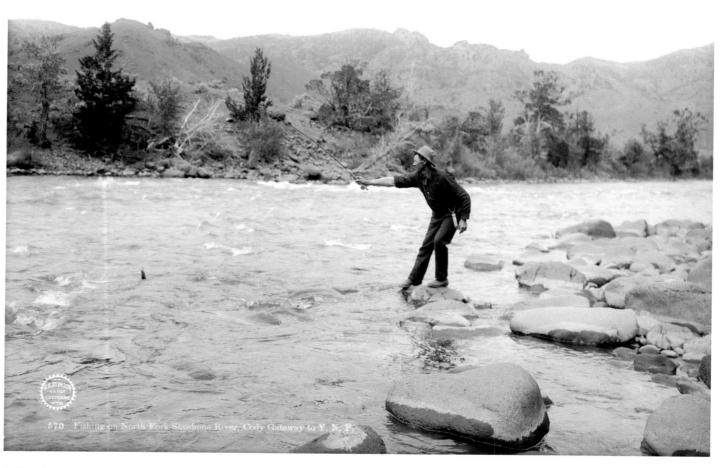

570 Fishing on North Fork Shoshone River, Cody Gateway to Y. N. P.

14. #570 Fishing on North Fork, Shoshone River

GPS coordinates: 44 27.7163n, 109 35.9036w

After snapping the photo of me substituting for Stimson, Lauren and I noticed that a lone fisherman had wandered down the river to our location. I talked with him about our rephotography project, and he graciously agreed to pose for us while he continued to work his fly rod. On vacation from South Dakota, he said he had not had as much luck as Stimson had a century earlier. With his boots and fishing gear, he certainly reflected his era as well. We began to joke that it was too bad he could not accurately duplicate the original photo by catching a fish. Then, a moment later, he did!

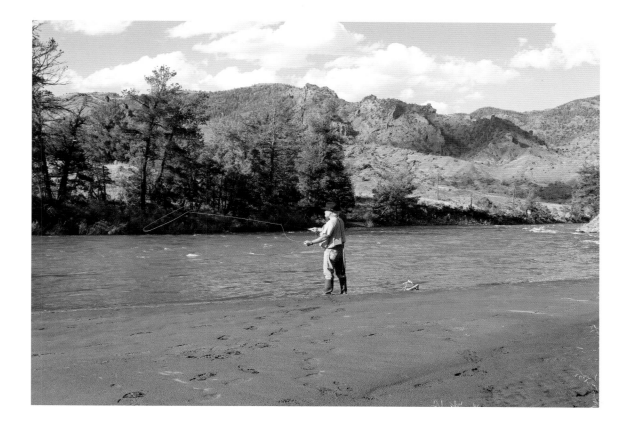

We had a good laugh and wondered about the magic of rephotography as he pulled the fish in and then released it back downstream.

Only later did I think more about what kind of fish each man had caught and what that might mean. According to Yellowstone National Park fisheries biologist Todd Koel, when J. E. Stimson fished the North Fork of the Shoshone in 1903, there was a 100 percent chance that he would have caught a Yellowstone Cutthroat Trout because they were the only fish in the river. When our South Dakota fisherman landed his fish in 2008, there was only a 20 percent chance that that fish was a native Yellowstone Cutthroat. More likely, there was an 80 percent chance that his fish was a non-native lake trout such as a rainbow trout that had been stocked or a rainbow/

Yellowstone hybrid derived from stocked fish that had swum upstream from Buffalo Bill Reservoir. According to Koel, these lake trout have no natural enemies, swim deeper and thus avoid birds and bears, live longer, and basically push out the native Yellowstone Cutthroats. Because rivers in Wyoming and Montana such as the North Fork of the Shoshone are part of the native trout's last stronghold, the National Park Service in Yellowstone has begun a Native Fish Conservation Plan to conserve native fish populations.

Rephotographic pairs are often more than just two before-and-after images. As in these images, they serve as a type of X-ray, exposing the cultural and environmental attitudes that linger just beneath the surface of the photographs.

577 Scene on Cody Gateway to Y. N. P., Big Horn Co., Wyo.

15. #577 **Scene on Cody Gateway**

GPS coordinates: 44 27.862n, 109 37.592w

This view of the spot where Sweetwater Creek empties into the Shoshone River is one of the few Stimson took in the national forest or Yellowstone Park *from* the Cody Road rather than *of* the Cody Road. Instead, it looks to the north toward Sunlight Peak in the Absaroka Range. My view is taken from a hill just south of the current highway so the foreground trees do not obscure the view. America's oldest Forest Ranger Station is located just to the right of the modern view.

578 Cody Gateway to Yellowstone National Park, Big Horn Co., Wyo.

16. #575 **Cody Gateway**

GPS coordinates: 44 28.063n, 109 38.289w

After looking north, Stimson immediately refocused on the Cody Road. This view looks west, seemingly above the river but actually from a river bend. Although individual pine trees can still be seen on the hillside in the modern view, the brush on the riverbank has thinned considerably. Note as well in the modern photo, and several others, the efforts made to place large boulders on the river's bank to protect the current highway from being eroded away by spring floods. Such rocks are a visual reminder that the North Fork is a free-flowing river from its source to Buffalo Bill Dam and Reservoir.

605 Pastoral Scene, Cody Gateway to Y. N. P., Wyo.

17. #605 **Pastoral scene**

GPS coordinates: 44 27.955n, 109 39.309w

Just past the last vantage point and before the Shoshone crosses over from the north to the south side of the Cody Road, the valley opens into a wide green pasture. Stimson labeled his view of this small cattle herd simply "Pastoral Scene." When Lauren and I decided that this area was the right location for my rephotograph, we figured to spend perhaps thirty minutes locating the right spot. We could easily line up the rock formations on the distant hills but could not get the bigger of the small hills on the left side at the end of the pasture to line up against the dark mountain at the left. We tried

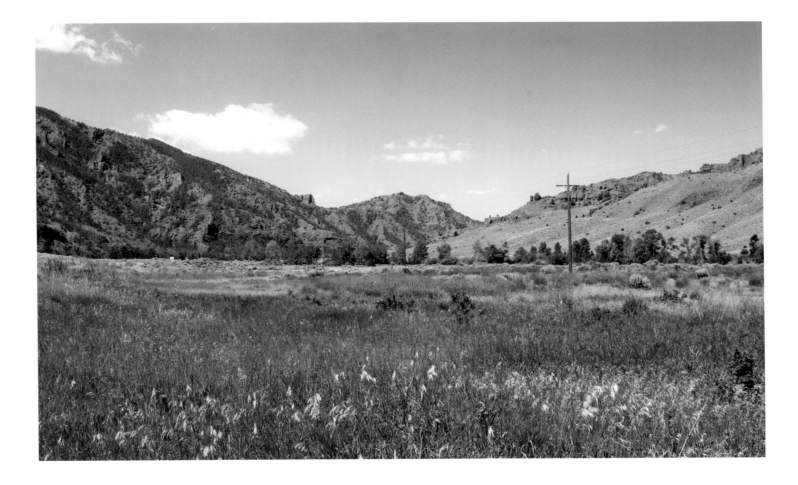

one spot, made photographs, looked at them on the camera screen, and then moved on to another. We started on the south side of the road, moved up and down its shoulder, then crossed over to the north side where we again moved up and down its shoulder and then eventually into the meadow. We lined up the rephotograph according to the place where the small rock outcroppings on the hills on the right bisected the right-hand slope of the distant mountain. But those small hills to the left still did not look right. Leaving my tripod in place, I walked back to the road, and as I looked again it hit me: the construction of the modern road had removed one of the hills. Once I lined up the view by considering what was missing, it all made sense and the rephotograph was made. It had taken only three hours.

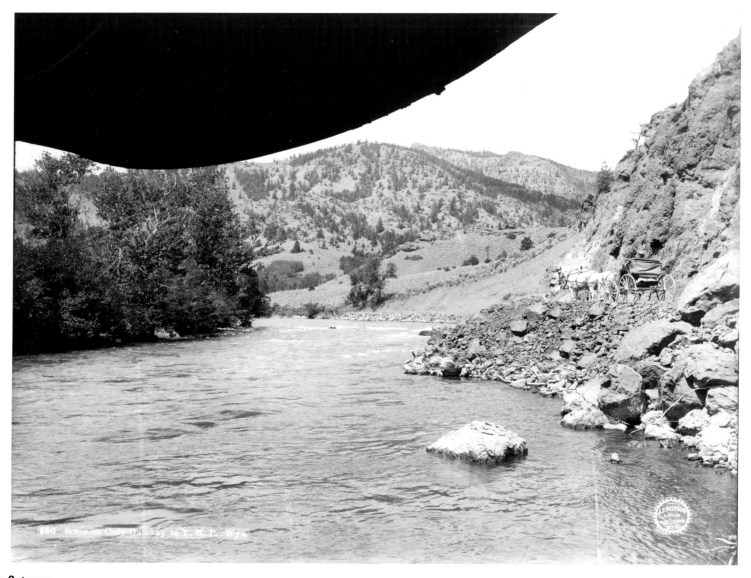

18. #580 **Scene on Cody Gateway**

GPS coordinates: 44 28.007n, 109 41.625w

No, that's not the Death Star descending onto the North Fork in Stimson's photograph. As discussed earlier, when J. E. Stimson made his photograph, professional photographers' preferred medium was not the flexible film of the mass-market Kodak but rather 8×10-inch sheets of glass containing dry, light-sensitive emulsion. This photograph has cracked, with part of it broken off and lost. Fortunately, my rephotograph confirms that only a slight piece of the very top of the hill has been lost, unless that mothership was indeed floating in the sky of the lost piece! Seriously, though,

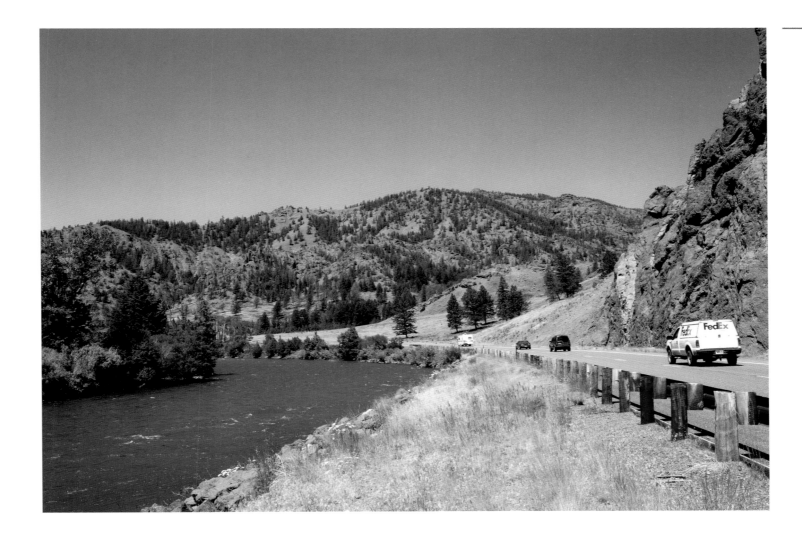

the fact that my photo was made on a digital camera using a postage-stamp–sized memory card with storage capacity for over 100 high-quality RAW images while Stimson had to carry enough fragile glass plates with him to make his views and then carry them back to Cheyenne reminds us of the marvels of the digital photography revolution.

As in so many other comparisons, we again see a classic Stimson composition in which the Cody Road is not only present but was placed by the photographer so that

Fred Chase and his team of white horses lead the viewer into the picture. Past the horses, we can see how the North Fork eroded the hillside as it curved toward Stimson's vantage point and how the modern road has filled in part of this erosion just to the right of the SUV. Pine trees have spread through the center of the photo, while small groves appear identical on the background hillsides. The FedEx truck traveling toward Yellowstone reminds us that, even on such a road, the world is never far away.

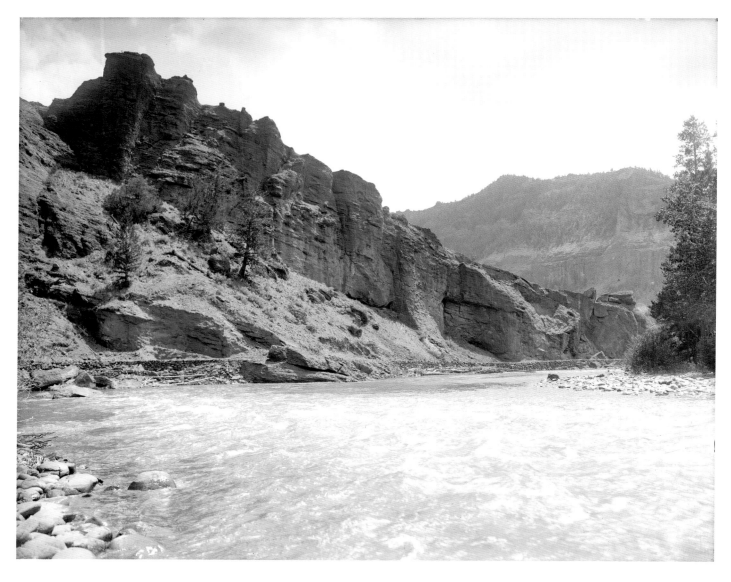

19. #578 **Canyon scene**

GPS coordinates: 44 27.678n, 109 44.220w

This view looks downriver at Mummy Cave, to the right of this exposed rocky hill. Here the North Fork comes in from behind the vantage point and makes a ninety-degree turn to the right around this hill. When Stimson photographed the site in July 1903, the Cody Road followed the north side of the river, coming into view at the right side of the photograph and running along the base of the hill, across the photograph, then turning and coming straight toward the camera position just off the left side of the image. It then continued along the north side of the river.

Today, two bridges have redirected the road so it now spans the North Fork just to the right of the modern scene, goes a couple of hundred yards, and then crosses the river

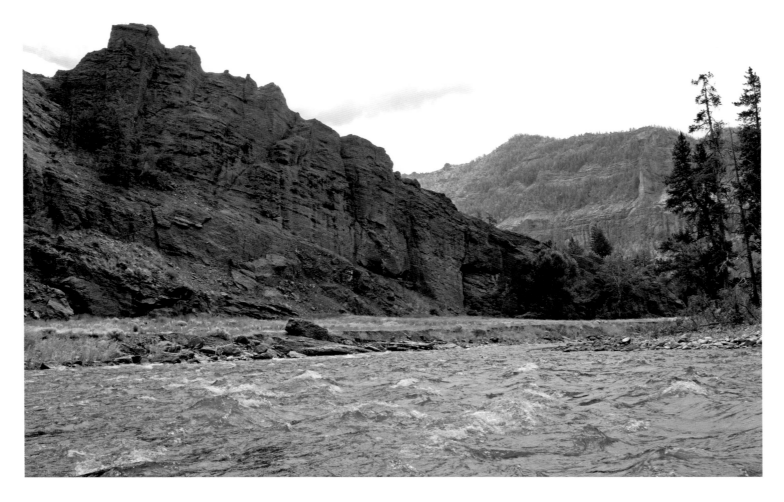

again to rejoin the original route. Think of the old road as following a horseshoe while the new road bisects it. To obtain the proper angle for this view, I had to abandon the tripod and shoot it by hand, kneeling on a small tuft of grass a foot from the river and about six inches off the ground.

Unbeknownst to Stimson, within his photograph a cave located in a rock alcove was carved out by the North Fork. Archaeologists excavated it from 1963 to 1966, more than six decades after Stimson made his photograph, discovering thirty-eight occupation levels from around 10,000 years ago to about 1600 CE. Many preserved

perishable artifacts such as cordage, netting, and coiled basketry were discovered. The cave also contained the remains of sheep, antelope, rabbit, marmot, grouse, porcupine, and other species from a hunt that took place almost 10,000 years ago. In addition, scientists discovered a male mummy approximately 1,000 to 1,300 years old, along with other artifacts that reveal eleven different earlier cultures. The cave has greatly expanded our understanding of the prehistoric Mountain West.

The cave has since been sealed with a protective barrier. The redirection of the road from its opening to the new bridges will also protect it.

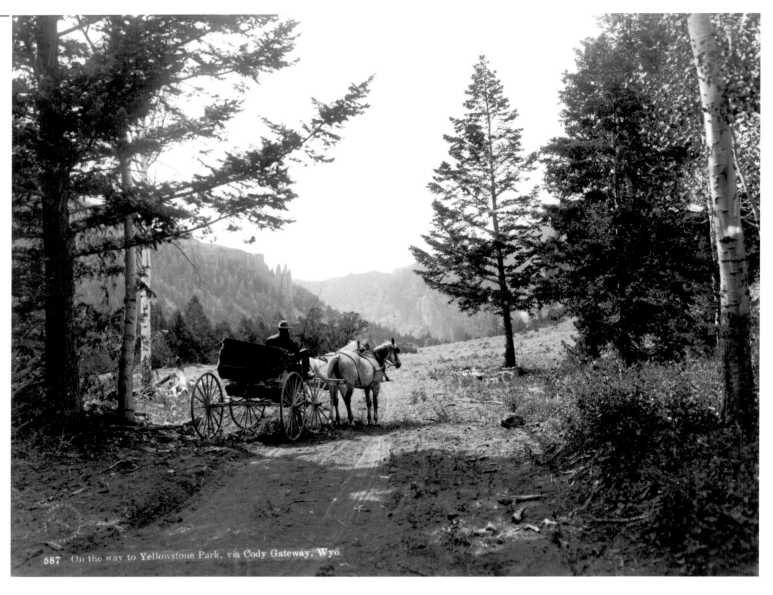

587 On the way to Yellowstone Park, via Cody Gateway, Wyo.

20. #587 **On the way to Yellowstone Park**

GPS coordinates: 44 27.23183n, 109 45.6173w

I have had a framed 16×20-inch print of this view hanging in my house since 1988. It is the first of four Stimson made in the vicinity of Sentinel Rock, the large rock formation on the right in the modern view but occluded from view by trees in the original image. Another classic Stimson composition, this view looks west to the silhouetted spires along the North Fork. Stimson framed the picture with trees to the left and right and shadows along the foreground. Fred Chase, his wagon, and his two

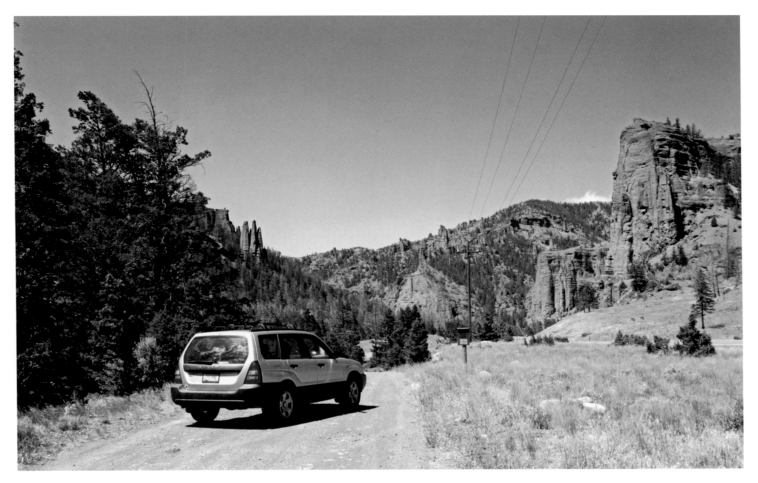

white horses are not only situated in the sun but are also slightly askew on the road so they help lead the viewer into the center of the composition and down the road to Yellowstone. One can count only a handful of tire marks in the soft dirt. Further into the image, dark pine trees and the darkened hill with the spires contrast with the lighter hillside behind it, giving the entire composition a great sense of depth. The nearness of the wagon makes it appear comparatively larger in the landscape, suggesting the power of humankind over nature in building this road to Wonderland. The caption, "On the way to Yellowstone Park," hints that the distance to Wonderland is nearing.

We struggled in our attempt to match this view. Its location is just west of the Newton Creek campground and just southeast of Sentinel Rock. As we moved about the vicinity trying to match up the spires against their hill and the slight rises against the back hill, we kept wondering why we were not seeing Sentinel Rock in Stimson's view. Could we see light through the aspen leaves at the right side of his image? Could these trees have blocked out that entire hill? There were large aspen tree stumps in the grass to the right of the road near the bear warning sign. In addition, the grassy hill further back had clearly been cut to allow the modern road to pass through. Finally satisfied that we were close, we parked our Subaru Forester with its 165-horsepower capability near the location where Fred Chase was parked with his 2-horsepower buggy and took the photo. A framed 13×19-inch color print of it now hangs next to my Stimson print above the desk at which I am writing this.

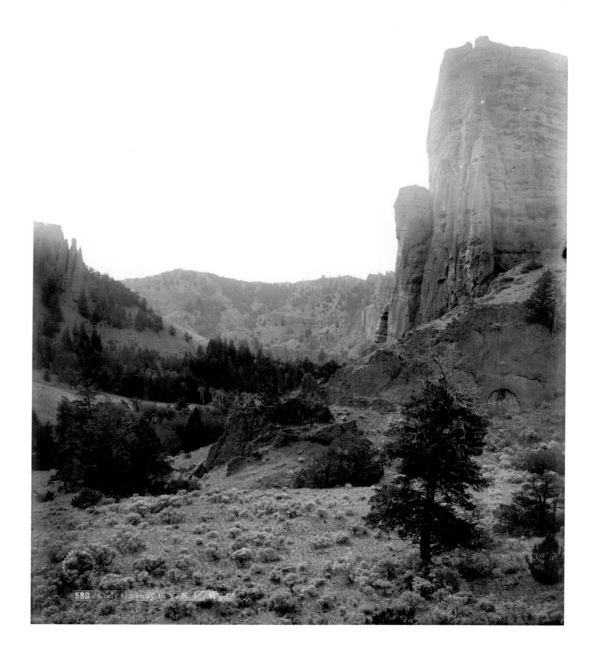

582 Cody Gateway to Y. N. P. Wyo.

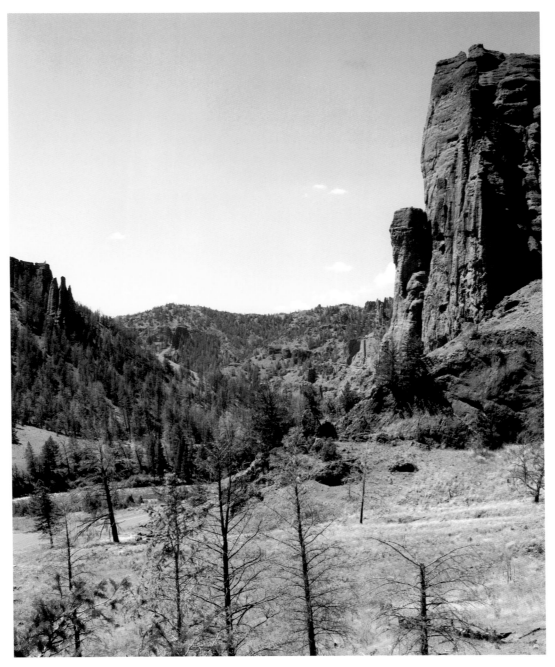

21. #582 Cody Gateway to YNP

GPS coordinates: 44 27.338n, 109 45.738w

Stimson's second vantage point for Sentinel Rock was easy to find; I just did not want to get to it. About a quarter mile west of the last vantage point is a parking pullout. After leaving the car there, I loaded up my usual assortment of gear—including a large camera bag with two camera bodies, four lenses, memory cards, batteries, chargers, plus a metal tripod with carrying bag and a copy of Stimson's photograph—and crossed the modern highway (just visible in the modern photo at the left base of the hill) into the small wooded meadow just east of Sentinel Rock. I set up the camera and started backing toward a small rocky ridge on the steep hill behind me. Not seeing the angle I expected, I looked back toward that ridge and noticed a small break in it about thirty feet up the slope. I knew that that had to be the vantage point, but I did not want to climb up there with everything I had to carry. I knew from my larger Wyoming project that Stimson liked to climb up on objects such as water towers and buildings to get better views for his photos. So I added the GPS unit to my load, used the tripod as a sort of walking stick, and climbed up to the location. It was about five feet across and very uneven, but it was clearly the spot. The view to the west simply opened up as Stimson's image. The little notch at the top against the sky and the smaller rock column in relation to the spires across the valley confirmed it. I set up the camera, balanced myself, and made the photo.

A comparison of the two images further reveals that the evergreens on the far hill have thickened considerably, while those along the river have done just the opposite. The trees in the foreground appear to have burned.

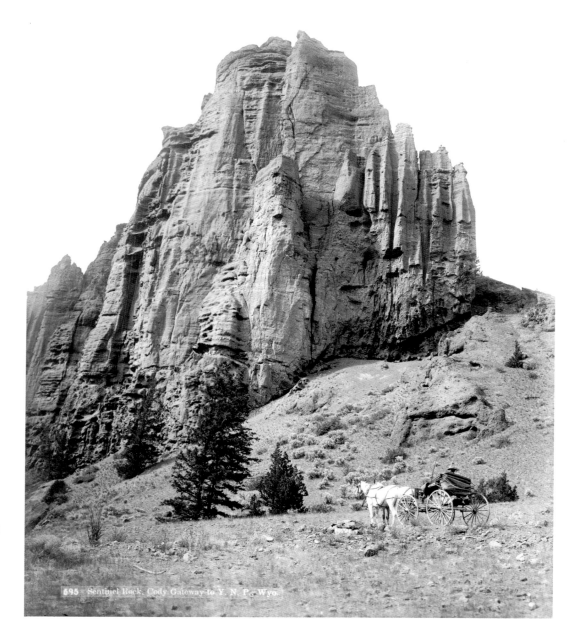

595 - Sentinel Rock, Cody Gateway to Y. N. P., Wyo.

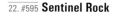 **22. #595 Sentinel Rock**

GPS coordinates: 44 27.3175n, 109 45.838w

Stimson's third view of Sentinel Rock is another classic composition, with the rock filling his camera's frame and silhouetted against the sky. He has again placed Fred Chase and the buggy on the road at the right, leading the viewer not only into his photograph but into Yellowstone as well.

My modern view shows the extensive excavation done for the modern two-lane paved road as well as a car speeding to the park.

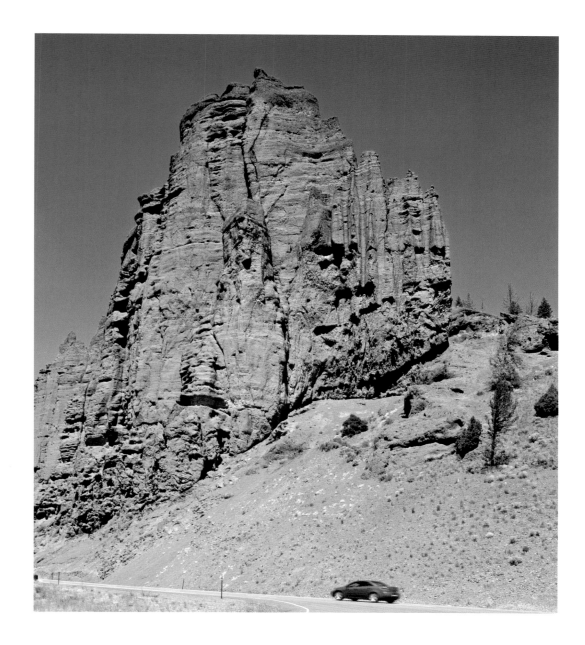

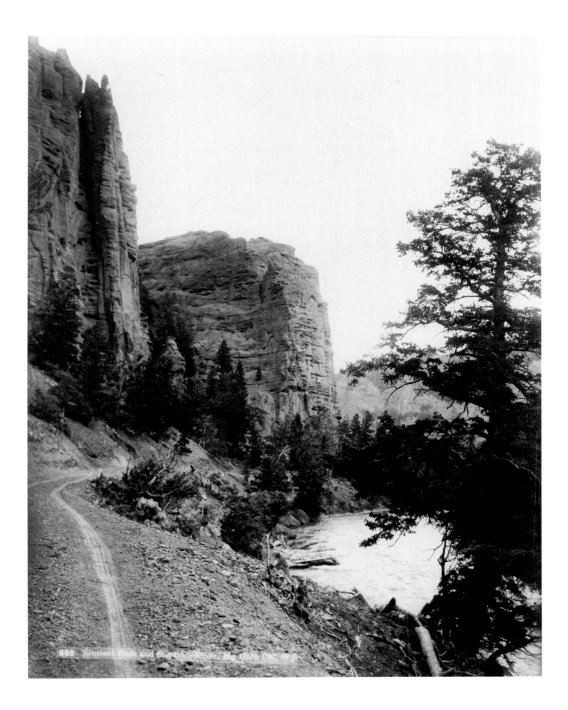

23. #598 Sentinel Rock and Shoshone River

GPS coordinates: 44 27.52383n, 109 46.10534w

For his fourth view of Sentinel Rock, Stimson had proceeded about a third of a mile along the road toward the park and was looking back downstream to Sentinel Rock at center. This location is just below the area known as the Palisades for the high cliffs on the north side of the river. Stimson again expertly composed his view by placing the curving river and road between the cliffs and the tree at right.

The large tree is gone in the modern view, but the guardrail and the beautiful afternoon light have a similar positive effect on the photo's composition. It is also a rare view in that no cars can be seen on the highway. Whether it's that sense of solitude or the soft light, the beautiful cliffs, or those two rabbit-ear–like rocks atop the cliff, this is one of my favorite pairs of images.

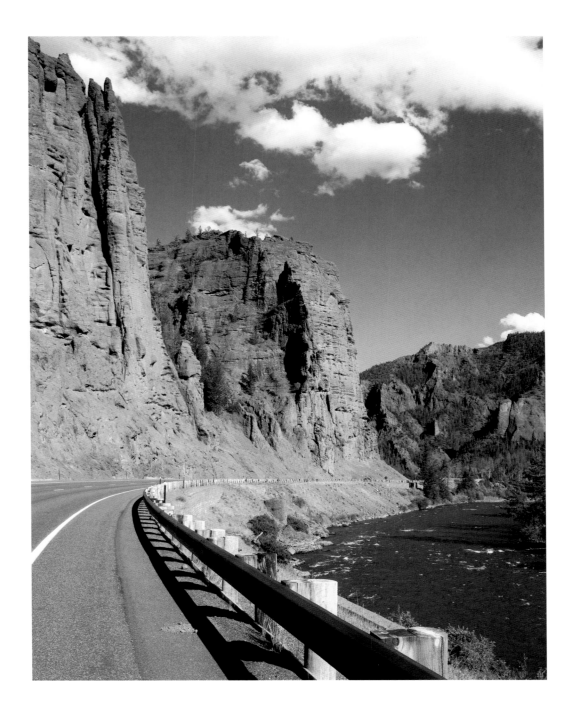

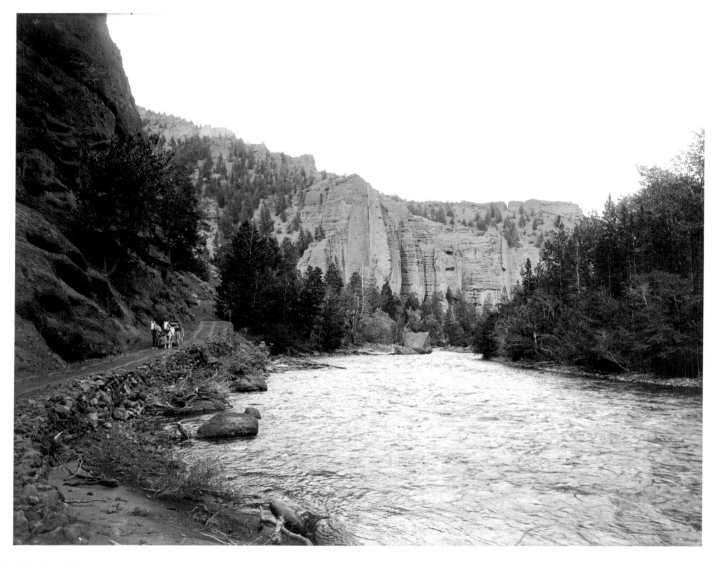

24. #596 Canyon and North Fork, Shoshone River

GPS coordinates: 44 27.451n, 109 46.627w

This next view was taken about a half-mile upstream from the last one and is again looking back downstream at a group of rocky cliffs known as the Palisades or Cathedral Rocks. At the far right of the formation, hidden behind the hill, is Sentinel Rock from the previous photos. The large boulder in the river is very distinct and can be seen not only in the many photos of the Palisades taken over the years but also on current satellite images such as Google Earth.

Stimson had hiked ahead of the team and placed them looking directly at the camera toward the park, on the road that winds around the left side of the image. Compared with image 587 (#20, four photos back), in which he placed his conveyance

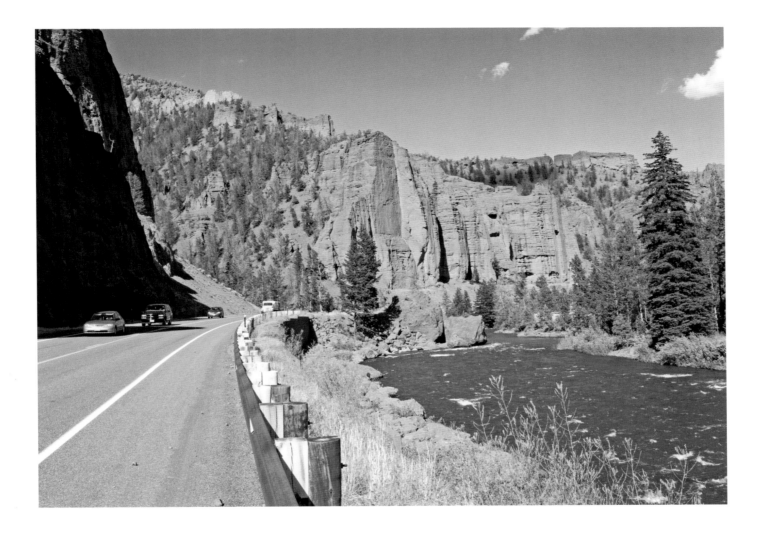

very near to him and thus larger in comparison to the scenery, here they are further back and seem comparatively small in the landscape. The effect is one of the sublime, of the overwhelming power of nature and God as expressed in the Cathedral Rocks over the smallness of humankind.

In comparing the two images, the widening of the road plus the added protection along the riverbank are the most obvious features. Many trees seem the same more than a century later, and the cliffs and the river still overpower the cars, continuing to provide that same sense of the sublime.

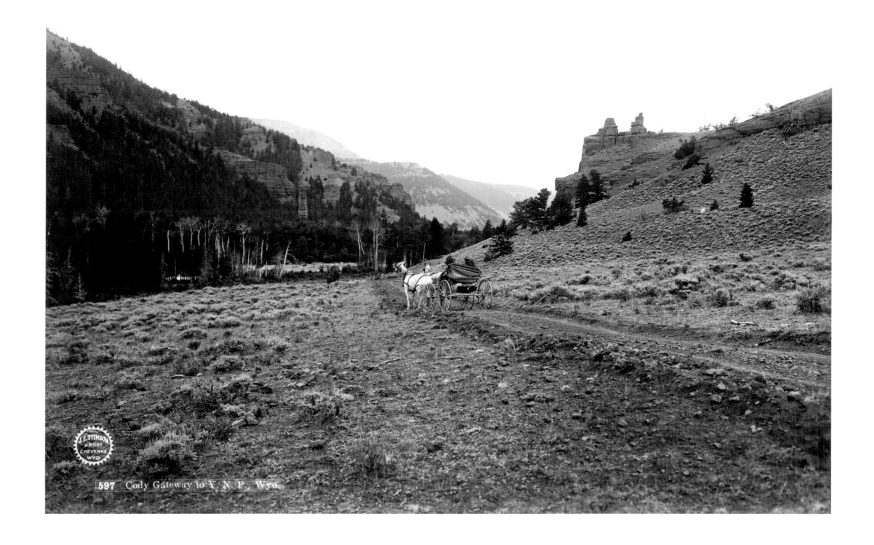

597 Cody Gateway to Y. N. P. Wyo.

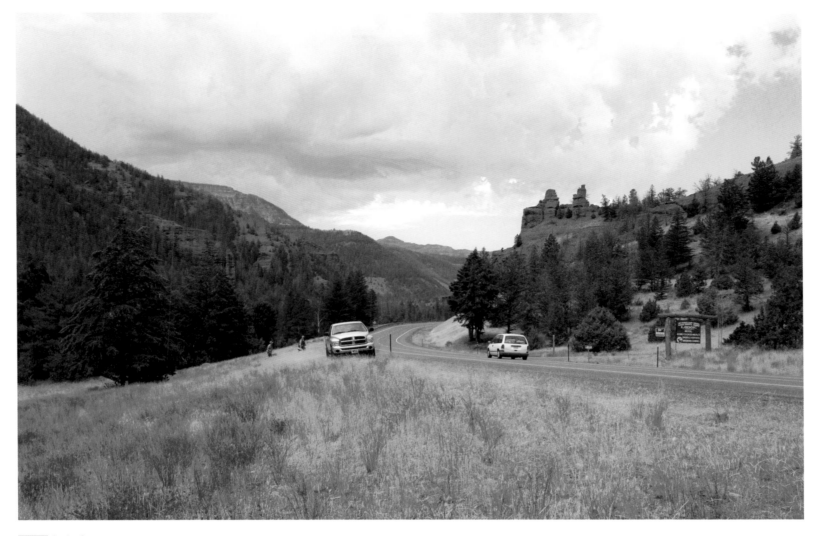

25. #597 Cody Gateway

GPS coordinates: 44 27.158n, 109 48.501w

We are nearing Yellowstone, and this view represents the last broad image of the road in the forest reserve. Once again, Stimson set up his camera so the road leads the viewer from right to center, and he positioned the team almost at that center so it feels as though we have traveled most of the road and are getting closer to the park.

This vantage point is just to the west of the rock formation known as Elephant Head (not visible), and in the modern view the sign for the Elephant Head Lodge, built in 1927, can be seen at the right mid-ground. The two rock formations on the right skyline easily identify the location. Note the expansion of evergreens on the hill to the right and along the river to the left.

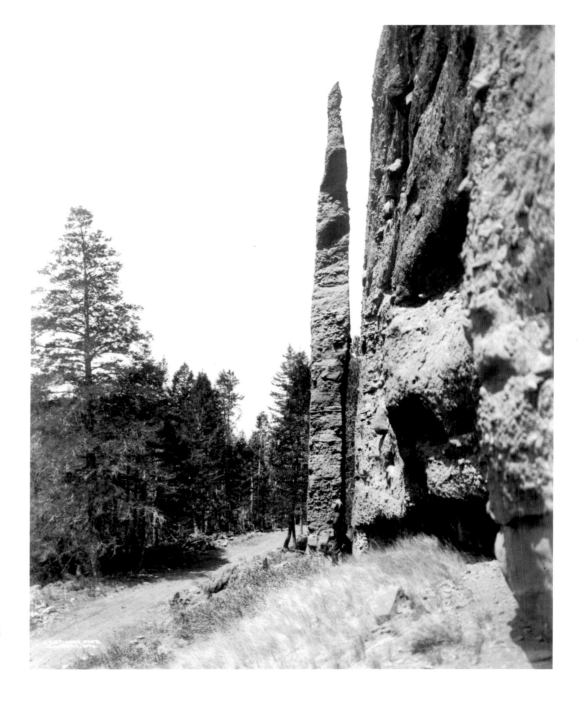

26. The "Needle," Cody Gateway

GPS coordinates: 44 27.24283n, 109 48.8415w

J. E. Stimson called this formation the "Needle," but most guidebooks label it "Chimney Rock." In 1903 the Cody Road passed just at the base of the formation, as can be seen in Stimson's view. Today, the modern highway passes about twenty yards further to the left. A close look reveals both of our traveling partners gazing up at the rock, Fred Chase in 1903 and Lauren in 2008. A large hand-colored print of this image hangs in the Cheyenne Masonic Lodge.

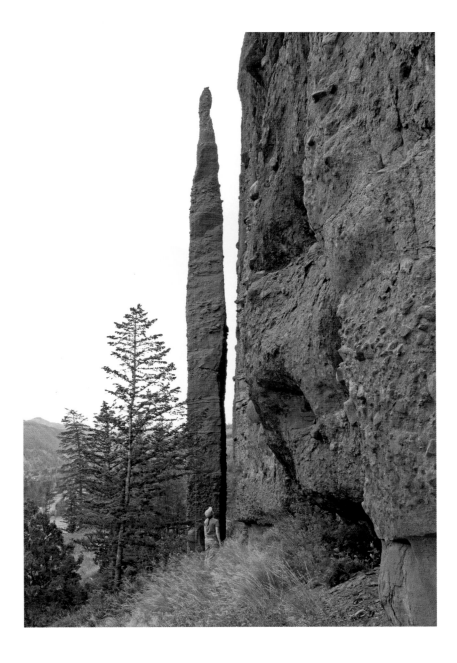

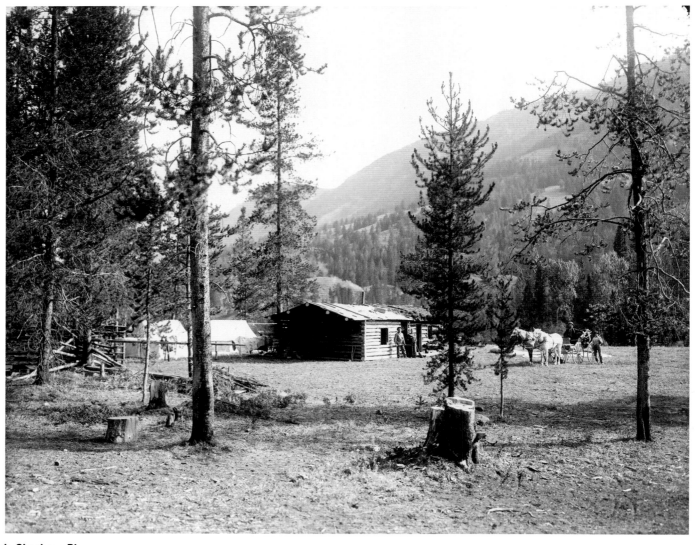

27. #574 **Baten's Cabin, North Fork, Shoshone River**

GPS coordinates: 44 30.159167n, 109 57.74783w

Sometimes a photograph is as important for what it does not show as for what it does show. This image looks northeast just north of the junction of the North and Middle Forks of the Shoshone River. The Cody Road has just crossed the North Fork for the last time as that branch turns toward its headwaters. The road instead heads west toward the park, now following the Middle Fork.

Stimson labeled his view "Baten's Cabin," but it should be "Braten's Cabin" for Walter Braten, who ran a livery stable in Cody. Together with Sam Berry, Braten operated this cabin as a "road ranch" for one season on the Cody Road.

About five months after Stimson took this photograph, Buffalo Bill Cody applied for a permit to build a hotel at a site just to the left of this view. The new inn would serve travelers along the Cody Road to Yellowstone, whose border was just three miles to the

west. The hotel's name is Pahaska Tepee, and construction began in 1904. It is a large log building and was completed and opened for business in 1905. It remains today as the oldest lodge on the Cody Highway and is on the National Register of Historic Places. But it was not there when Stimson traveled the road in late July 1903.

Today, the site of Braten's Cabin lies within the grounds of Pahaska Tepee. The tall tree behind the picnic table may very well be the tree at the back of Braten's Cabin. The original Pahaska Tepee building is just out of view to the left, and the tepee's trail horse corral is right behind this vantage point.

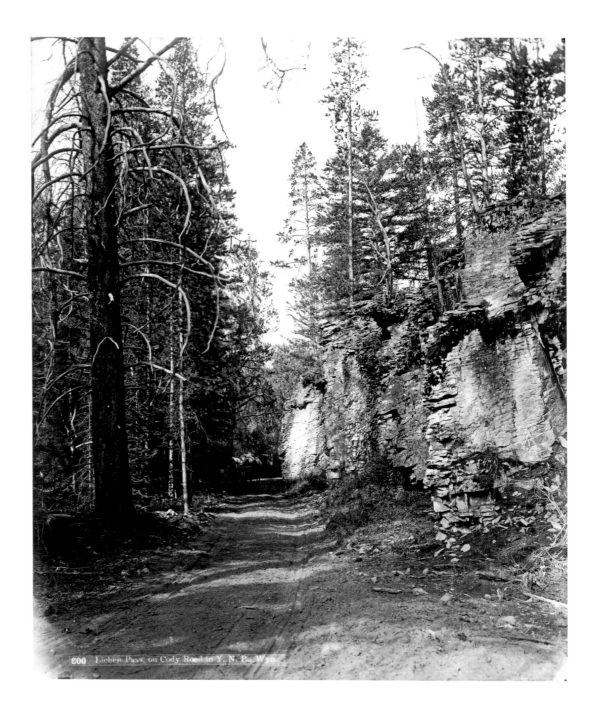

600 Lichen Pass, on Cody Road to Y. N. P., Wyo.

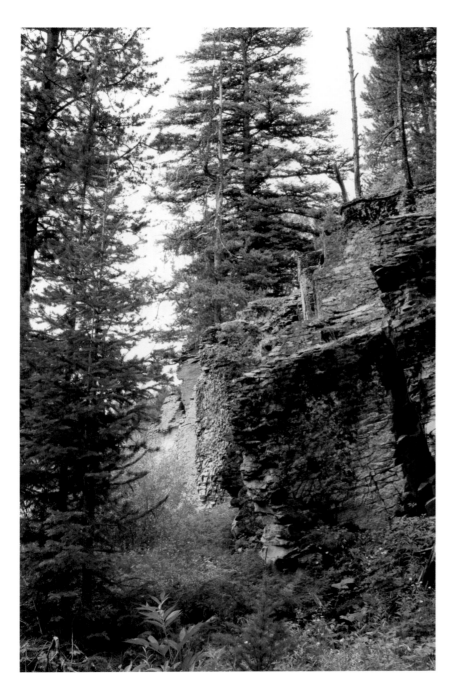

28. #600 **Lichen Pass on Cody Road to YNP**

GPS coordinates: 44 28.9315n, 110 1.468167w

Although Stimson labeled this view as *on* the Cody Road to Yellowstone, it is actually his first *inside* Yellowstone National Park and is located just within the East Entrance. The name "Lichen Pass" appears in none of the park's guidebooks. In fact, by most definitions that define a "pass" as a low spot in the mountains that can be traversed, it is hard to understand how this location is a "pass," as the Middle Fork of the Shoshone runs parallel to the entrance road here.

The only reference I have found is in Yellowstone National Park historian Lee Whittlesey's 2,000-page volume of park place names called *Wonderland Nomenclature*. According to Whittlesey, it is located about a mile west of the East Entrance "where rock walls are apparent to the north of the road." Whittlesey goes on to say that Lichen Pass, "if it can be so called, was named in or about 1903 by photographer J. E. Stimson or taken from local usage by him" when he made his image. He concludes that the name was apparently derived "from the presence of lichens growing on the rocks."

In 2008, I knew none of this information and doubted if I would ever find the location. Luckily, coming out of the park one afternoon, I noticed a rock outcropping very similar to the one in the picture just inside the East Entrance. We turned the car around and parked on the side of the road. As we walked into the woods a few feet, we could clearly see that the original road hugged much closer to this outcropping. Although the forest had closed in on the 1903 scene, we could still make out the formations. I made the rephotograph as cars zoomed by just ten feet away. The modern view was blocked by trees, so this angle is moved slightly.

As discussed in the history of the Cody Road, the concept of liminality is one whereby the normal rules of society do not seem to apply. For many Americans, Yellowstone represented this type of Wonderland, both because they were tourists on holiday and because the park's geysers, waterfalls, and canyons seemed completely otherworldly. As we shall see, as J. E. Stimson pushed into Yellowstone, place names became somewhat confused in his otherwise accurate photograph captions. Perhaps this was simply because he was in the middle of a very long and grueling photo assignment. Then again, perhaps Wonderland was starting to turn rock formations and lichen into mountain passes.

Lichen Pass represents one of those forgotten landscapes seemingly just out of sight. Several million people a year buzz past it and never stop. Perhaps because I know its secrets, this is one of my favorite rephotographic pairs.

29. #589 Middle Creek Canyon from Sylvan Pass

GPS coordinates: 44 27.78783n, 110 7.4483w

As with Stimson's view of Braten's Cabin, where Pahaska Tepee has now stood for over a century, this view down Middle Creek Canyon from Sylvan Pass became best-known after 1905 as the location of the famous Corkscrew Bridge that wound its way in a loop over itself to ease the steep ascent up Sylvan Pass. But when Stimson visited in July 1903, there was no Corkscrew Bridge; and by the time I rephotographed, that route had been bypassed for more than seven decades in favor of a new road higher up the mountain on the left side of this image. A close look at the original reveals the familiar Fred Chase along with his horses and buggy heading down the pass toward Cody. As in other images, Stimson had placed his conveyance far in the distance, decreasing its relative size and clearly giving a sense of the overwhelming power of nature in America's

first national park. As in other, similar compositions, this feeling of being overpowered by God's handiwork resonates with feelings of the sublime.

My vantage point is very close to the original, just to the side of the modern road at the top of Sylvan Pass. Warning signs and reports of grizzly bears in the vicinity that day kept me from venturing very far down the old road. Nevertheless, hints of the original road dot in and out of the valley floor, while the modern road clearly cuts higher across the hillside to the left. The loose rock for which Sylvan Pass is famous can also be seen on the left. At the back of the photo, the ridgeline above the Middle Fork is called the Beaverdam, and its snowfields and slide areas, despite fire and bark beetle damage, seem very similar to Stimson's view. The original road and the Corkscrew Bridge, further down the canyon, are hidden by the many trees. The view from Google Earth, however, clearly shows them both just below the current road.

30. #599 **Summit, Sylvan Pass**

GPS coordinates: 44 27.8155n, 110 7.4865w

The summit of Sylvan Pass has been both a famous place for visitors entering Yellowstone on the Cody Road and an infamous one in the battle to keep it free of snow for those same travelers. Recall that it was Hiram Martin Chittenden's decision to build the Cody Road through Sylvan Pass rather than nearby Jones Pass because Sylvan was 1,000 feet lower and "its scenic attractions [were] unsurpassed in any part of the mountains." At the same time, the engineer recognized that the route would be "excessively difficult" because of its steep grades and "immense obstacles." Early travelers such as Charles Heath in *Trial of a Trail* commented on the loose rock and the

snowfields atop the pass. Heath noted that more than 150 men were shoveling snow to keep it open when his wagon party passed through in July 1905.

Today, the pass is equally famous for the extreme efforts to keep it open for snowmobilers in winter by blasting away potential avalanches. To do this, the state of Wyoming has literally waged war on the pass, firing howitzer shells into the ice and snow. As I walked around the vicinity of my vantage point, I noticed a "Warning: Unexploded Shells" sign in the rocks near my feet. Then, just a month after the photo was made, the Wyoming governor asked the state legislature for money for a second howitzer to be stationed at Cody and brought up to the pass to help clear the snow and

ice. A Park County commissioner commented at the time that keeping Sylvan Pass open to snowmobile travel was vital to Cody's economy.

The pair of photographs hints at the complexities of Sylvan Pass. Stimson's view, with the road cutting between the piles of loose rock and snowfields, is almost abstract in its composition. The snowfield at the base of the background mountain seems strikingly familiar although small in the new photo. My rephotograph similarly shows the enormous amount of rock that has been taken from the site for snow removal and road work, and it makes one wonder if this is indeed the same location. It is. Take another look at the hillside, snowfields, and rock outcrops.

What confounds the two images is the loss of all the loose rock at the base of the far hill. In addition, the idea that resources in a national park would be *used* rather than *preserved* surprises most people. Indeed, just beyond this site and clearly visible on Google Earth is a construction site. But the gravel, snow, and ice are part of the bigger story on Sylvan Pass and are at the very heart of the seemingly contradictory National Park Service mission: to protect the resources of the parks while at the same time making them available to the public. The controversy is being fought all over the country, from high atop Sylvan Pass to my own state of Arizona, where debates over scenic flyovers and river raft trips compete with preservation of Grand Canyon National Park.

With so much going on at such an amazing and historic place, it is probably an understatement to conclude that Sylvan Pass is one of the most contested places both on the Cody Road and in the twenty-first–century American West.

584 Sylvan Pass, Y. N. P., Wyo.

31. #584 Sylvan Pass

GPS coordinates: 44 28.031n, 110 08.001w

Just as the previous view hints at the cultural conflict surrounding Sylvan Pass, this pair of photographs looking back eastward away from the park suggests some of the ecological impacts of the Cody Road. Road building has flattened the slopes along the road, no doubt affecting water flow. Native plants and trees have been removed, and the three cars chugging over the pass hint at increased noise and air pollution.

We tend to think of the sense of freedom and independence automobiles provide to allow us to explore Yellowstone. But as scientists suggest, roads can also lead to increased road kill, invasion of exotic plants and pests, habitat fragmentation, pollution, and, in the end, homogenized ecosystems and weakened global diversity. Indeed, roads may often lead to both intended destinations and unforeseen consequences.

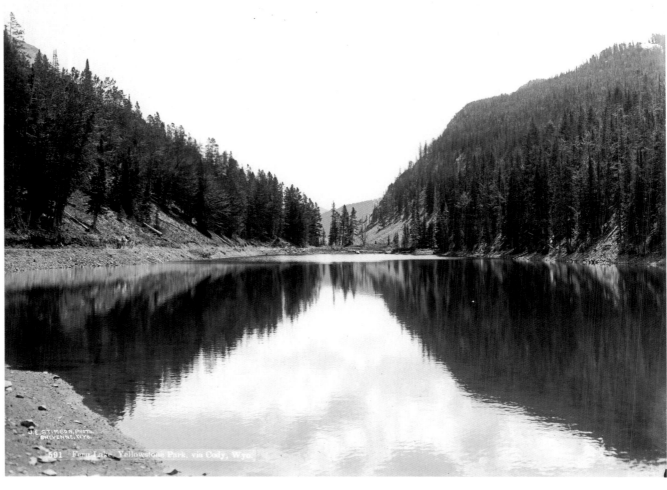

J.E. STIMSON, PHOTO
CHEYENNE, WYO.

591 Fern Lake, Yellowstone Park, via Cody, Wyo.

32. #591 Fern Lake (actually Eleanor Lake)

GPS coordinates: 44 28.225n, 110 08.529w

Less than a mile after crossing the sublime Sylvan Pass, the Cody Road brings travelers to picturesque Eleanor Lake, which Stimson called Fern Lake in 1903. Why Stimson was confused is not clear, as Hiram Martin Chittenden had named the lake in 1901 or 1902 for his daughter Eleanor as he was constructing the East Entrance. Perhaps, suggests Yellowstone Park historian Lee Whittlesey, Stimson simply made up the name. Then again, Stimson spent most of the summer and fall of 1903 traveling throughout Wyoming making photographs for the St. Louis Fair. When he returned to Cheyenne to develop his plates, perhaps he simply forgot or confused the name.

In his photograph, Stimson has moved his camera to the far western side of this little lake and is looking southeastward back toward Sylvan Pass. The Cody Road skirts the lake on the left side of the photograph, with Fred Chase and the team barely visible. The distant mountains are washed out because of Stimson's blue-sensitive photo plates. The most striking feature of the original photograph is the smooth lake and its stunning reflection of the surrounding forest and mountains.

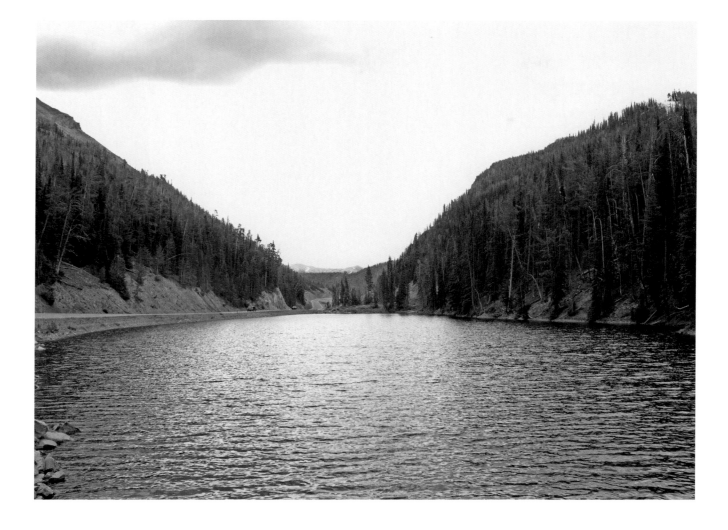

Although the weather did not cooperate to produce a similarly still lake when I was there, the hillsides and especially breaks in the forest canopy still line up. This is one of the few instances in which the modern road seems less built up than the one in Stimson's photograph.

At the start of this description, I used the term *picturesque* to describe Stimson's image compared with the *sublime* one of Sylvan Pass. The use of the terms is intentional. Although many people use them interchangeably, they have distinct meanings to students of landscape. The sublime suggests rugged raw nature and often incorporates the overpowering presence of God. But the picturesque should remind one of a landscape painting or a scene arranged by art, including showing the handiwork of a human intermingled with nature. Here, Stimson has done just that. By selecting a camera position at the center of the small lake and then angling his lens slightly upward to the far opposite shore, he uses the two dark converging hillsides set against a white sky, as well as their reflections in the calm waters, to frame the emergence of the Cody Road as it breaks from the wild of Sylvan Pass. In doing so, the image reassures viewers/travelers that the worst is behind them and that they are literally on the downhill path to Wonderland.

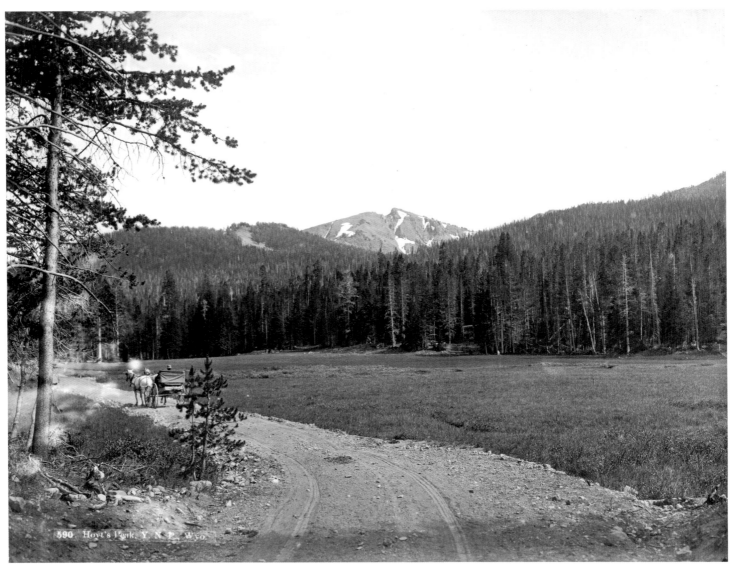

590. Hoyt's Peak, Y. N. P., Wyo.

33. #590 Hoyt's Peak (actually Top Notch)

GPS coordinates: 44 28.490167n, 110 9.4095w

Fresh off his misidentification of Eleanor Lake as Fern Lake, Stimson is also incorrect in calling this view Hoyt's Peak. The correct name of the mountain in view is Top Notch Peak. Hoyt's Peak is out of the camera's view to the left. This is probably

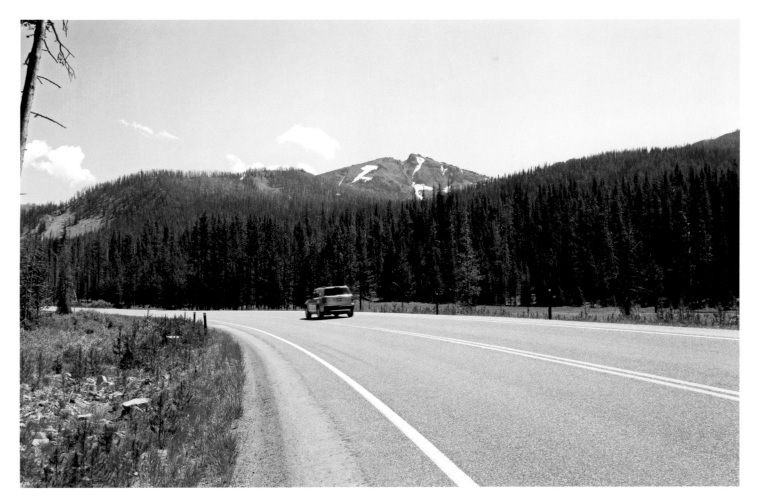

another example of the photographer simply being confused when he returned to Cheyenne after several months in the field making images.

The camera location is a little park between Eleanor Lake and Sylvan Lake. A small stream meanders through the meadow. This photograph looks south, with Fred Chase and the team on the road back to Cody. Although the hillsides and open areas within the forests clearly match up, what is most amazing are the snowfields on Top Notch.

Two photographs taken in July 105 years apart show nearly identical, zigzaggy patches of snow. With so many natural wonders such as geysers, waterfalls, and canyons, this little scene, like the Lichen Pass shot (#28), seems almost ordinary for Yellowstone. But unlike Lichen Pass, this stretch of the Cody Road remains a part of the current one. Millions of visitors pass over it every year, never knowing that they are riding over a historical path. This secret helps make this one of my favorite images.

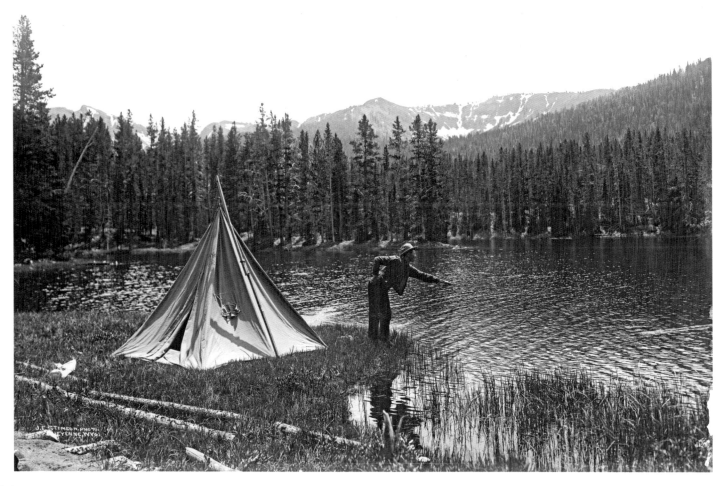

34. #586 **Upper end, Sylvan Lake**

GPS coordinates: 44 28.687n, 110 09.493w

When Hiram Martin Chittenden described the possible route over Sylvan Pass in his 1901 Annual Report, he noted that the route would pass Sylvan Lake, a "small but exceedingly beautiful sheet of water." Stimson must have felt the same way because he shot four views of it. This one, which he simply called "Upper End Sylvan Lake," shows

Fred Chase fishing from a small grassy bank on which a tent was erected. In its report on Stimson's trip, Cody's *Wyoming Stockgrower and Farmer* wrote: "Mr. Chase caught a six pound trout in Sylvan lake and the artist succeeded in getting a photo of the scene just as the fine fish leaped clear of the water in his frantic efforts to escape." As noted earlier,

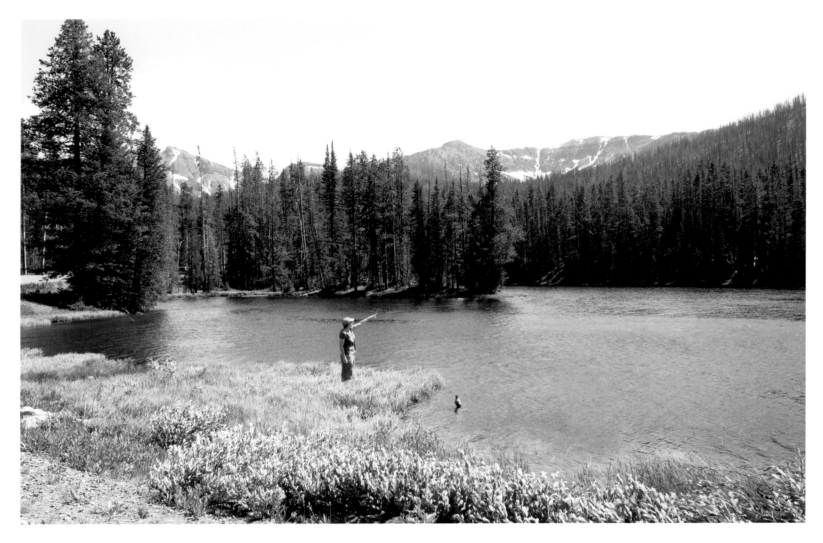

this would have been a native Yellowstone Cutthroat Trout. The road is barely visible in the lower left-hand corner of the frame.

My rephotograph was taken at the edge of a small parking lot, but the original Cody Road can still be seen as a brownish area in the lower left-hand corner. The modern road is visible at the base of two aspens just to the left of the large pines at left.

Lauren is standing on the same little bank of grass on which Fred Chase stood in the original photo. In the distance, the scorched trees from the 1988 Clover Mist Fire rise above the far shore of the lake and still stand out against the distant peaks of Top Notch, Mount Doane, Mount Stevenson, and Grizzly Peak. As in the previous view, many of the irregular snowfields remain.

35. #585 **Fern Lake, Hoyt's Peak in distance**
(actually Sylvan Lake, Top Notch Peak in distance)

GPS coordinates: 44 28.732n, 110 09.564w

J. E. Stimson must have been confused about where he was that day or perhaps in labeling his photos. Or he may have been in a liminal state. He had mistaken Eleanor Lake for Fern Lake and then labeled Top Notch as Hoyt's Peak. Here he combines the two, but my rephotograph clearly shows that it is in fact his second view of Sylvan Lake with Top Notch Peak in the distance. Interestingly, the Burlington Railroad's 1912 brochure, "In Camp and Ranch in the Yellowstone Country," also mislabeled the view, using Stimson's exact wording. Since the previous photo is labeled "Upper End of Sylvan Lake," a better description for this view would have been "Middle Section of Sylvan Lake."

To get to this vantage point, I had to wade to a little island just off the eastern shore of Sylvan Lake and then walk out to its southernmost point. As I looked through the viewfinder, the trees at left clearly lined up. As in the previous view, the snowfields on the distant peaks of Top Notch, Mount Doane, Mount Stevenson, and Grizzly Peak are strikingly similar.

The scorched trees on the far right side of the modern photograph are also a result of the 1988 Clover Mist Fire. Part of the infamous 1988 Yellowstone fires, this particular fire actually began as two separate blazes. The Mist Fire started on July 9 in the Absaroka Mountains. Two dates later the Clover Fire began nearby. The two had combined into one fire by July 20 and were not put down until snow and rain began to fall on September 11. The fire eventually burned more than 140,000 acres, stretching across the northeast section of the park from the area around the Cody Road all the way to the Northeast Entrance near Cooke City, Montana. All told, more than 250 fires started in the park between June and August 1988, charring almost 800,000 acres, or 36 percent of the park's lands.

The 1988 Yellowstone fires changed the way the National Park Service deals with fire. Although the Park Service had allowed "natural fires" in the park since the early 1970s, the 1988 fires led to stricter guidelines for the management of such fires and greater funding for fire protection. At the same time, the fires and their aftermath have confirmed for some the place of fire in the park's ecosystem. Others worry about the possibility of burning down the entire park and advocate for a return to total fire suppression. Thus, like the gravel, snow, and ice on Sylvan Pass, fire and its role in Yellowstone's ecology and economy remains a point of contention.

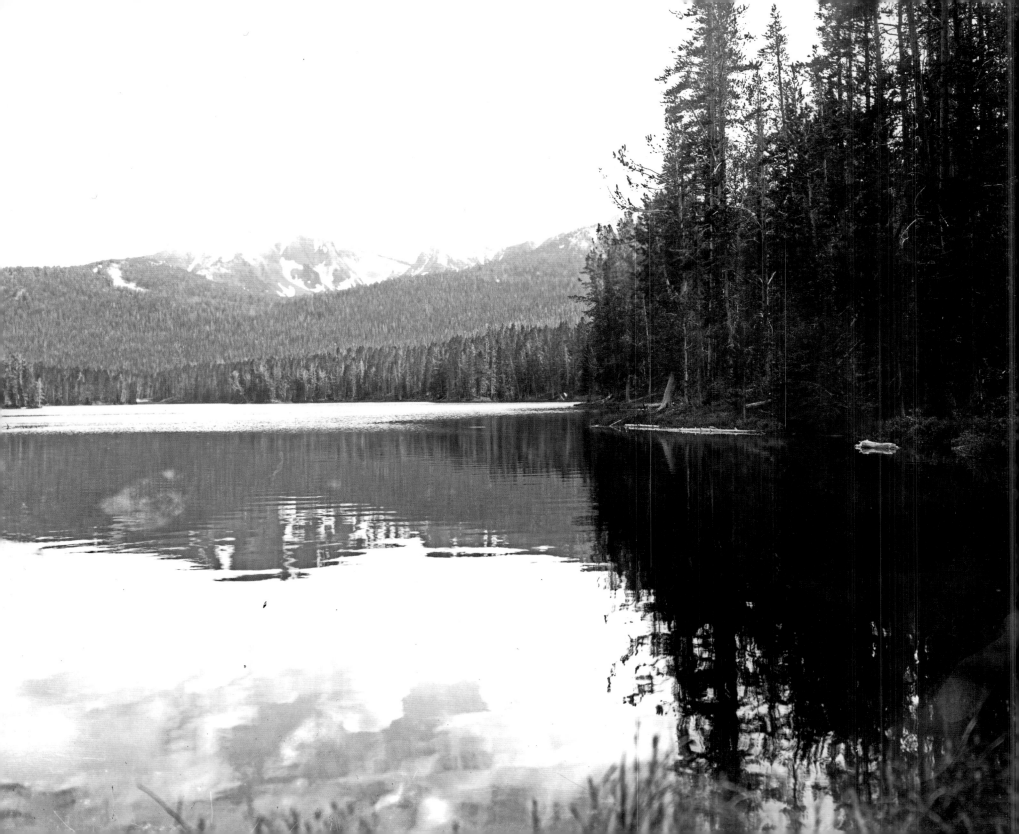

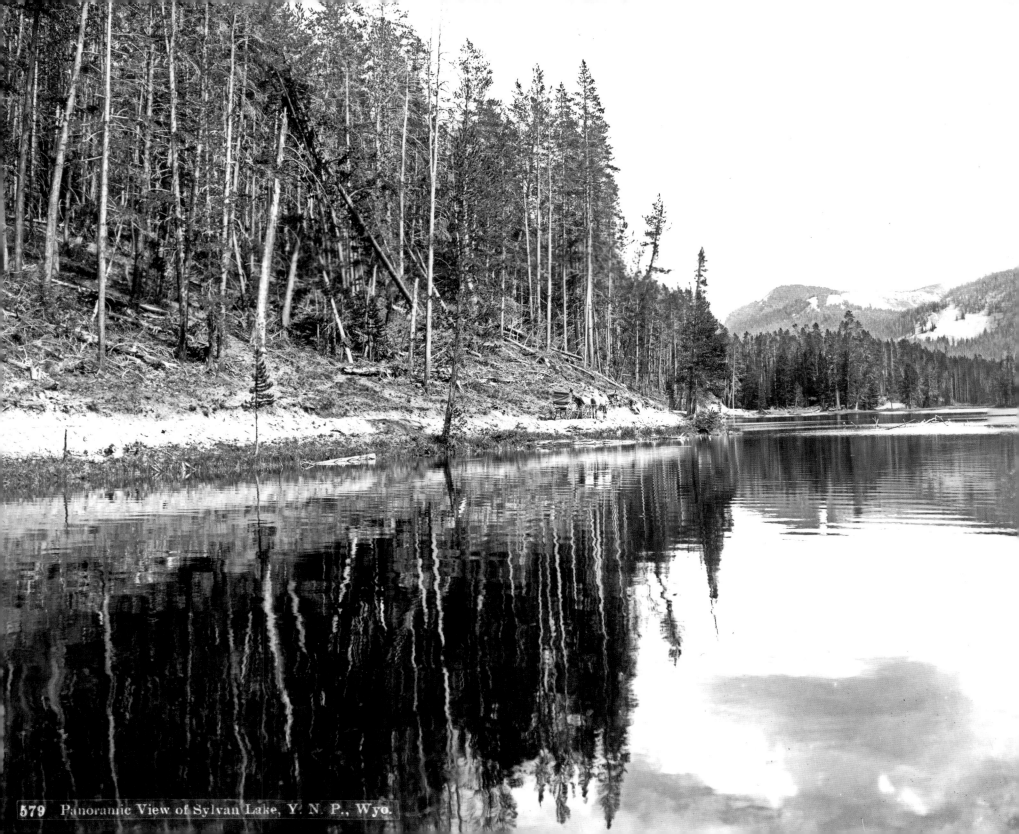

579 Panoramic View of Sylvan Lake, Y. N. P., Wyo.

36. #579 and #579a **Sylvan Lake panorama**

GPS coordinates: 44 28.983n, 119 09.831w

This view is from the northern end of Sylvan Lake and looks back toward Top Notch Peak and Sylvan Pass. The Cody Road can be seen skirting the lake on the left side of the photograph. Fred Chase and the team can also be seen, looking toward the camera. As in his view of Eleanor Lake, Stimson captured Sylvan Lake reflecting the distant peaks in a very picturesque manner.

Stimson made two panoramic series of Sylvan Lake from this point during that summer of 1903. After rephotographing them both, I learned that they were made from this very point and the only difference was a slight shift of the camera left or right. This photograph incorporates two separate images, #579 and #579a. I used several tools in Adobe Photoshop to stitch scans of the two images together into one continuous view.

In his collection of more than 7,500 photographs, Stimson only made a couple of dozen panoramic scenes involving multiple views. Although true panorama cameras were available, Stimson used his regular 8×10 large-format view camera. This caused a parallax problem, in which the two views overlapped and offered slightly different vantage points that, when connected, create visual distortions. This occurs when the lens is positioned in front of the pivoting point of the tripod. The same effect occurs if you close one eye, then look at your outstretched finger against a far wall. As you turn your head to one side, the finger seems to move relative to the wall because your eye is positioned in front of the turning axis in your neck.

To fix parallax in the field, I used a special panoramic head on my tripod, which has two built-in adjustable rails that allow me to move the center of the camera lens back and over to a point directly above the pivoting axis of the tripod. It also has pre-set trips to create set degrees of movement as the camera rotates. Because it was easier to connect my images when I allowed them to overlap, I actually made eight photos from the left side of the view to the right side instead of simply matching Stimson's two shots. I had to make sure that nothing such as a car moved from one image to the next as I rotated my camera, otherwise that car could appear as multiple vehicles in the final panorama. So, as I took this series of images, I waited for one car to be in about the same position as Fred Chase's buggy in the original photo, made that single picture, then waited a few seconds for the car to move out of view before completing the panoramic series. Back home, I stitched the multiple images together in Photoshop and produced one very large panoramic—and picturesque—image.

37. #592 Scene near Sylvan Pass

GPS coordinates: 44 29.36067n, 110 11.35967w

The vantage point of this view is on the descent from Sylvan Lake to Yellowstone Lake. The view looks to the east directly at the snowfields on Avalanche Peak, with Hoyt's Peak to the right and Sylvan Pass to its right. Down the slope on the right side of the picture, out of view, is Clear Creek. Although several early travelers described the Chittenden Road in the park as being as good as a city boulevard, here it seems rocky and a bit precarious as it hugs the mountainside. As can be seen in the modern photograph, this area was also hard-hit by the 1988 Clover Mist Fire that eventually burned more than 140,000 acres.

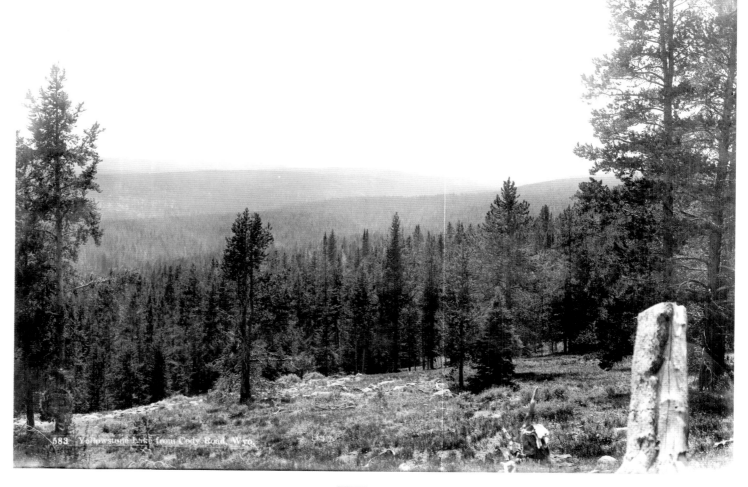

38. #583 **Yellowstone Lake from Cody Road**

GPS coordinates: 44 29.421n, 110 11.863w

The final photograph from Stimson's July 1903 trip on the Cody Road that I rephotographed is this view of Yellowstone Lake. The vantage point is about a half-mile west of the last view but with this shot looking west toward the distant lake and the

mouths of Cub and Clear Creeks. As in the previous set of photographs, the devastating effects of the 1988 Clover Mist Fire can clearly be seen in the rephotograph.

After reaching Yellowstone Lake, Stimson turned around and traveled back to Irma where he was met by H. W. Darrah, a member of the Cody Club, who had arranged his

travel to the park. Darrah took the photographer to his lumber mill, then east to the small town of Meeteetse, where Stimson resumed his photographic fieldwork for the St. Louis Fair Commission.

J. E. Stimson's 1910 Return to Cody

J. E. Stimson returned to Cody in the summer of 1910 and made photographs of the Shoshone Irrigation Project and the nearby Big Horn Basin communities of Worland, Kane, Ionia, and Lovell. Since his 1903 visit, much had changed. The federal Bureau of Reclamation had carved a new road between Cedar and Rattlesnake Mountains west of Cody to access Shoshone Dam. Travelers marveled at its twists, turns, tunnels, and excessive grade. When that project was completed in 1910, the waters inundated the communities of Irma and Marquette, as well as much of the original path of the Cody Road as it swung around Cedar Mountain to join the North Fork of the Shoshone. To compensate, the bureau built another new road from the dam around the north side of the reservoir to the old road to the west. In addition to these projects, the state of Wyoming had carved a new county, called Park County for its proximity to Yellowstone, from Big Horn County and named Cody its county seat. As part of his visit, Stimson made a series of photographs of the new road from Cody to the reservoir. Access to some of these sites is now restricted because of issues of terrorism and safety, but I include four of them here.

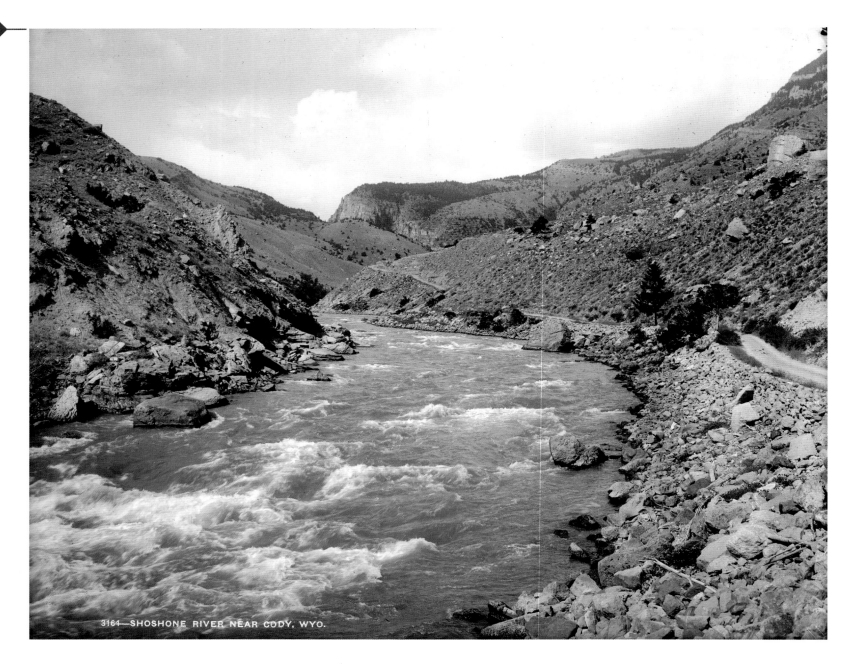

3164—SHOSHONE RIVER NEAR CODY, WYO.

39. #3164 **Shoshone River near Cody**

GPS coordinates: 44 30.67365n, 109 9.2745w

The route of the 1908 road to the Shoshone Dam (now called Buffalo Bill Dam) is controlled by the Bureau of Reclamation and is only open for day use. The vantage point for this view is about a third of a mile west of the locked gate. The modern highway, built in the 1960s to replace the original road, crosses high above the Shoshone River. Dark trees and a modern road to the top can be seen on Rattlesnake Mountain in the right distance.

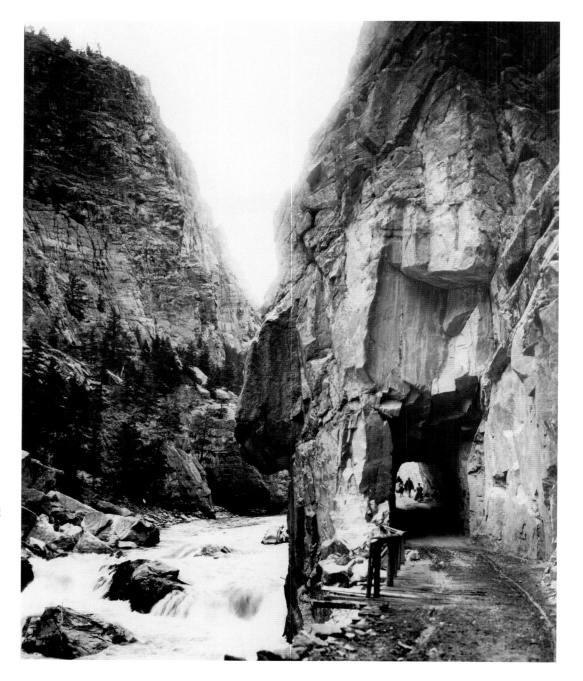

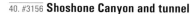

40. #3156 Shoshone Canyon and tunnel

GPS coordinates: 44 30 22.32n, 109 10 38.00w

This view depicts one of several tunnels blasted from solid rock in the depths of Shoshone Canyon. Automobiles are no longer allowed this far into the canyon, so to reach this spot, Lauren and I had to load all our gear into backpacks and then hike in about two miles from our parked car. Just beyond this tunnel, a chain-link fence across the road stops visitors from accessing the dam and the original route.

With its steep canyon walls and raging river, this photograph offers another sublime view. Visitors often remarked on the excitement of this new road to Yellowstone.

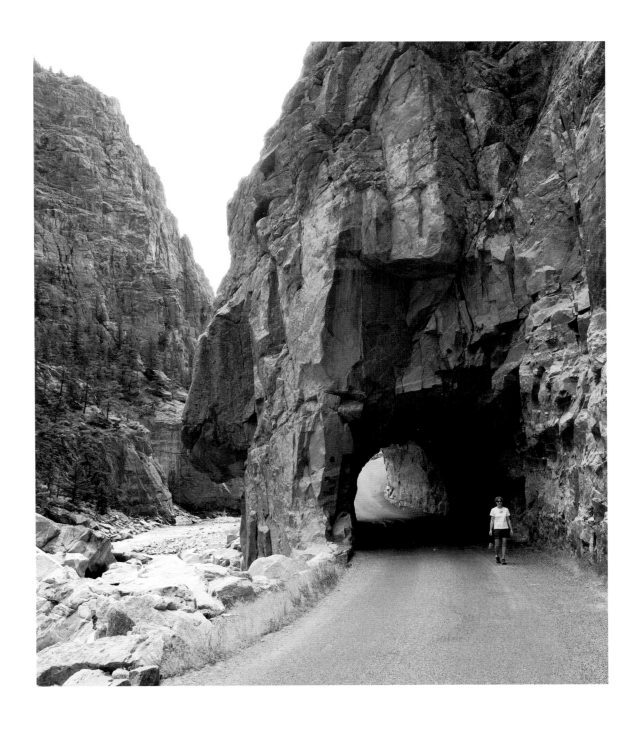

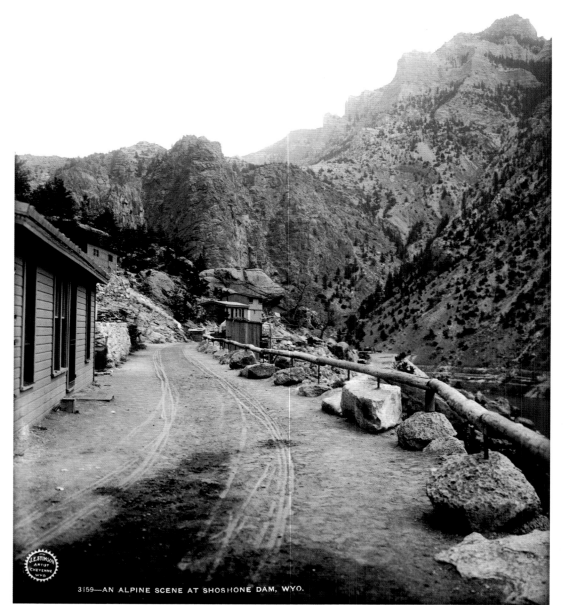

3159—AN ALPINE SCENE AT SHOSHONE DAM, WYO.

41. #3159 **Alpine scene at Shoshone Dam**

GPS coordinates: 44 30.025n, 109 11.278w

Although Stimson accessed this vantage point by driving up the twists and turns of the route through Shoshone Canyon, our route was by way of the new highway, which goes through two tunnels high above the river and the old road. Stimson's vantage point for this "alpine scene" is directly on the road near some buildings that remain from the dam's construction. It looks east toward the dam and Cedar Mountain. Today, this spot is located just beyond the last tunnel on the edge of the visitor center parking lot about a quarter-mile west of the dam. Renamed for Buffalo Bill in 1946, the dam was raised twenty-five additional feet in 1993, as can be seen in the higher water levels. Close inspection reveals that the vegetation on Cedar Mountain on the right appears denser as well.

As in the previous scene, visitors in Stimson's day had open access to the river road and the dam. Today, security is much tighter. Just beyond this image, the Buffalo Bill Dam Visitor's Center, built in 1993, contains displays about the history of the irrigation project and dam construction and a small gift shop, controls access to the top of the dam, and serves as a de facto visitor center for the town of Cody for folks coming in from Yellowstone by selling nightly rodeo tickets and providing information on local lodging.

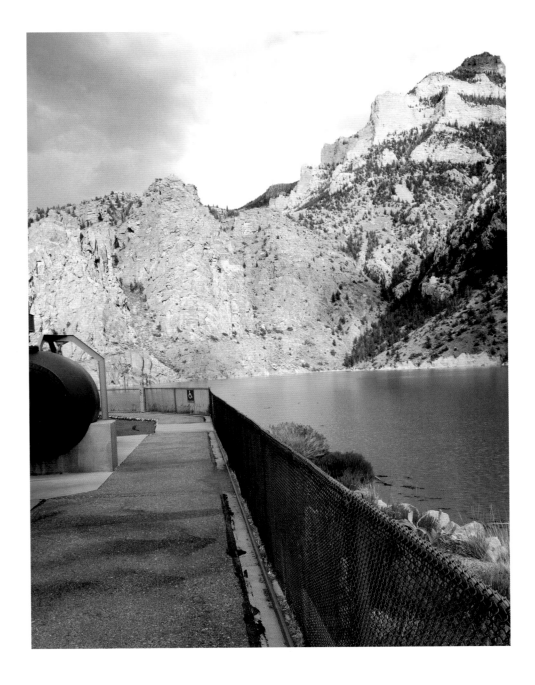

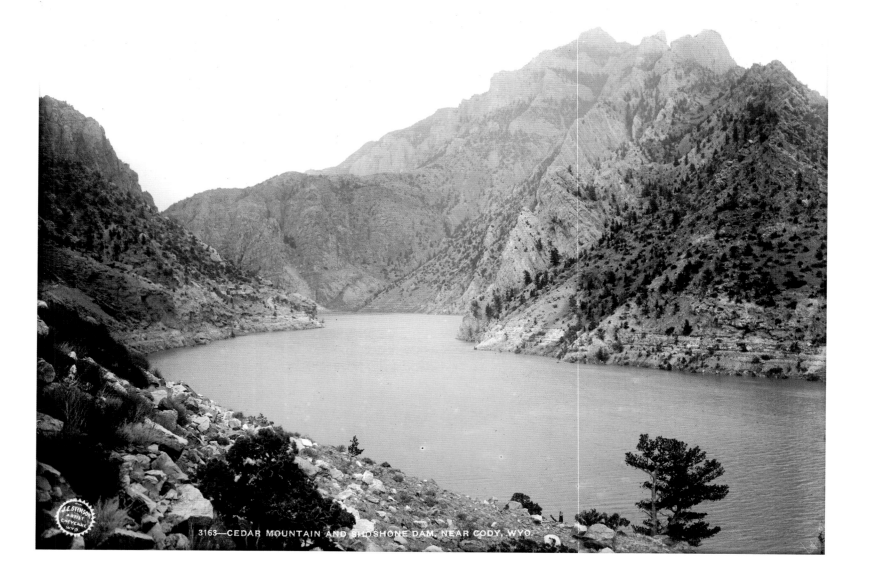

3163—CEDAR MOUNTAIN AND SHOSHONE DAM, NEAR CODY, WYO.

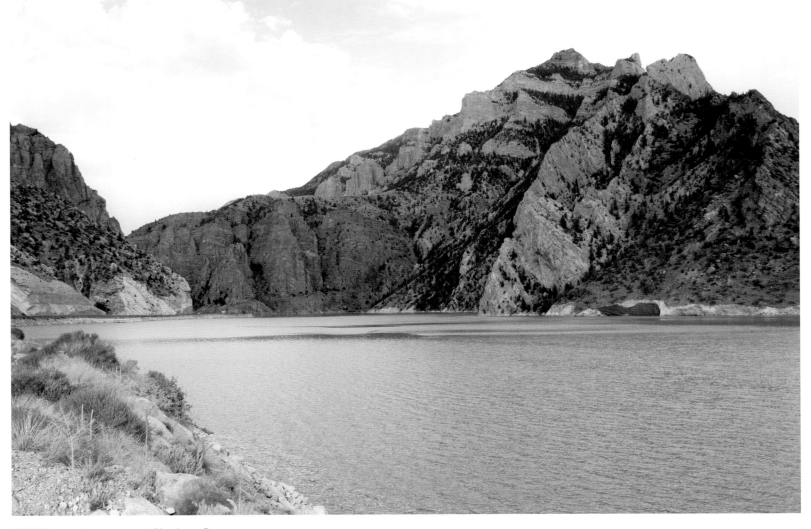

42. #3163 **Cedar Mountain and Shoshone Dam**

GPS coordinates: 44 29.977n, 109 11.99w

On the original route around the reservoir, this spot was situated below the road just before it turned through a tunnel to the northwest. Today, it is below a scenic pullout on the modern road, about six-tenths of a mile above the last spot. The view is downstream toward the site of the dam, with Cedar Mountain on the right. The old community of Marquette would be hundreds of feet below the surface. The most noticeable difference in the two photos is again the effects of the dam having been raised twenty-five feet in 1993, as water levels have clearly covered more of the landscape than is the case in Stimson's view.

Afterword

It has been four years since I rephotographed J. E. Stimson's trip to Yellowstone over the newly opened Cody Road. In that time I have married and moved into a new home in Flagstaff. Because my dog Nellie had been ill and then passed away in the spring of 2011, I have spent exactly six nights away from home since returning from Wyoming. In that same amount of time, several hundred thousand people have traveled the Cody Road to Yellowstone. There have been avalanches across it at Sylvan Pass and fires along its shoulders. The road endures.

In the process of writing this book, I have examined Stimson's views over and over, read many accounts of travelers who took the Cody Road beginning in 1903, read histories of the ranches and tourist lodges along the route, reviewed my rephotographs repeatedly, plotted the GPS points from each rephotograph, and studied the locations on Google Earth. In short, the Cody Road has become very familiar to me.

As I again look over my rephotographs in the process of writing this book, it is amazing how much detail of my time on the Cody Road comes back to me. I think back to walking through the sagebrush down to the river to photograph Signal Mountain—which Stimson called Crimson Tower—only to be stopped by a canal between the North Fork and me. Then,

as I set up my camera, to hear splashing—instantly thinking bear—and see three river otters swimming up the canal in front of me. I remember being atop Sylvan Pass in a July storm, scrambling over rocks to find the right vantage point, and seeing a small wooden sign facedown in the rocks. When I turned it over it said "Warning: Unexploded Shells." I recall the thrill of discovering that Stimson had labeled several of his images beyond Sylvan Pass incorrectly and thinking, does anybody else know what I know? I recollect wading across a few feet of Sylvan Lake, then tramping through water and grass down to the edge of a small island, and seeing Stimson's image come into my viewfinder. Finally, I am reminded of when we were coming down from Sylvan Pass toward the East Entrance to Yellowstone National Park. We noticed a small outcropping of rock, stopped the car, and were amazed to find what Stimson had labeled "Lichen Pass."

All of these memories, and many more, have made the Cody Road familiar to me. But what is familiarity? *Webster's Dictionary* suggests that familiarity can mean "being in close acquaintance with something," and I suppose that is the basis of my relationship with this route to Yellowstone. After traveling back and forth on it, finding Stimson's original vantage points, seeing his compositions through my own camera, and then studying the route's history, I have been in "close acquaintance" with it.[1]

My "acquaintance" with the Cody Road leads me to wonder about Stimson. After traveling around the state in the summer of 1903 photographing it for the St. Louis Fair, J. E. Stimson must have had a similar familiarity with the Wyoming of his day. Although he misnamed or confused a few spots in Yellowstone, he must have been as knowledgeable about the state's scenery as anyone at that time. And just imagine the stories he probably knew! In his biography of Stimson, Mark Junge relates one tale the photographer told his grandchildren. It seems that Stimson had taken a personal rail car out on the Union Pacific mainline to photograph a band of sheep. After spending much of the day herding them into his composition, he returned to town only to discover that he had stopped several transcontinental trains to get his photo. One has to wonder about his other stories of that first trip on the Cody Road to Yellowstone.[2]

Although we can never know these stories, the process of researching the places where Stimson made his photographs and then standing in the same spots and rephotographing the sites might be one way to begin to better understand what he may have been thinking. I know that as I have become more and more familiar with the Cody Road and Stimson's vantage

points, it seems that perhaps the grandeur of the route in 1903 is more commonplace today. I use the words *sublime* and *picturesque* to discuss Stimson's original photographs but seldom to describe my rephotographs. Why is this? Could the exceptional in Stimson's view have become the common landscape of today? I'm troubled by the thought because the Cody Road remains an amazing and scenic excursion. So is it simply nostalgia generated by his black-and-white prints or perhaps the horse and buggy in the images? Is it the primitive dirt road visible in his photos compared to the busy highway of today? Or, better still, is it the knowledge that period travelers described that primitive dirt road as being as smooth as a city boulevard?

One thought that occurs to me is the simple idea of speed. Speed is a function of both velocity and distance. What this means is that not only have cars reduced the travel time on the Cody Road from days to an hour, they have also changed our visual comprehension as we see objects in the distance come and go so much faster. I think about those rock towers in the photograph near Signal Peak, and it reminds me of early migrants on the Oregon Trail. If you read enough of those diaries, you begin to see that landmarks such as Chimney Rock in western Nebraska were much more notable to people traveling by ox-drawn wagon than they are to car-bound drivers today. Although the formation is the same, our perception of it has been changed by the simple fact that we are speeding by at seventy-five miles per hour rather than eighteen miles a day. The same is true of those rocky towers and J. E. Stimson. As he moved up the road toward the park, he would have seen those towers for a good part of the morning. In contrast, I saw them for perhaps five or ten minutes. The point here is that not only has the landscape become more familiar through studying it, but we did not see it for as long to begin with.

Speed is also a function of our evolving digital world. Faster computers and download times have made access to more and more information easier and easier. The benefits range from the digital Wyoming Newspaper Project to the Pegman feature on the Street View of Google Earth. The ability to use both historical firsthand accounts and contemporary images of the Cody Road from my computer in Flagstaff has made each collection much more accessible than it would have been if I had had to go to Wyoming again. And with accessibility comes familiarity. In short, the ever-increasing speed of the digital world is also making the real world more familiar.

All of this rambling comes back to the question of whether the sublime and picturesque landscape found in Stimson's photographs is now part of the ordinary, or vernacular,

landscape of today. We have all heard stories of people who live and work in locations with spectacular scenery such as Yosemite, Yellowstone, or some other such place; and the notoriety of it gets lost in the daily commute back and forth to work to the point that they really no longer see the intrinsic beauty of their locations. Is it the same with rephotography? By learning all I can about a specific place and then seeing and finding that place over a period of time, have I removed its intrigue? Have I pulled back the curtain and learned that the wizard is nothing more than a man?

In the end, as I think back to my time on the Cody Road, I not only remember the otters and misnamed mountains, but I also remember the smell of the mountain air and the utter beauty of the place. I remember the thrill of finally standing in the same spot Stimson had photographed and focusing my viewfinder onto the same scene and thinking that I had somehow learned a secret about the place that no one else knew. These qualities are not accessible in the virtual world of computers, at least not yet. Knowledge of and familiarity with a place do not detract from a sense of place but instead add new layers of intrigue to it. Comparing the Cody Road of 2008 with that of 1903 makes me want to go back and look at it again and again. I hope it does the same for you as well.

Notes

1. http://mw2.merriam-webster.com/dictionary/familiarity [accessed September 12, 2010].

2. Mark Junge, *J. E. Stimson: Photographer of the West* (Lincoln: University of Nebraska Press, 1985), 6.

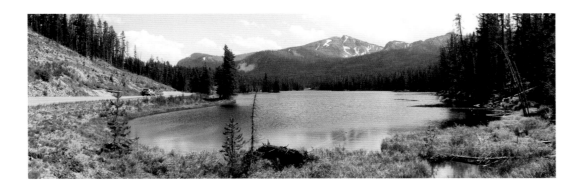

Select Bibliography

Adams, Ansel. *The Camera*. Boston: Little, Brown, 1980.

Alice's Adventures in Wonderland by Lewis Carroll. Millennium Fulcrum Edition 3.0. http://www. cs.cmu.edu/~rgs/alice-table.html (accessed September 2, 2010).

Amundson, Michael. "The British at Big Horn: The Founding of an Elite Wyoming Community." *Journal of the West* 40, no. 1 (Winter 2001): 49–55.

Amundson, Michael. "No Longer a Home on the Range No More: The Booms and Busts of a Wyoming Uranium Mining Town, 1958–1985." *Western Historical Quarterly* 26 (Winter 1995): 483–505. http://dx.doi.org/10.2307/970850.

Amundson, Michael. "Pen Sketches of Promise: The Western Drawings of Merritt Dana Houghton." *Montana: The Magazine of Western History* (Fall 1994): 54–65.

Amundson, Michael. "The Rise and Fall of Big Horn City, Wyoming." *Wyoming Annals* (Spring-Summer 1994): 10–25.

Amundson, Michael. "These Men Play Real Polo: The History of an Elite Sport in the 'Cowboy' State, 1890–1930." *Montana: The Magazine of Western History* (Spring 2009): 3–22.

Amundson, Michael. "Through the Lens of Stimson: Past and Present." *Annals of Wyoming* [Cheyenne] (Spring 1988): 32–45.

Amundson, Michael. *Wyoming Time and Again: Rephotographing the Scenes of J. E. Stimson*. Boulder: Pruett, 1991.

Amundson, Michael. *Yellowcake Towns: Uranium Mining Communities in the American West*. Boulder: University Press of Colorado, 2002.

Baldwin, Kenneth H. *Enchanted Enclosure: The Army Engineers and Yellowstone National Park; A Documentary History*. Washington, DC: Office of the Chief of Engineers, United States Army, 1976.

Barnhart, Bill. *The Northfork Trail: Guide and Pictorial History Cody, Wyoming to Yellowstone Park*. Wapiti, WY: Elkhorn, 1982.

Bonner, Robert E. *William F. Cody's Wyoming Empire: The Buffalo Bill Nobody Knows*. Norman: University of Oklahoma Press, 2007.

Burlington Route. "In Camp and Ranch Buffalo Bill Country/The Cody Road into Yellowstone" (brochure). Chicago: Burlington Route, 1915.

Burlington Route. "In Camp and Ranch in the Yellowstone Country/The Cody Road into Yellowstone" (brochure). Chicago: Burlington Route, 1912.

Burlington Route. "The Cody Road into Yellowstone Park" (brochure). Chicago: Burlington Route, 1905.

Burlington Route. "The Cody Road into Yellowstone Park" (brochure). Chicago: Burlington Route, 1906.

Burlington Route. "The Cody Road to Yellowstone Park" (brochure). Chicago: Burlington Route, 1916.

Burlington Route. "The Cody Road thru the Buffalo Bill Country/The Cody Road to Yellowstone Park" (brochure). Chicago: Burlington Route, 1924.

Burlington Route. "The Cody Road thru the Buffalo Bill Country/The Cody Road to Yellowstone Park" (brochure). Chicago: Burlington Route, 1925.

Burlington Route. "The Cody Road thru the Buffalo Bill Country/The Cody Road to Yellowstone Park" (brochure). Chicago: Burlington Route, 1929.

Burlington Route. "The Cody Road thru the Buffalo Bill Country/The Cody Road to Yellowstone Park" (brochure). Chicago: Burlington Route, 1935.

Burlington Route. "The Cody Road thru the Buffalo Bill Country/The Cody Road to Yellowstone Park" (brochure). Chicago: Burlington Route, 1936.

Burlington Route. "The Cody Road thru the Buffalo Bill Country/The Cody Road to Yellowstone Park" (brochure). Chicago: Burlington Route, 1938.

Burlington Route. "The Cody Road thru the Buffalo Bill Country/The Cody Road to Yellowstone Park" (brochure). Chicago: Burlington Route, 1939.

Burlington Route. "The Cody Road thru the Buffalo Bill Country/The Cody Road to Yellowstone Park" (brochure). Chicago: Burlington Route, 1946.

Burlington Route. "Go Burlington and Include the Famous Cody Road to Magic Yellowstone" (brochure). Chicago: Burlington Route, 1953.

Campbell, Reau. *Campbell's New Revised Complete Guide and Descriptive Book of the Yellowstone Park.* Chicago: Rogers and Smith, 1909.

Carter, John E. "Architecture, Photography, and a Quest for Meaning." *Exposure* (Fall 1987): 16.

Chittenden, Hiram Martin. *The Yellowstone National Park: Historical and Descriptive*, 4th ed. Cincinnati: Roberts Clarke, 1903.

Chittenden, Hiram Martin. *The Yellowstone National Park: Historical and Descriptive,* new and enlarged edition, completely revised. St. Paul, MN: J. E. Haynes, 1924.

Churchill, Beryl Gail. *Challenging the Canyon: A Family Man Builds a Dam.* Cody, WY: WordsWorth, 2001.

Cody Lions Club. *The Cody Road to Yellowstone Park: Most Scenic Seventy Miles in the World..* Cody, WY: Lions Club, 1927.

Cody Lions Club. *The Cody Road to Yellowstone Park: Most Scenic Seventy Miles in the World.* Cody, WY: Lions Club, 1928.

Culpin, Mary Shivers. *The History of the Construction of the Road System in Yellowstone National Park, 1872–1966: Historic Resource Study*, vol. 1. Denver: Division of Cultural Resources, Rocky Mountain Region, National Park Service, 1994.

Dutton, Allen A. *Arizona: Then and Now.* Englewood, CO: Westcliffe, 2002.

Federal Writers' Project. *Wyoming: A Guide to Its History, Highways, and People.* New York: Oxford University Press, 1941.

Fielder, John. *Colorado 1870–2000.* Englewood, CO: Westcliffe, 1999.

Fielder, John. *Colorado 1870–2000 II.* Englewood, CO: Westcliffe, 2005.

Fox, William L. *View Finder: Mark Klett, Photography and the Reinvention of Landscape.* Albuquerque: University of New Mexico Press, 2001.

Frost, Ned W., and Fred J. Richard. "Cody Road thru Yellowstone Park" (brochure). Cody, WY: Frost and Richard, 1912.

Frost and Richard Camping Co. *Cody Road thru Yellowstone Park.* Cody, WY: Frost and Richard Camping Co., 1915.

Furtwangler, Albert. *Acts of Discovery: Visions of America in the Lewis and Clark Journals.* Urbana: University of Illinois Press, 1993.

Ganzel, Bill. *Dust Bowl Descent.* Lincoln: University of Nebraska Press, 1984.

Goin, Peter. *Stopping Time: A Rephotographic Survey of Lake Tahoe*. Chapter by C. Elizabeth Raymond and Robert E. Blesse. Albuquerque: University of New Mexico Press, 1992.

Goss, Bob. Geyser Bob's Yellowstone Park Historical Service. http://geyserbob.org/home.html (accessed September 2, 2010).

Goss, Bob. "Holm on the Range: Camping the Yellowstone with Aron 'Tex' Holm." *Annals of Wyoming: The Wyoming History Journal* (Winter 2010): 2–21.

Guptill, A. B. *Haynes Guide to Yellowstone Park: A Practical Handbook*. St. Paul, MN: F. Jay Haynes, Pioneer Press, ca. 1903.

Hales, Peter B. *William Henry Jackson and the Transformation of the American Landscape*. Philadelphia: Temple University Press, 1988.

Haynes, J. E. *Haynes New Guide and Motorists' Complete Road Log of Yellowstone National Park*, 37th ed. St. Paul, MN: J. E. Haynes, 1926.

Heath, Charles A. *A Trial of a Trail, from Cody to the Yellowstone: Notes from the Journal of Charles A. Heath*. Chicago: Franklin, 1905.

Historical Society of Pennsylvania's website. http://www.hsp.org/sites/default/files/migrated/findingaidv18albertype.pdf (accessed July 19, 2011).

Houze, Lynn Johnson. *Images of America: Cody*. Charleston, SC: Arcadia, 2008.

Houze, Lynn Johnson. *Cody: Then and Now*. Charleston, SC: Arcadia, 2011.

Jackson, William Henry. *Colorado: 1870–2000: Historical Landscape Photography*. Contemporary photography by John Fielder; text by Ed Marston. Englewood, CO: Westcliffe, 1999.

Jackson, William Henry. *Colorado: 1870–2000 II: Historical Landscape Photography*. Contemporary photography by John Fielder; text by Gillian Klucas. Englewood, CO: Westcliffe, 2005.

Johnson, Stephen. *On Digital Photography*. Sebastopol, CA: O'Reilly Media, 2006.

Jones, William C., Elizabeth B. Jones, and Louis C. McClure. *Photo by McClure: The Railroad, Cityscape, and Landscape Photographs of L. C. McClure*. Boulder: Pruett, 1991.

Junge, Mark. *J. E. Stimson: Photographer of the West*. Lincoln: University of Nebraska Press, 1985.

Kensel, W. Hudson. *Pahaska Tepee: Buffalo Bill's Old Hunting Lodge and Hotel, a History, 1901–1946*. Cody, WY: Buffalo Bill Historical Center, 1987.

Klein, Maury. *Union Pacific,* vol. 2: *1894-1969*. Minneapolis: University of Minnesota Press, 2006.

Klett, Mark, Kyle Bajakian, William L. Fox, Michael Marshall, Toshi Veshina, and Byron G. Wolfe. *Third View, Second Sights: A Rephotographic Survey of the American West*. Santa Fe: Museum of New Mexico Press, 2004.

Klett, Mark, Philip L. Fradkin, Rebecca Solnit, Mark Klett (photographer), and Michael Lundgren (photographer). *After the Ruins, 1906 and 2006: Rephotographing the San Francisco Earthquake and Fire*. Berkeley: University of California Press, 2006.

Klett, Mark, Ellen Manchester, JoAnn Verburg, Gordon Bushaw, and Rick Dingus. *Second View: The Rephotographic Survey Project*. Albuquerque: University of New Mexico Press, 1984.

Klett, Mark, and Eadweard Muybridge. *One City/Two Visions: San Francisco Panoramas, 1878 and 1990*. San Francisco: Bedford Arts, 1990.

Klett, Mark, Rebecca Solnit, and Byron Wolfe. *Yosemite in Time: Ice Ages, Tree Clocks, Ghost Rivers*. San Antonio: Trinity University Press, 2008.

Lageson, David R., and Darwin R. Spearing. *Roadside Geology of Wyoming*. Missoula, MT: Mountain Press, 1988.

Larson, T. A. *History of Wyoming*. Lincoln: University of Nebraska Press, 1978.

La Shure, Charles. What Is Liminality? October 18, 2005. http://liminality.org/about/whatisliminality (accessed September 2, 2010).

Leslie's Weekly XCVL, no. 2493 (June 18, 1903).

McCarthy, Walt. *The Wapiti Valley: Cody to Yellowstone*. Cody, WY: Rustler, ca. 1971.

Meagher, Mary, and Douglas B. Houston. *Yellowstone and the Biology of Time: Photographs across a Century*. Norman: University of Oklahoma Press, 1999.

Meeks, Harold A. *On the Road to Yellowstone: The Yellowstone Trail and American Highways, 1900–1930*. Missoula, MT: Pictorial Histories, 2000.

Miller, M. Mark. *Adventures in Yellowstone: Early Travelers Tell Their Tales.* Guilford, CT: Globe Pequot, 2009.

Murray, Ester Johansson. *A History of the North Fork of the Shoshone River*. Cody, WY: Lone Eagle Multimedia, 1996.

Newell, F. H., and the United States Geological Survey, Department of the Interior. *Fourth Annual Report of the Reclamation Service*. Washington, DC: Government Printing Office, 1906.

Nicholas, Liza. *Becoming Western: Stories of Culture and Identity in the Cowboy State*. Lincoln: University of Nebraska Press, 2006.

1904 World's Fair Society Home Page. http://www.1904worldsfairsociety.org/index.htm (accessed July 20, 2011).

North Fork Resort Owners Association. *The Most Scenic Fifty Miles in America! The Cody Road to . . . Yellowstone National Park through the Beautiful North Fork Valley of the Shoshone River Where Nature Smiles for Fifty Miles Lying between Cody, Wyoming and Yellowstone National Park*. Wapiti, WY: North Fork Resort Owners Association, 1942.

Noss, Reed. The Ecological Effects of Roads. http://www.wildlandscpr.org/node/41/print (accessed October 7, 2010).

Official Guide to the Louisiana Purchase Exposition. St. Louis: Louisiana Purchase Exposition Company, 1904.

Olsen, Russell A. *Route 66 Lost and Found: Ruins and Relics Revisited*. St. Paul, MN: MBI, 2004.

Pickering, James H., Carey Stevanus, and Mic Clinger. *Estes Park and Rocky Mountain National Park Then and Now*. Englewood, CO: Westcliffe, 2006.

Rogers, Garry F., Harold E. Malde, and Raymond M. Turner. *Bibliography of Repeat Photography for Evaluating Landscape Change*. Salt Lake City: University of Utah Press, 1984.

Rothman, Hal K. *Devil's Bargains: Tourism in the Twentieth Century American West*. Lawrence: University Press of Kansas, 2000.

Runte, Alfred. *Trains of Discovery: Western Railroads and the National Parks*. Boulder: Roberts Rinehart, 1990.

Rydell, Mark W., and Rob Kroes. *Buffalo Bill in Bologna: The Americanization of the World*. Chicago: University of Chicago Press, 2005.

Shaffer, Margerite. "Seeing America First: The Search for Identity in the Tourist Landscape." In *Seeing and Being Seen: Tourism in the American West*, ed. David M. Wrobel and Patrick T. Long, 165–201. Lawrence: University of Kansas Press, 2001.

Shoshone National Forest. *Interpretive Guide: North Fork Shoshone River, Shoshone National Forest*. Cody, WY: Shoshone National Forest, 1991.

Steele, David M. *Going Abroad Overland: Studies of Places and People in the Far West*. New York: G. P. Putnam's and Sons, 1917.

Stephens, Hal G., Eugene M. Shoemaker, and John Wesley Powell. *In the Footsteps of John Wesley Powell: An Album of Comparative Photographs of the Green and Colorado Rivers, 1871–72 and 1968*. Boulder: Johnson Books and the Powell Society, 1987.

Stimson, J. E. *Yellowstone Park*. Brooklyn, NY: Albertype, 1903.

Stimson, J. E. *Catalogue of Wyoming Views*. Cheyenne: J. E. Stimson, 1904.

Trachtenberg, Alan. *Reading American Photographs: Images as History, from Matthew Brady to Walker Evans*. New York: Hill and Wang, 1990.

Turner, Raymond H., Robert H. Webb, Janice E. Bowers, and James Rodney Hastings. *The Changing Mile Revisited: An Ecological Study of Vegetation Change with Time in the Lower Mile of an Arid and Semiarid Region*. Tucson: University of Arizona Press, 2003.

Waite, Thornton. *Yellowstone by Train: A History of Rail Travel to America's First National Park*. Missoula, MT: Pictorial Histories, 2006.

Warren, Louis S. *Buffalo Bill's America: William Cody and the Wild West Show*. New York: Knopf, 2005.

Webb, Robert H. *Grand Canyon, a Century of Change: Rephotography of the 1889–1890 Stanton Expedition*. Tucson: University of Arizona Press, 1996.

Webb, Robert H., Diane E. Boyer, and Raymond M. Turner, eds. *Repeat Photography: Methods and Applications in the Natural Sciences*. Washington, DC: Island, 2010.

Whiteley, Lee, and Jane Whiteley. *The Playground Trail: The National Park-to-Park Highway; To and Through the National Parks of the West in 1920*. Boulder: Johnson, 2003.

Whittlesey, Lee H., and Elizabeth A. Watry, eds. *Ho! for Wonderland: Travelers' Accounts of Yellowstone, 1872–1914*. Albuquerque: University of New Mexico Press, 2009.

Whittlesey, Lee H., and Elizabeth A. Watry, eds. *Storytelling in Yellowstone: Horse and Buggy Tour Guides*. Albuquerque: University of New Mexico Press, 2007.

Whittlesey, Lee H., and Elizabeth A. Watry, eds. *Wonderland Nomenclature: A History of the Place Names of Yellowstone National Park*. West Yellowstone, MT: Microfiche, 1988.

Whittlesey, Lee H., and Elizabeth A. Watry, eds. *Yellowstone Place Names*. Helena: Montana Historical Society Press, 1988.

Wyckoff, William. *On the Road Again: Montana's Changing Landscape*. Seattle: University of Washington Press, 2006.

Wyoming Department of Transportation. *Wyoming's Buffalo Bill–Yellowstone Country Scenic Byways*. Cheyenne: Wyoming Department of Transportation, 2004.

Wyoming Newspaper Project. http://www.wyonewspapers.org/ (accessed July 20, 2011).

Wyoming State Historical Society. *Rediscovering the Big Horns*. Cheyenne: Bighorn National Forest Volunteer Committee, 1976.

Wyoming State Museum. *Along the U.P. Line: A Listing of the J. E. Stimson Photographs in the Collection of the Wyoming State Museum*. Cheyenne: Wyoming State Museum, 1977.

Yochim, Michael J. *Yellowstone and the Snowmobile: Locking Horns over National Park Use*. Lawrence: University Press of Kansas, 2009.

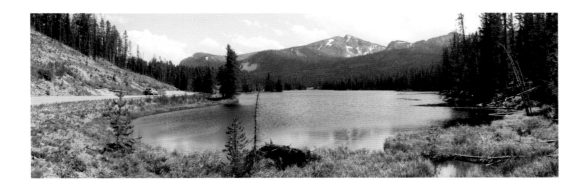

Index

Vernacular landscape, 143–144

W

Wapiti, Wyoming, 4, 62, 65, 66
Wapiti Creek, 36
Wapiti Inn, 37–39, 41–42, 56, 66
Wapiti Valley, 1
West Entrance, 30
Wild West Show, 15, 57
Whittlesey, Lee, 109, 116
Wilderness, 43, 45, 55, 57, 63
Wind River Mountains, 9

Wonderland, 23, 46–47, 93, 109, 117
Wyckoff, William, 21
Wyoming Department of Commerce and Industry, 15
Wyoming Department of Immigration, 14
Wyoming economy, 9
Wyoming Newspaper Project, 20, 22, 143
Wyoming State Archives, Museum, and Historical Department, 15, 20, 23, 51
Wyoming State Capitol, 12

Wyoming Stock Grower and Farmer, 33, 34, 35, 39, 120
Wyoming Territory, 9
Wyoming Time and Again, 17, 18, 77

Y

Yellowstone Cutthroat Trout, 46, 81, 121
Yellowstone Falls, 43
Yellowstone Fires of 1988, 19, 121, 123, 126–127
Yellowstone Forest Reserve. *See* Shoshone National Forest

Yellowstone Lake, 2, 30–34, 36, 39, 51, 127–129
Yellowstone National Park, 1, 4, 5, 6, 9, 11–13, 15–18, 22–23, 29–31, 34, 37–38, 41, 44–45, 51, 54, 56–59, 66, 81–82, 89, 96, 102–103, 106–129, 131, 134, 136, 141–144
Yellowstone Park Camping and Transportation Company, 37, 39, 42
Yellowstone River, 32, 36–37, 73

Z